THE HAND THAT ROCKED THE CRADLE

The Art of Birth and Infancy

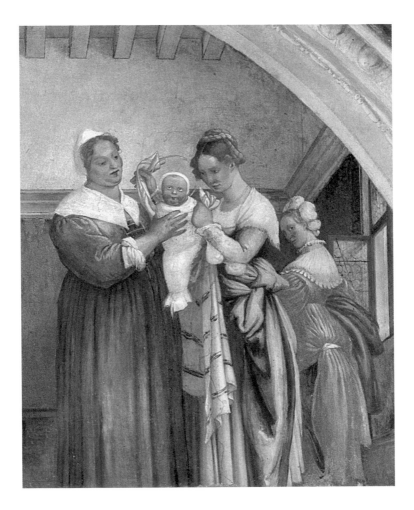

THE HAND THAT ROCKED THE CRADLE

The Art of Birth and Infancy

Sue Laurence

Unicorn Press

First published 2018 by
Unicorn Press
60 Bracondale
Norwich NR1 2BE

www.unicornpublishing.org

ISBN 978 1 911604 55 6

Designed by Nick Newton Design
Printed in Wales by Gomer Press Limited, Llandysul Enterprise Park, Llandysul, Ceredigion

FRONT COVER: *Portrait of a Baby*, circle of Mary Beale, oil, English, 1690–1730
ENDPAPERS: *The Cholmondeley Ladies*, the British School, oil, *c*.1600–10
FRONTISPIECE: *Birth of the Virgin* by Lorenzo Lotto, detail of fresco, Italian, 1524

Contents

Acknowledgements

Many people have provided sound advice, critical feedback and support throughout the period of writing this book. It has had a long gestation but I hope that this has not detracted from the final outcome.

Family and friends have been crucial in the process of researching and writing. My sister Anne Laurence read an early draft and made many helpful suggestions. Caroline Pratt gave very generously of her time and helped tighten up the narrative. My daughters Martha and Ellie have read early drafts and provided critical and very positive feedback in equal measure. Their partners Theo Lloyd and Jonny Lifschutz have shared their delight in the book's progress.

Friends have been supportive throughout. Nicola Wyld was very enthusiastic about the idea when it was still a project in progress and read a number of early drafts. Lesley Ruda, Mary Buckley and Fred Smoler have offered support and encouragement; Daphne Davies and Simon Burton have provided advice and generous hospitality. Henrietta Heald helped me navigate the publishing world.

I am particularly grateful to Hugh Tempest-Radford for reading a very early draft when it was a project in progress and recognising its potential and at a later stage offering to publish it. Without him this book could have been relegated to a dusty back drawer. Delia Gaze has been a rigorous editor which I have really appreciated. Nick and George Newton have provided excellent design and Susannah Stone's picture research experience has been invaluable. Last but not least my greatest debt is to Jeremy Gray who has been with me throughout this journey, reading critically but very constructively at every stage of the process and providing me with essential moral support, nurturing and love.

Introduction

This book explores the art and artefacts of birth and infancy from the later medieval period to the beginning of the twentieth century in western Europe and North America. The rich selection of images and objects offers a fresh perspective on the crucial early years of a child's life up to the age of three. Some show heirlooms that commemorated, celebrated and memorialised the infant. Others were more modestly made, and often were improvised objects of an ephemeral quality.

Childbirth practices and child-rearing were influenced by a variety of beliefs that drew on folklore, religion, philosophical and scientific ideas, and technical innovations. Folk beliefs endured for a long time and often invoked magical and metaphysical forces and prophecies. They also entailed rituals relating to the natural and supernatural worlds, as well as applying distinctive materials, substances and objects to protect the foetus and the infant from evil influences. Christian churches naturally treated birth, like death, as a crucial rite of passage and set out rules, rituals and punishments informed by Christian belief. These rules regulated the role of midwives and upheld the mother as a martyr whose penance as a daughter of Eve required her to risk death while submitting to the pain of childbirth. Christian churches also promoted maternal breastfeeding as women's godly duty. It was also expected that the mother undergo a period of incarceration or 'quarantine', at the end of which she would be 'churched', a thanksgiving ceremony originating in the Jewish rite of purification. Above all, the Catholic Church wanted to ensure that the infant received the essential sacrament of salvation, baptism, although in the sixteenth century some Protestant communities became less insistent on this.

Social reformers, philosophers, physicians, philanthropists and a growing number of domestic commentators also influenced childbirth and childcare practices and expressed their views on a vast range of issues from swaddling to how infants should learn to walk. Most of the policies relating to infant care proposed by experts such as John Locke in the late seventeenth century hinged on the idea that infants needed to toughen up and exercise self-discipline in order to face the adult world. This, it was believed, could be achieved more readily via the removal of such protective measures as padded hats and baby walkers and through early and successful potty training. During the eighteenth century many physicians also believed that 'Dame Nature' should take her course, and criticised the use of forceps during childbirth as unnecessary medical intervention.

By the nineteenth century childbirth and childcare practices were influenced by the increasing privacy of the domestic interior and the emergence and development of institutions like the lying-in and foundling hospitals. New medical discoveries, the medicalisation of the birth process, better hygiene and cleanliness in the home also contributed to ensure that mothers and infants were more likely to survive the ordeal of childbirth and to improve their life chances afterwards. This was offset by mothers becoming more isolated during childbirth in lying-in hospitals, where they were increasingly removed from the support of family and friends. Meanwhile, the lying-in chamber within the home, far from being a sanctuary for women, was becoming a contested territory among doctors, midwives, fathers and mothers. While real advances in medicine and hygiene did improve infant care in areas such as feeding, the decline of wet nursing and the rise of the 'dry nurse' and baby farmer often substituted one form of neglect for another.

CHAPTER 1

The womb, conception and pregnancy

Let me be as the fruitful vine on the walls of my
husband's house, and let (at the least) one olive plant
spring out from me, to stand about this table.

Prayer from *Helpe unto Devotion*
by Samuel Hieron, 1620, p.150

Fertility and infertility

From the medieval period to the end of the nineteenth century, women's first duty was considered to be to bear and nurture children, and, since childbirth was seen as a natural stage that every woman passed through, there was little toleration of 'barrenness'. This meant that women who could not conceive were frequently humiliated and mocked. Infertile women tried to make sense of their condition by convincing themselves that it was caused by invisible malevolence.[1] Pregnancy was seen as a natural state for all women and so, if no conception took place, there was an assumption, prevalent from the sixteenth century that the womb was 'wandering' around the body unsatisfied. One common fear was that this could lead to the womb ending up in the brain. This prompted physicians to invoke the term 'hysteria' derived from the Greek, meaning 'womb', to denote this mental condition, which was thought to originate in this part of the body.

Folk remedies were also recommended to promote female fertility by healers and 'wise women', particularly in rural communities throughout western Europe, and amulets were sometimes used for this purpose as well.[2] Prayers and offerings at holy shrines throughout Europe were also widespread practices.[3] The many other fertility rites prevalent throughout Europe included a belief that prayer accompanied by a woman poking her finger through a keyhole could restore fertility.[4] *Mandragora* (**fig. 1**) and leeks, as well as suppositories of laudanum, were also thought to promote conception.

The problem of infertility was focused on women. Advertisements for dubious fertility potions and powders appear to have emerged in the seventeenth century, and astrologers were enlisted to predict the optimum times for conception. Some women in England, desperate to conceive, frequented the consulting rooms of the

1 *Mandragora* (mandrake plant) by Leonhart Fuchs from *Officina Isingriniana*, 1542.

astrological physician Richard Napier (1559–1634), famous for his treatment of mental disturbance and insanity. In his detailed notes he testified to the slander to which these women were submitted as 'barren women'.[5] There was also a prevailing prejudice during the seventeenth and eighteenth centuries that certain social and ethnic groups, such as the poor and the Irish, rarely suffered from 'barrenness'.[6]

Remedies to restore women's fertility such as taking the waters at spas were often recommended by doctors for the upper ranks and for royalty. In an attempt to cure her infertility, Mary of Modena, wife of James II (reg. 1685–88), visited the spa at Tunbridge Wells in 1687, but with no discernible effect. She went to Bath Spa two months later in August, and her successful conception on her return was partly attributed to its waters.[7] Spas continued to be popular for treating infertility in women into the nineteenth century. The caricature in **fig. 2** shows a doctor offering a female patient his personal sexual services to assist the spa fertility cure.

During the eighteenth century quack doctors continued to exploit men's anxiety about impotency and couples' concerns at the woman not falling pregnant. Some doctors such as Dr Buchan maintained that infertility proliferated amongst the rich and affluent, attributing it to 'high living'.[8] In response to the decline in fertility amongst this section of the population, Dr James Graham, whose clients included Georgiana, Duchess of Devonshire, ran a 'Temple of Health and Hymen', prescribing the new science of electricity, milk baths and friction techniques for couples desperate to conceive.[9] In the most private part of the temple Dr Graham housed a

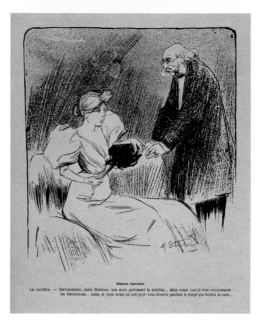

2 A woman patient at a spa is told by her doctor that the treatment for her fertility might be helped by the presence of a diverting friend, i.e., him, lithograph by M. Stephane, 1896.

'celestial bed' powered by 'magnetised electricity', which he hired out for £50 a night as a fertility shrine (**fig. 3**).[10] By the nineteenth century various patent medicines continued to claim that they could promote conception, such as the cordial *Balm*

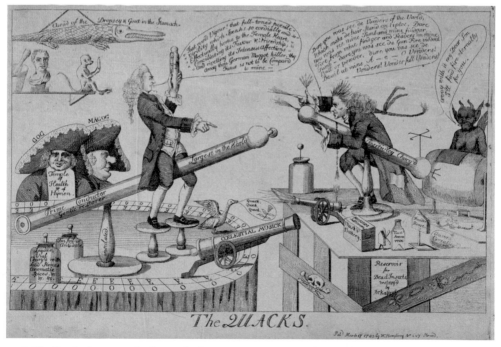

3 *The Quacks* (two unorthodox medical practitioners, James Graham and G. Katerfelto, battling against each other), etching by W. Humphreys, 1783.

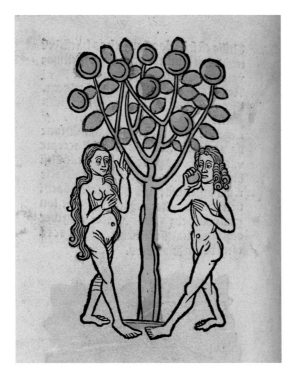

4 *Adam and Eve under the Tree of Life,* coloured woodcut by Arnaldus de Villanova, Mainz, Germany, 1491.

of Gilead. The manufacturers asserted that all that was required was to prescribe a daily dose of two tablespoons of this liquid, 'when a woman enters into a state of matrimony', and success was guaranteed.[11]

During the Victorian period the Brothers Grimm wrote several fairy tales based on much older German folk tales that addressed the subject of infertile women. In *The Tale of the Almond Tree*, sometimes known as *The Juniper Tree*, which is a thinly veiled variation on the theme of Eve's fall, the infertile wife prays day and night for a child. One day she cuts her finger while peeling an apple under a juniper tree. As she casts a wish to have a child, the blood she drops from her finger makes the tree gradually blossom and then produce fruit. After six months the fruits are so enticing that she succumbs and eats them, greedily forcing them down and enabling her to become pregnant. However, although the consumption of the fruit helps her to give birth successfully, it manages to poison and kill her in the process.[12] Interestingly, during the sixteenth century the state authorities in Germany granted pregnant women immunity from criminal prosecution in certain cases of theft, for example, when a pregnant woman stole fruit.[13] Hence the moral fable, the fairy tale and the lenient response by the state towards women who stole fruit invoked associations with the temptation of Eve and the need for redemption, a biblical allusion that would not have been lost on Germans at that time (**fig. 4**).

Predicting and detecting pregnancy

A scientific process for diagnosing pregnancy from urine, known as uroscopy, was developed around the thirteenth century. Albertus Magnus (1193–1280) invented a test for pregnancy that involved observing if milk floated to the top of a urine sample provided by a woman. Later the Lutheran physician Jacob Rueff, who practised in Zurich, put forward a different theory for detecting pregnancy in his widely used classic practical handbook for midwives, the *De conceptu et generatione hominis* (1580). He maintained that if an iron needle coated with urine displayed black spots this meant that the woman was pregnant.[14] Practitioners who deployed such diagnostic techniques were known by the seventeenth century as 'Piss prophets' (**fig. 5**), but there were other pregnancy tests that did not involve urine. One English woman, Katherine Chaire, who charged exorbitant fees to women desperate to conceive claimed that she could ascertain pregnancy successfully by the curious method of burning linen underclothing; an alternative method consisted of washing women's clothing with rosewater and soap.[15] However, she provided no clear evidence how pregnancy could be ascertained by applying these techniques. Throughout the

5 A Physician examining the urine of a pregnant girl, unknown artist, oil, Netherlands, 18th century.

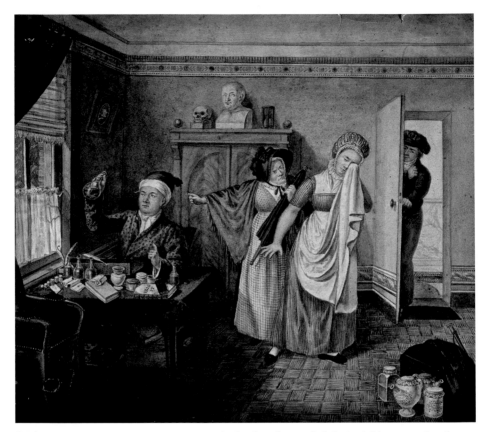

6 Physician examining a urine specimen in which a faint figure of a baby is visible, watercolour by I. T., 1826.

eighteenth and nineteenth centuries uroscopy continued to be used to detect pregnancy, as the image in **fig. 6** illustrates.

There were many beliefs concerning prospective births. Rocking an empty cradle was thought to prophesy many future offspring. Many people, however, relied on evidence relating to animal behaviour and natural phenomena. For example, the sight of four magpies was believed to be an omen denoting a prospective birth: 'One for sorrow, two for mirth, three for a wedding, four for a birth'. In various regions of France certain types of birdsong were also thought to prophesy such an event.[16] Women also relied on omens to predict the sex of the unborn child. For example, if a mother received a lily she was to expect a boy and if a rose a girl.[17] In addition, there was not only considerable faith in the power of alcohol to facilitate birth but also a belief that imbibing alcohol while pregnant ensured a male child. The umbilical cord was also considered a good indicator of future fertility, the knots denoting the number of children predicted for the family.

In northern Europe the Protestant theologian Martin Luther (1483–1546) was influential in challenging some of these beliefs. He had many staunch followers, one of whom was the physician Jacob Rueff, who, together with other members of the medical profession, was beginning to question certain beliefs relating to childbirth. German and Austrian sixteenth-century obstetric textbooks were very critical of those midwives who resorted to folk customs and recommended that they should be severely punished for any negligence that occurred by being buried alive or broken on the wheel.[18]

By the sixteenth century certain beliefs about pregnancy and childbirth were beginning to be outlawed by church authorities in Europe. In England in 1520 a childless couple, John Phipps and his wife, who were desperate to conceive, clung on to the notion that keeping an empty cradle by the bedside would magic up an infant for them.[19] This was reported, and they were sent up before the ecclesiastical authorities for upholding what was regarded as a questionable belief based on superstition. Although by the late seventeenth century the role of astrologers in childbirth was declining, folk beliefs were passed on through the generations of families and were extraordinarily enduring, persisting up to the nineteenth century and beyond.

'Markings' and curious births

From medieval times to the nineteenth century, women in Europe and America were thought to be particularly susceptible during pregnancy to changes of emotion and environment that could cause 'markings' or deformities in the baby. 'Monstrous' births, as they were known, were also attributed by midwives to supposed sexual immorality during pregnancy. A more extreme version of this was a belief that monstrous births were the product of sexual intercourse with the devil. This view was rejected by Jacob Rueff, who took the view that these births were the result of inducing God's wrath for the lawful act of love being used excessively.

Given the fear of producing monstrous births, people clung to beliefs that were thought to combat disability, such as wearing a slit smock to avoid a baby with a harelip.[20] But there were also other recommended methods. In south-west Germany instances of abnormal births had to be reported by the clergy to the Supreme Council, a body controlled by the Church, and mothers had to explain the circumstances that had given rise to their infant's deformity. This could involve something the mother had seen, felt or experienced. These beliefs gave rise to bizarre claims, and many town councils in Germany during the seventeenth century responded by imposing ordinances. One of these instructed beggars to hide their deformed limbs out of consideration for pregnant women. Other citizens deemed ugly or ill had to

be removed out of sight of the pregnant woman for fear they might induce a deformity in the unborn child.

There were also claims of women giving birth to animals, which was attributed to the committing of bestiality. In 1569 it was alleged that an English midwife gave birth to a cat, and in the Dutch Republic in 1677 an inhabitant of The Hague was reported to have given birth to a puppy.[21] In England in 1726 Maria Tofts claimed to have given birth to rabbits as a result of a craving for eating rabbit during her pregnancy (**fig. 7**), but far from exposing her as a fraud, a group of physicians helped to perpetuate this famous hoax. Opinion was divided about her claim and this induced the king, George I (reg. 1714–27), to call for an investigation. Tofts was eventually unmasked as someone who had hoped that her freak status would win her a royal pension.

During the seventeenth century there were also concerns relating to a mother's conduct and how this might adversely influence the outcome of a birth, and also how the behaviour of others towards the mother could also potentially produce a 'monstrous birth'. One example is that of a Catholic mother during the period of the English Civil War (1642–51), who, it was believed, had been cursed with a headless child because it was claimed she had said during her pregnancy that she

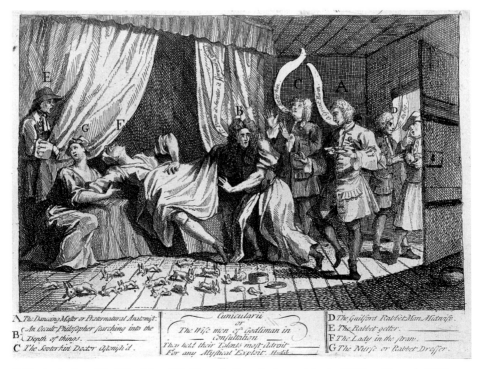

7 *Cuniccularii; or, The Wise Men of Godliman in Consultation*, etching by William Hogarth, 1726.

A certaine Relation of the Hog-
faced Gentlewoman called Miſtris *Tannakin*
Skinker, who was borne at *Wirkham*
a Neuter Towne betweene the Emperour and the
Hollander, ſcituate on the river *Rhyne.*
Who was bewitched in her mothers wombe in the yeare 1618.
and hath lived ever ſince unknowne in this kind to any,
but her Parents and a few other neighbours. And
can never recover her true ſhape, tell ſhe
be married, &c.
Alſo relating the cauſe, as it is ſince conceived, how her mother
came ſo bewitched.

London Printed by *J.O.* and are to be ſold by *F. Grove*, at his ſhop
on *Snow-hil* neare *St. Sepulchers Church.* 1640.

8 *A certaine Relation of the Hog-*
faced Gentlewoman, woodcut, 1640.

would rather bear a child with no head than a future Roundhead.[22] One well-doc-umented example of the marking of an embryo by an animal was that of Mistress Tannakin Skinker, a German, who was believed to have been transformed into 'a hog-faced gentlewoman' in her mother's womb (**fig. 8**). Examples such as this were attributed to curses aimed at the pregnant mother. In this particular case the mother had refused to give money to a beggar, who then punished her by casting a spell on her, resulting in the deforming of the unborn infant. Mothers witnessing disturbing scenes such as executions were also considered to endanger the foetus.[23]

Fears also allegedly contributed to markings. For example, during the nineteenth century many people believed the popular story that the cause of Joseph Merrick's deformity was that his mother had been frightened by an elephant when she was pregnant – he was known as the elephant man. Even by the turn of the century child-care experts were perpetuating the belief in 'mother's marks' resulting in deformities and disfigurements, with Mrs Ada Ballin, a domestic commentator, exhorting newly married pregnant women to 'avoid anything which so gravely injures her possible offspring'.[24]

'Pregnant men'

There were other claims of curious birth phenomena prevailing from the fourteenth century to the eighteenth. One of the most bizarre was that men were capable of giving birth to babies. The earliest documented example was in 1330 in a Flemish village. A man called Louis Roosel made an impassioned imitation of his wife's labour and this it was believed gave rise to the semen circulating through his body to ferment, rendering him fertile and causing his right buttock to swell up. This bulge continued to grow until the man was delivered of a baby boy from it nine months later. Another example also emphasised the potency of male semen alone to generate children. This event is believed to have taken place in France in 1696, when, aroused by caressing a nun, a Cistercian monk's passion was believed to have fermented his semen[25] so as to produce a foetus inside his left testicle. This is recorded by Claude Brunet, who collected such strange accounts and reported them in the *Leyden Journal.*[26]

Later, in 1759, a thirty-two-year-old Dutchman called Isach Sleck from Dordrecht complained of pains and contractions in his chest; he was initially diagnosed with water retention but was then found to be pregnant when his chest, which had

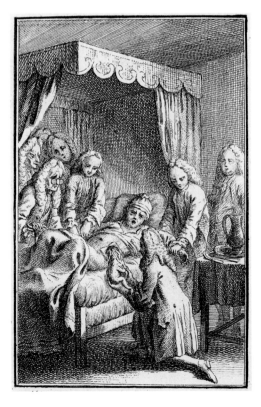

9 *L'homme de Dordrecht,* frontispiece of *Recueil complet de pièces curieuses,* engraving, French, 1759.

a membranous pocket in it resembling a womb, was opened up. To the astonishment of the assembled surgeon and doctors a baby was revealed that had reached full term (**fig. 9**). The medical profession attempted to offer an explanation for this phenomenon, suggesting that the baby was Sleck's twin who had somehow become fertilised inside Isach rather than within their mother's womb. Doctors speculated that the embryo had remained dormant inside the man for many years and then had grown very slowly in the cavity of his diaphragm when he became an adult. French academicians were invited to investigate the claims of the Dutch doctors involved in the case, but the patient died before closer scrutiny could take place.

Beliefs about conception and birth

There were also curious theories about how babies came to be born. It is tempting to speculate that these may have originated in adults' desire to conceal how babies were conceived. By maintaining ignorance it was thought that unwanted babies and pre-marital sexual activity would be prevented. Above all pre-marital sex was believed by the Christian churches to represent a grave threat to morality and to marriage.[27]

While the myth that babies appeared out of bird's eggs (**fig. 10**) goes back to classical antiquity, babies emerging from water sources such as lakes, ponds and waterfalls have wider pagan origins.[28] Plants or flowers were also believed to produce babies. In France it was thought that babies could be found under cabbages,[29] while

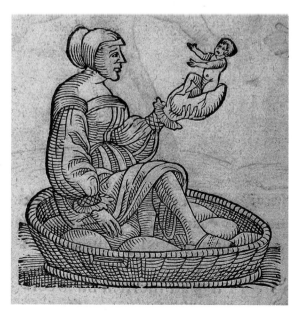

10 *Selenetidae*, woodcut by Lycosthenes Conradus, Basle, 1557.

the gooseberry bush was the equivalent birth myth in England. In 1755 Lady Judith Milbanke recalled how, aged three and a half, she was told that her sister had been found in a parsley bed.[30] Eleanor Farjeon, who wrote a memoir of her nursery days in England during the 1890s and whose middle-class experience was probably quite typical, was told as a child that she had originated as a fairy and then materialised in a snowdrop, and that her brothers were born from an apple blossom and a geranium respectively.[31] Animals were also thought to bring infants to parents. The idea of storks carrying children, while probably having classical origins, seems to have gained currency during the nineteenth century in northern Europe, particularly in the Netherlands and Germany.[32] Ignorance about where children came from, however, was not restricted to small children. At the end of the nineteenth century in England, Mrs Leyton, at fifteen, was employed as a maternity nurse for a family. Her role was to care for the mother and the newly delivered baby, but she admitted: 'I knew nothing about the facts of life.'[33]

There were strong beliefs surrounding the best month for a baby to be born, which was said to be July. The best day was reputed to be Sunday, because it was the day of the Resurrection,[34] although Puritans in New England rejected this belief since they believed that the Sabbath should be strictly respected. Conversely, the worst day was deemed to be Friday and midday was unlucky. The notion that midnight was the most auspicious time for a baby to be born was less controversial.[35]

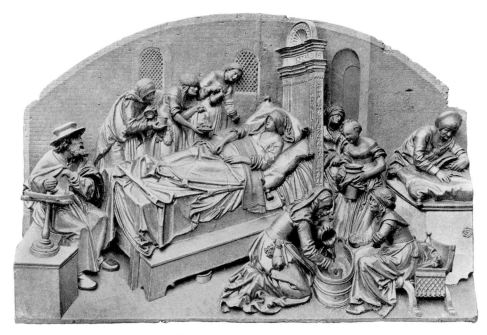

11 *Lying-in scene*, relief, German, 1510.

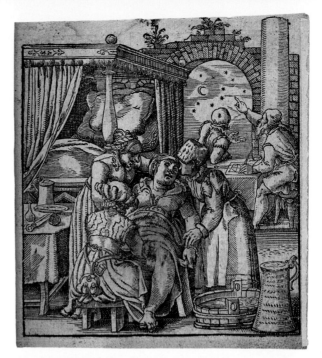

12 Illustration of midwives from *De conceptu et generatione hominis* by Jacob Rueff, woodcut, Frankfurt, 1587.

13 Trencher and bowl, *Tagliere da parto*, painted by Nicola da Urbino, maiolica, Italian, 1533–38.

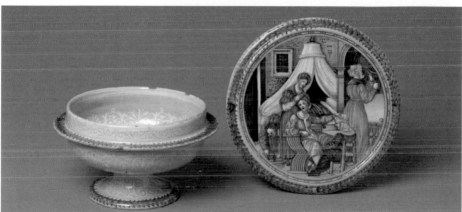

Astrologers also played an important role in predicting both the timing of the birth and the new infant's future prospects. Given the very high stakes involved in their jobs, midwives had recourse to astrological predictions relating to how the mother would fare in her labour.[36] A male astrologer seen on the left in this religious sixteenth-century German relief (**fig. 11**), was often present at the time of an infant's birth in the more prosperous households of northern Europe and the Mediterranean countries, and are represented in many fifteenth and sixteenth-century depictions of birth (**fig. 12**). Their predictions involved drawing up a child's horoscope or its 'nativities', which charted the course of the stars at the exact day, hour and minute of its birth. This could be done at the exact time of birth at the request of the parents, or retrospectively, provided that the astrologers were supplied with details. **Fig. 13**

shows an astrologer looking through a telescope while the mother is preparing for the onset of labour. Henri IV of France (reg. 1589–1610) insisted that there was a well-regulated clock at his son's birth. By ensuring that the time was accurate, his astrologers were, it was claimed, equipped to formulate the dauphin's horoscope with greater certainty.[37]

Modesty and concealment

Since women's clothing tended to conceal their pregnancy, and most clothing and underclothing were designed in such a way as to make the wearer's condition difficult to detect, it is not surprising there are not many obviously pregnant women featured in portraits before the twentieth century. During the medieval period this absence is partly attributable to the enlarged stomach representing a standard of beauty for all women whether pregnant or not. Hence, artists tended to use other methods to indicate pregnancy, such as the dishevelment of clothing involving stays unlaced from the bottom and extra loose folds of smock depicted in the front.[38] A French four-teenth-century ivory depicts St Joseph looking surprised and worried by Mary's preg-nancy. The artist indicates her pregnancy by Joseph's gesture of touching her stomach, together with the profusion of loose folds in the front of Mary's voluminous gown.[39] To signify her condition, Piero della Francesca's *Madonna del Parto* of *circa* 1455–60 shows the Virgin opening the slit in her loose smock with her hand.[40] The illegitimate pregnancy of Gabrielle d'Estrées, mistress of Henri IV, is celebrated in a painting in which she is depicted naked rather than clothed, to underline her status as the king's favourite mistress.[41] Her sister, Julienne d'Estrées, Duchess de Villars, who stands beside her, pinches Gabrielle's nipple in a symbolic, discreet allusion to her pregnancy. Pinching the breast was also a method that was employed by midwives to detect pregnancy in women by seeing if the breast would draw milk.[42]

The wearing of loose-fitting *Regentücher* or 'rain clothes' to conceal pregnancies in Germany was banned by the Lutheran city authorities in Nuremberg in 1532 on the grounds that they could conceal illegitimate pregnancies.[43] There was certainly vested interest in concealing an illegitimate birth, as the more visible a pregnancy the less likely it became that a householder would take in the mother, for fear of reprisals for harbouring her.[44]

It was also quite common for the abdomen and breasts to be covered up with bandages, which were considered to be beneficial by providing support for the abdominal muscles. In addition, many pregnant women in the late seventeenth and eighteenth centuries wore a long apron tied just beneath the breasts to cover the abdomen.[45] This can be seen in this print by Thomas Cook after William Hogarth, in which a heavily pregnant unmarried mother denounces the wrong father in front

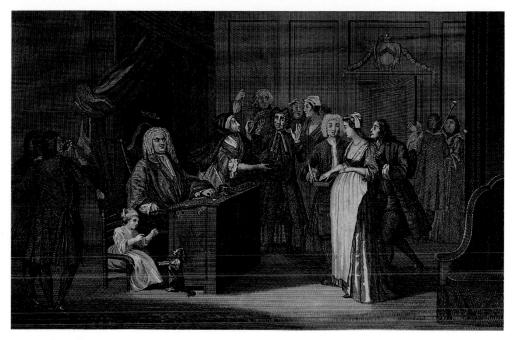

14 *The Affiliation*, engraving by Thomas Cook after William Hogarth, 1803.

of a magistrate. The alleged father holds up his hands in despair, berated by his angry wife, who believes that he has cheated on her, while the actual father sidesteps the accusations and prompts the pregnant woman by whispering in her ear (**fig. 14**). The bye-line on the print describes how: 'Here pregnant mother screens the real sire, and falsely swears her bastard child'.

It was still usual to disguise pregnancy in public in the eighteenth century, and Georgiana, Duchess of Devonshire (1757–1806) promoted a fashion for false fronts to dresses to conceal the condition. Given the expense of textiles, altering and adapting clothing from something entirely different was commonplace. By sewing in an adjustable waistband and lacing at the back, the wearer could resume wearing the garment after the pregnancy.[46]

The concern to preserve pregnant women's modesty continued into the nineteenth century. An illustration in an obstetrics book written by the famous French surgeon Jacques Maygrier (1771–1835) shows a pregnant woman standing up with no sign of a protruding belly, fully clothed in a corseted dress reaching down to her ankles. The physician kneels at her feet and averts his eyes while he conducts a gynaeco-logical examination, fumbling beneath the hem (**fig. 15**). By 1807 Dr Buchan was praising the fashion for abandoning the corset, which he argued was detrimental to the breasts and womb. Despite his entreaties, however, the fashion for tight corsets

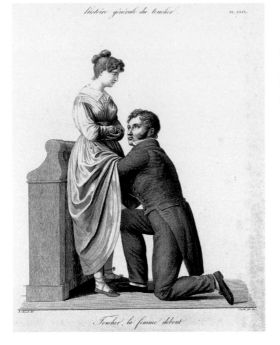

Toucher la femme debout

15 *Toucher la Femme debout*, a vaginal examination in a vertical position, from *Nouvelles démonstrations d'accouchemens* (*sic*) by Jacques Maygrier, engraving, Paris, 1825.

for pregnant women resumed later in the century.[47] Some childcare experts believed that there was no need for pregnant women to lead a reclusive existence, providing they dressed discreetly, 'in such a way as not to make it apparent'.[48]

Above all, modesty had to be upheld, and in the nineteenth century this was accompanied by a squeamish dislike of discussing women's gynaecology, summed up in Rudyard Kipling's poem of 1896:

> We ask no social questions – we pumped no hidden shame.
> We never talked obstetrics when the Little Stranger came.[49]

Preparing for lying-in

During the medieval period, a pregnant woman of noble birth was expected to enter the lying-in chamber and accompanying antechambers a month before she was due to give birth. This marked the beginning of a period of confinement marked by abstention from sex and release from normal household duties. To underline the solemnity of the occasion and the importance of birth as a rite of passage, noble-women received Communion before entering the chamber, accompanied by a cere-monial procession of lords and ladies. At the entrance to the lying-in chamber, all the men were excluded. All the domestic duties were undertaken by serving women.[50] In Italy an important part of the preparation consisted of female servants arranging the mother's hair, since it was believed that the style would influence the outcome. This activity is depicted on this Italian Renaissance tin-glazed bowl (see fig. 13).

Affluent pregnant women in sixteenth- and seventeenth-century Europe were urged to spend as much of their pregnancy as possible in the home and to focus their attention on objects of contemplation.[51] In addition, unlike their poorer counterparts who could not afford to rest, they would either take to their beds weeks before the birth or receive visitors reclining on day beds[52] or chaises longues, or sitting in invalid chairs with padded cushions and high backs, reinforcing the notion that pregnancy and childbirth were a disease (**figs. 16** and **17**).

16 Daybed, reign of James II (1685–88), walnut framed with cane-panelled seat. Ightham Mote, Kent.

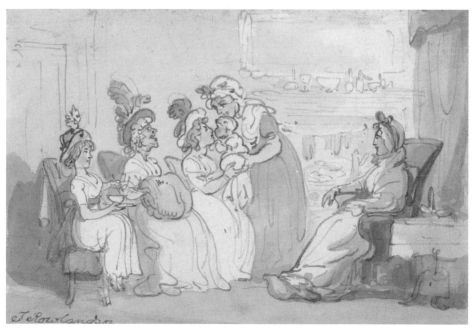

17 *The Visitors being Shown Baby*, watercolour with pen and ink by Thomas Rowlandson, undated.

Nevertheless, contrary to the tenets of politeness and modesty found in contemporary advice books, and contrary to the notion that pregnancy was an illness and that women should be treated as invalids, some women led an extraordinarily active life throughout their pregnancies. In 1735 Elizabeth, Duchess of Marlborough did not avoid going out but adapted her clothing to conceal her condition.[53] In 1767 Queen Charlotte appeared at a birthday ball when she was thirty-three weeks pregnant, dancing four times with the king of Denmark, and was dancing all night immediately before the birth of her eighth child, Ernest.[54] By the end of the eighteenth century more enlightened doctors, such as Dr Buchan, were recognising that pregnancy was not a disease, but acknowledged that many women were 'indisposed' for most of the duration of their pregnancies.[55] Far from retiring from society, Frances, Lady Churchill kept up a full social life throughout her pregnancy in 1805. By contrast, Queen Victoria (reg. 1837–1901) did not subscribe to this behaviour and complained that society women were rebelling against enforced retirement during pregnancy. Moreover, she observed disdainfully that they were beginning to dance within a fortnight of their confinement and waltzing when seven months pregnant.[56]

In nineteenth-century America pregnant women from the upper ranks continued to lead active lives while hiding their condition, although they shunned public places. Wherever possible they were encouraged to enjoy fresh air and encouraged in moderate open-air pursuits. The Bostonian socialite Isabella Stewart Gardiner (1840–1924) seems to have been more reclusive than most women and disappeared from the social scene altogether when she became pregnant, hiding herself away out of modesty and becoming coy about moving in polite society. Earlier, in the American South, the wives of plantation owners undertook vigorous exercise in the form of riding and walking in the early months of pregnancy, and this was considered efficacious to their condition.[57]

Certainly, for the lower ranks, hard, physical work in late pregnancy was justified by members of the medical profession in Britain, since it was thought to promote easier labour through separating the pubic bones from each other and opening up the birth canal.[58]

Abortion

Abortion was undertaken secretively and it is possible that the frequent discussions around obstructions in the menstrual flow during the seventeenth and early eighteenth centuries were euphemisms for early abortions.[59] It was very easy for women to find out how to carry out an abortion. Apart from learning techniques by word of mouth, recipes for abortifacients were ubiquitous in herbal recipe books and

included such herbs as pennyroyal, savin and ergot. One sixteenth-century book devoted to herbal remedies had a whole chapter devoted to abortion.[60] It recommended as 'a remedy to expel a dead child' that a woman should sit over a pot of hot water mixed with specified herbs and plants. Other methods were recommended to terminate pregnancies, such as consuming steel filings. By the seventeenth century, however, many clerics were urging women to resist the temptation to abort by using 'physic' and other practices, reflecting a growing concern that women were resorting to these homemade remedies.[61]

Abortion was made illegal in England in 1803, but it was very common amongst poor communities in urban industrialised areas at the end of the nineteenth century and was used as a substitute for contraception to limit family size. This rise in abortion was facilitated by the availability of drugs and chemicals that could be purchased for a 'pennyworth'. One popular method of abortion was the consumption of lead pills, which had horrific side effects and could lead to death. This prompted the medical profession to lobby for tightening up the abortion law and making lead a poison that could be secured only on prescription. It also involved doctors alerting the police when abortions that had used lead poisoning were brought to their attention.[62]

Miscarriage

Poor nutrition, chronic illness and inadequate antenatal care all contributed to the high incidence of miscarriages throughout western Europe from the medieval period up to the seventeenth century. In Germany during the sixteenth and seventeenth centuries as many as one in eight pregnancies ended in miscarriage, and undoubtedly abortions were sometimes dismissed as miscarriages to avoid controversy.[63]

Mothers and less often fathers were blamed for causing miscarriage, and this was sometimes carried to extremes when they were forced to look at the dead infant or the foetus as a punishment.[64] In England, it was alleged that Queen Anne (reg. 1702–14) had twelve miscarriages and five stillbirths, and her disappointment was undoubtedly compounded by the pressure placed on her to produce a male heir, particularly given that her sister, Queen Mary (reg. 1689–1694), had remained childless.[65] While it is not known if she was deemed responsible for the failure to produce live offspring, miscarriage was often blamed on mothers as those around them waited impatiently for a male heir.

Georgiana, Duchess of Devonshire was berated by her father for her miscarriages: 'I cannot resist the writing you a little word from here to let you know how sorry I am that you have failed making me a grandfather; however what has been may be again, and you will succeed better another time if you will have a little prudence.'[66]

Women were also prone to blame their own conduct and actions for their miscarriages: Marie-Antoinette, queen of France (d. 1791) attributed one miscarriage to her attempts to close a carriage window. Nineteenth-century physicians such as William Buchan reinforced the tendency for women to reproach themselves by attributing miscarriage to the 'Improper conduct of women themselves'.[67] In addition, the need to obey doctors' injunctions to avoid miscarriage was sometimes laid down with disciplinarian zeal. Dr Thomas Bull threatened: 'and remember also, that with one act of disobedience she may blast every hope of success'.[68]

Environmental factors were also thought to contribute to miscarriage. The popular public health theory of miasma prevailed throughout the eighteenth and nineteenth centuries, but was discredited towards the end of the latter. It was premised on the belief that noxious miasmas poisoned the atmosphere and adversely affected the health of the population in general and mothers and infants in particular. For this reason doctors cautioned pregnant women against visiting riverbanks and marshy areas where miasmas were thought to abound.[69]

CHAPTER 2

A child is born

HARK! forth from the abyss a voice proceeds,
A long low distant murmur of dread sound,
Such as arises when a nation bleeds
With some deep and immedicable wound;
Through storm and darkness yawns the rending ground,
The gulf is thick with phantoms, but the chief
Seems royal still, though with her head discrown'd,
And pale, but lovely, with maternal grief
She clasps a babe, to whom her breast yields no relief.

Childe Harolde by Lord Byron, canto IV, on the death
of Princess Charlotte and her stillborn son,
5 November 1817

The risks, hazards and dilemmas of birth

The dangers of childbirth were acute for both mother and baby. Birth was a hazardous activity, and maternal and infant mortality were high throughout western Europe during the medieval period. In sixteenth- and seventeenth-century England 2.5 per cent of women died in childbirth and 20 per cent of children died before the age of five years. In London during the seventeenth century women were a hundred times more likely to die in childbirth than they are today.[1] The risks of the mother and infant dying in the birth process were generally reduced if the child was delivered at home rather than in a lying-in hospital. At times the latter were rife with disease, particularly puerperal fever, a fatal blood disease that was highly contagious and affected women in childbed.

The alabaster memorial of Anne Leighton, first wife of Sir John St John Lydiard, depicts maternal and infant mortality (**fig. 18**). Sir John married Anne when she was twelve and she bore him thirteen children, four of whom died in infancy. She died in 1628, two months after giving birth (presumably of childbirth-related complications) to her last child, Henry, who survived. Anne is carved tightly clutching her small infant in her left arm; her face appears vacant and oblivious to the baby, accentuating the loss both to her newborn son and to her other surviving children,

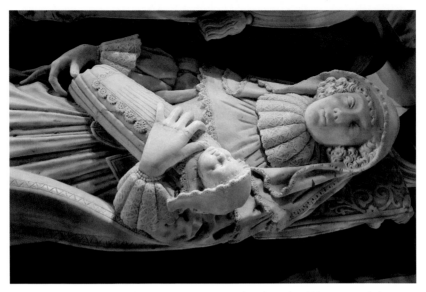

18 Memorial to Anne Leighton, 1634. St Mary's church, Lydiard Tregoze, Wiltshire.

who kneel at the side of the monument. Her deceased infants are distinguished by being mounted on medallions in a reclining position.

By the eighteenth century infant mortality had declined, in part as a consequence of rising living standards. In 1789 William Blake movingly captured the combination of relief and fear that accompanied every birth (**fig. 19**):

> My mother groaned! My father wept.
> Into the dangerous world I leapt:
> Helpless, naked piping loud:
> Like a fiend hid in a cloud.
> Struggling in my father's hands:
> Striving against my swaddling bands:
> Bound and weary I thought best
> To sulk upon my mother's breast.

Fathers were regularly faced with the moral dilemma of whether to pray to preserve the life of the mother or that of the child when there was a prospect of one or other of them dying. Of course, sometimes the outcome was even more catastrophic and both mother and baby died. Martin Luther exalted maternal self-sacrifice and women's endurance of pain and believed that bearing children was their paramount function.[2] He was also uncompromising when it came to their death in childbirth and expected mothers to die rather than sacrifice their offspring. He famously addressed this topic by declaring:

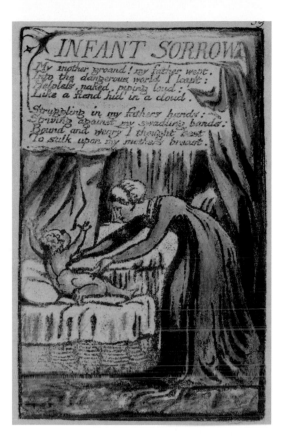

19 'Infant Sorrow', from William Blake, *Songs of Innocence and Experience*, relief etching, 1789–94.

'Should it mean your death, then depart happily, for you will die in noble deed and in subservience to God. If you were not a woman you should now wish to be one for the sake of this very work alone that you might thus gloriously suffer and even die in the performance of God's work and will.'[3]

Much later, John Knyveton (1729–1809), a male midwife and surgeon, confided to the pages of his diary a view formerly deemed heretical by many Protestant churches, that, much as he wanted a son, faced with a stark choice he would save his wife's life:

'And for personal botheration, I am worried about Elizabeth: for to our great joy and surprise, she is again with child: but secretly I am very anxious, remembering her weakness when our daughters were born, am trusting to God all will go well.' He continued: 'I would rather lose the child, much as I long for a son, than my dear Elizabeth.'[4]

The embroidered motto 'Bless the Babe and Save the Mother' sewn on the front of one mid-nineteenth-century pincushion, a traditional gift to new mothers, also

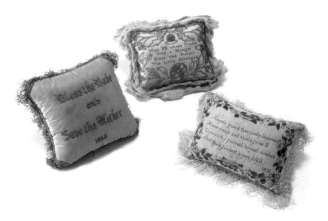

20 Layette pincushions, silk, lettering made from pins, English 1862.

reflects the terrible dilemma families faced with the prospect of maternal or infant death in childbirth or, worse still, both of them not surviving (**fig. 20**).

Fathers attending the birth

Six of James II's eight children by his first wife, Anne (d. 1671), died in early childhood, as did five of his children by his second wife, Mary of Modena. Each time his wife gave birth there were undoubtedly tensions as to whether the baby would survive and a hope that their fortunes as a family would change. James attended the birth of his first son and then temporarily left his wife's lying-in chamber to pray that the baby would survive. In 1610 Henri IV of France also remained with his wife, Marie de' Medici, throughout her twenty-two hours of labour during the birth of his first-born legitimate son, Louis. The only time he was not by her side was when he had to eat and even then he insisted that he be kept informed of her progress.[5] Once labour had begun, he deputed two monks to pray without interruption outside her lying-in 'pavilion'.

The tension surrounding a forthcoming birth is evoked very poignantly in a seventeenth-century engraving by Abraham Bosse (**fig. 21**). The setting is an affluent lying-in chamber with a fire roaring in a large fireplace. The midwife, her assistant and the husband surround the mother, who is nearing the end of her labour, lying down on a folding bed covered by a sheet. We see the infant's head gripped by the midwife as it starts to emerge. An imaginary dialogue among all the figures is printed below the engraving, which includes the midwife declaring that it will not be long before the infant (whom she is sure will be a boy) is safely delivered. The husband responds by saying: 'That news comforts me. All my grief has vanished. Carry on dear heart have courage your pain will soon be gone.'

In Britain, George III (reg. 1760–1820) did not attend the birth of his first son, but he was so ecstatic about the news of the birth that he rewarded the messenger

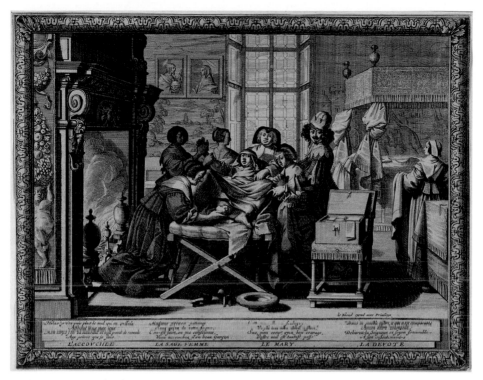

21 A woman giving birth in a lying-in chamber, from *Le marriage à la mode*, engraving by Jean le Blond (1635–1709) after Abraham Bosse.

with £500.[6] It is claimed that, since the king missed this birth, he was determined to witness that of his second son, Frederick. The labour was so swift, however, that this event eluded him again, and he was first alerted to his birth by the infant's lusty screams. Prince Leopold, husband of Princess Charlotte (1796–1817), was a royal father who successfully managed to attend the birth of his son, but sadly it developed into tragedy when the son turned out to be stillborn. We know that there were other courtiers in attendance since eyewitnesses recorded his moving reaction: 'At last the poor prince arrived. He was quite green and yellow. He put us all so much in mind of his darling, stopping his tears to tell us all – not omitting to say often how thankful he was that poor Charlotte had told him how perfectly happy she was.'[7]

This stillborn infant and the death of Princess Charlotte after fifty hours of labour reminded the British people how fragile the lives of mothers and their babies could be. Inspired by this event, there was a proliferation of paintings, prints and pottery commemorating the princess.[8] New Hall pottery in Shelton was one of the companies that turned out such vessels.[9] A lithograph of the cenotaph in St George's chapel, Windsor commemorating her death in childbirth is melodramatic and maudlin: it shows prostrated grieving figures at its base, draped in flowing shrouds

(**fig. 22**). The traumatic event of Charlotte's sudden death led her physician, Sir Richard Croft (**fig. 23**), to write the following letter the day after the delivery, in which his sense of failure and self-reproach are evident: 'My mind is in a pitiable state and grant that neither yourself nor anyone that is dear to you should ever have to suffer what I experienced at this moment.'[10] Four months later he committed suicide in his consulting rooms by shooting himself in the head.

Napoleon Bonaparte was allegedly in the bath at the time of the delivery of his son, the infant king of Rome, on 20 March 1811. One writer drew amusing parallels between Napoleon's bravery in battle and his cowardice at his wife's *accouchement*, which is compared to the retreating manoeuvres in a battlefield:

> … there was a half-hour of combat before which Napoleon, who
> had witnessed unperturbed the spectacle of the battlefield, sickened
> and fled, pale and unnerved. The warrior at least can stretch his arm
> against the assailant, but with what cruel odds is the mother victim
> [con]fronted. The trial was soon ended however![11]

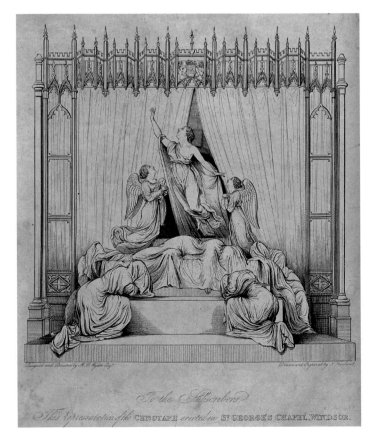

22 Cenotaph commemorating Princess Charlotte in St George's chapel, Windsor, lithograph by T. Fairland, 1826.

23 Portrait of Sir Richard Croft, Bt, stipple engraving by W. Holl after Sir G. Haytor, 1801.

After he had been banished to St Helena in 1815, Napoleon, anxious to correct the historical record and establish his heroic legacy, claimed that far from escaping the birth scene, he had actually saved the life of his wife, Marie Louise. This, he alleged, was achieved by assisting in the difficult breach delivery by holding her while the *accoucheur* applied the forceps to the infant.[12]

Queen Victoria documented her experience of lying-in in exuberant detail and described her husband's solicitousness while attending her first-born: "The Prince's care and devotion were quite beyond expression. His care was like that of a mother, nor could there be a kinder, wiser or more judicious nurse.'[13] The example of the Prince Consort attending his wife's confinement provided not just a role model for his sons-in-law, Prince Louis of Battenberg and Crown Prince Friedrich of Prussia, but for the urban gentry as well.[14] Friedrich provided an unusually detailed eye-witness account of the whole traumatic birth of his son in 1859, who was later to become Kaiser Wilhelm II. The event reduced the prince to a state of collapse once it was over, throwing himself on to his wife's bed, where she lay considerably more exhausted than he.

Apart from influencing his sons-in-law, Prince Albert's presence during Queen Victoria's labour also unleashed a fierce debate in the letter columns of the medical journal *The Lancet* between town and country doctors. In one of these a country

doctor, claiming also to represent his female midwife attendants' opinions as well, objected to what he deemed was the insidious practice of husbands intruding into the lying-in room and breaching the rules of propriety and delicacy. This generated a host of rebuttals from metropolitan doctors, who claimed that it was about time the mystique of the lying-in chamber was cast aside and men were allowed to be by the side of their wives. One metropolitan doctor prophesied that the custom of the husband's attendance at their infant's birth, made respectable by the royal couple, 'will soon spread, together with the various other improvements emanating from the metropolis, even into the most remote provincial districts'.[15]

Improvements in obstetric and antenatal care did indeed spread from the metropolis, as this doctor had predicted, but women were increasingly submitted to more impersonal processes that neglected the social aspects of childbirth, leaving them isolated from their husbands, friends and family.

Midwives' remedies and instruments

Assistance at the birth was provided by women known in England as 'godsibs' or 'gossips', later known as 'handy women' and midwives (see fig. 12). In France they were known as *sage femmes* (wise women) and in Germany *Hebammen* (relieving nurses), and were usually accompanied by a female assistant. Midwives used herbal remedies and potions to hasten delivery, the use of which was sometimes strongly criticised by certain doctors since they included abortifacients as well as concoctions for easing labour. These controversial ingredients included rye, ergot, laudanum and hart shorn.[16] If the baby was slow to arrive, midwives throughout Europe also frequently brought some alcohol with which to regale the mother in an attempt to accelerate the birth or to revive the infant. Louise Bourgeois, the royal midwife to Marie de' Medici and Henri IV, dosed their eldest son, the dauphin, with a spoonful of wine from the king's store after the twenty-two-hour labour, which left the baby weak. She was careful to secure the king's consent and ensured that he witnessed her use of the wine so that she would not be blamed for harming the infant.[17]

If the labour was unduly protracted, midwives in rural parts of France encouraged mothers to drink their husband's urine.[18] In seventeenth-century England consuming fragments of the consecrated wafer, tying the skin of a wild ox to the thigh and consuming the exotic maldiva nut were also considered to help labour.[19] Amongst early settlers in America, midwives recommended a draught of another woman's breast milk to speed delivery and relieve labour pains.[20] To ensure that the mother's pregnancy came to term and she did not miscarry, amulets of animal and vegetable origin such as the root of the mandragora and the rose of Jericho were consumed. Minerals such as jet and eagle stone were either used in vessels or worn on various

parts of the mother's body, for their alleged supernatural powers would diminish the likelihood of miscarriage as well as hasten the labour process. In 1633 in England, Elizabeth, Countess of Newcastle was given eagle stone to wear to ease the labour process.[21] In France, snakeskin, silver medallions, silk girdles and rolled manuscripts containing prayers were used, in the belief that they would protect the foetus if they were applied to the mother's body.

Catholic women fearful of an impending birth would pray to the Virgin Mary. The relics of her girdle were believed to assist women in labour. Two monks, Robert de Bures and Guido de Asshewell, brought a fragment of the Virgin's girdle from Westminster Abbey to Elizabeth de Bohun, Countess of Hereford (daughter of Edward I), to assist in the birth of her child, which took place on 10 September 1304 at Knaresbrough Castle.[22] Similarly, Marie de' Medici instructed that a fragment of St Margaret's girdle should be brought from the church of St Germain-des-Prés in Paris to assist her when labour began. This allegedly helped prevent women from crying out during labour.[23] A popular cult surrounded St Margaret of Antioch throughout western Europe (**fig. 24**), but there were other female saints whose assistance was invoked both before and during birth. Women about to give birth also prayed to male saints, including St Leonard, St Vincent and St Dominic.

24 *St Margaret of Antioch*, wooden statue, French, 1700–1850.

25 Blunt hook, double-headed, Europe, 1750–1850.

The midwife's most important instruments were her hands. They were not only used for delivering the child but also for anointing and massaging the baby. Just before the baby presented itself the midwife would prepare her hands with aromatic oils made from herbs or flowers, such as wild thyme, lily and oil of musk.[24] In France, pregnant women were prepared for the birth by the application of *pomades* to their abdomen. The constituents could include melted pork and rosewater, calves' foot marrow, caul of a kid or the grease of a chicken or goose.

The midwives' accessories and implements included a distinctive pouch, seen here hanging from the belt of the seated midwife (see fig. 12). They would also carry a pair of scissors and a knife used for cutting the umbilical cord, linen thread to stitch up any tears, a sponge for wiping up blood and washing the mother down, and sometimes a small phial of holy water for emergency baptisms. A more sinister item in the repertoire of instruments was a hook normally used to hang up cooking pots but sometimes used when a baby had become stuck inside the mother (**fig. 25**).[25]

In Britain by the nineteenth century the small bath tub that was brought along for the birth had been replaced by a two-gallon tin tub, and the midwife's pouch had been superseded by a little black bag sometimes knows as the 'midder bag', which many small children were led to believe contained the baby.[26] This bag would contain the analgesic chloroform, ergot to contract the uterus after delivery, cord clamps, scissors and forceps.

Nourishing the mother and father

Nourishing the mother after the delivery was considered as important as feeding the newborn infant. There is a whole medieval and Renaissance religious iconography devoted to the birth of John the Baptist (**fig. 26**) and the Virgin Mary (**fig. 27**). This shows midwives feeding either John the Baptist's mother, Elizabeth, or the Virgin's

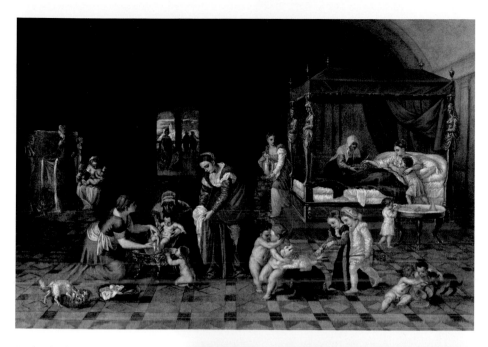

26 *Birth of St John the Baptist* by Lambert Sustris, oil, Dutch, 16th century.

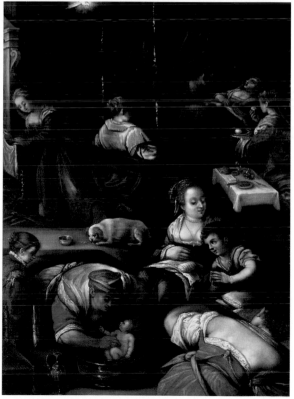

27 *Birth of the Virgin* by Leandro Bassano, oil, Italian, 1580.

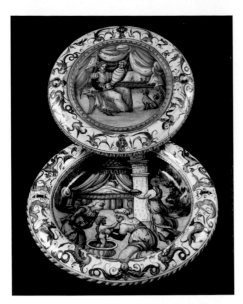

28 Birthing dishes depicting childbirth scenes, Italian, *c.*16th century.

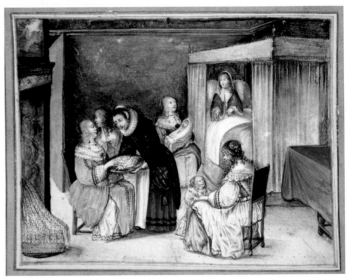

29 Lying-in chamber or *Kraamkamer*, watercolour by unknown Dutch artist, 17th century.

mother, St Anne, from a trencher or bowl. In Renaissance Italy the *desco da parto* was a decorated wooden tray, later substituted by a ceramic, such as maiolica, on which sweet delicacies were laid to celebrate the infant's birth (**fig. 28**). In a Dutch water-colour of a lying-in scene the godsibs or 'gossips' pass round sweetmeats on a birthing tray (**fig. 29**). These trays and bowls combined classical scenes with heraldic crests to reveal the lineage of the child. More intimate scenes of women in labour were also painted deep in the interior of the bowl, which were cunningly revealed only to the women who ate out of them. These scenes, far from presenting a picture of the pain and drama associated with childbirth, depicted reassuring scenes of women during the lying-in process.

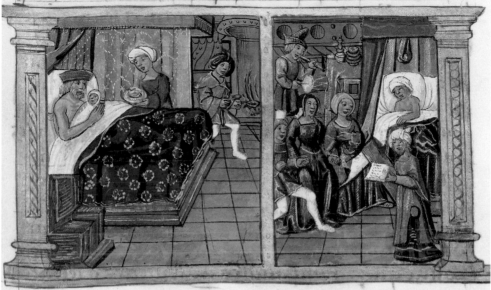

30 'La couvade' from *Le livre des merveilles du Mond*, by Marco Polo, French, 1520–1530.

Ongaresche were bowls with low feet that were used for holding either broth or 'caudle', a spiced, watery gruel, laced with alcohol such as brandy, given to sustain the mother. Caudle was not the sole form of sustenance for mothers recovering from childbirth during the seventeenth and eighteenth centuries. Nursing manuals also recommended beer, particularly stout, to restore her stamina[27] and emotional well-being.[28]

In some communities men believed that they needed sustenance after their partners' delivery. In France and other parts of western Europe there was a custom known as the *couvade*, which involved men imitating the *accouchement* and lying-in of women by taking to their bed with the newborn infant while their wife or the midwife waits on them, plying them with nourishment. This ancient rite was particularly strong in southern Europe, in particular Spain and the islands of Corsica, Cyprus and Rhodes. A sixteenth-century French manuscript depicts the father lying in bed with the swaddled child as he is coaxed by the midwife to take some liquid substance such as caudle, as though he has just given birth (**fig. 30**). Perhaps this was an acceptable gloss on what was a more basic human emotion of a jealous father regressing as a result of attention being diverted away from him towards the new arrival. In medieval Cambridgeshire there was also a recognition that men might have sympathetic pains during their wife's labour and take to their bed. The remedy applied by 'gossips' was to dose them with cake containing pain-killing herbs.[29]

Birthing chairs and other props used by midwives

Midwives were also often expected to bring a three-legged stool known as a 'cricket' or nursing stool to sit on and birthing chairs or their earlier equivalents for the mother.[30] The latter were common throughout medieval Europe and were very rudimentary: they were often horseshoe-shaped with a narrow rim that supported the mother's bottom (**fig. 31**). It seems that female midwives were particularly keen on birthing chairs that enabled women to sit rather than lie down. Indeed, where female rather than male midwives prevailed there was a reluctance to abandon the basic birthing chair, which continued to be used up to the nineteenth century. Italian midwives were particularly reluctant to give up their birthing chairs and used them for much longer than their counterparts elsewhere in Europe.

As birthing chairs got larger they were often hinged so that they could be folded up easily. Many Italian versions were handed down within midwives' families. One that remained in a family of Sicilian midwives for three generations was affectionately nicknamed 'the miraculous chair of Palermo' (**fig. 32**). In eighteenth-century Philadelphia, one birthing chair owned by a midwife was known as 'the portable ladies' solace', which suggests that it was believed to offer relief and was easy to move from client to client.[31] Sometimes birthing chairs were dual purpose, such as the hooded wickerwork 'growneing chair' seen in the background of religious paintings[32] and also found in rural parts of Britain, which reverted to an ordinary chair when not used for childbirth.[33]

If a birthing chair was not used, sitting, lying, crouching and kneeling on all fours were all typical positions the midwife might encourage the mother to adopt for delivery. Adaptation of household objects was the norm in poorer households. Linen cords, which were often attached to the beam over the bed by the midwife, were available for women to clutch and two ordinary chairs were pushed under the mother's arms while she crouched. Alternatively, the woman would kneel on a straw mattress and cling to the back of a chair. Another recommendation was for the mother to kneel on a pillow placed on a low stool with her elbows leaning against the edge

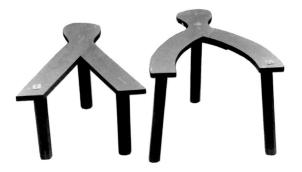

31 Model parturition chairs (based on 14th-century Italian examples).

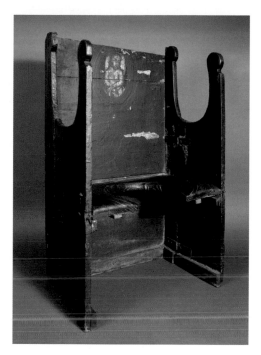

32 The 'miraculous chair of Palermo', wood
and leather, Sicilian, 1701–1830.

of a table.[34] One method employed in east Virginia in America was to maintain a
semi-recumbent position by leaning on a double mattress propped up against an
inverted chair. For a potential breech birth, midwives sometimes employed ladders,
attaching the expectant mother to its rungs, feet upwards.[35] Another extreme tactic
employed by midwives during the seventeenth century resembled a tug-of-war.[36] It
involved a couple of them holding the mother by the middle and pulling one way,
while another group of women pulled the limbs of the infant in the other direction.

The afterbirth

The midwife also had to be very vigilant, since many subscribed to the belief that
if the afterbirth were stolen it could be used by malign forces to harm the baby. As
late as the eighteenth century in Europe midwives were vulnerable to accusations of
witchcraft and this led to safeguards being imposed. In France this took the form
of more respectable, qualified midwives ensuring that neither the afterbirth nor
the corpses of stillborn infants would be used for witchcraft or magical practices.[37]
Women harboured many fears associated with the afterbirth, such as the risk that
the baby might inadvertently be strangled by circles of the umbilical cord. This led
some pregnant women to believe that they should avoid circular movements, such as
unwinding skeins of thread or wool.[38]

Some aspects of childbirth were considered to bring good luck. A 'caul', for instance – the protective covering surrounding the child in the womb (**fig. 33**) – was preserved as a good-luck charm right up to the twentieth century in Britain, France and America, sometimes in a locket. An excellent example is the gold locket commemorating the birth of John Monson, which is engraved with his name and date of birth, 1597, like so many objects dedicated to children (**fig. 34**). Less often the caul around the head of the baby was thought to provoke evil behaviour in an infant.[39]

A caul also bestowed good luck on sailors and was believed to protect them from drowning. In the Grimm fairy tale of *The Giant with the Three Golden Hairs* it was prophesied that an ordinary boy would marry the king's daughter. Infuriated by the news, the king tries to sabotage the prediction by attempting to drown the boy who was a potential suitor. But the boy survives due to the protection of the caul in his possession and, true to the prophecy, marries the princess.

In certain regions of France, the midwife would rub the placenta after it had come away on to the baby's face to ensure a good complexion. She might also retain it and make it into a cake, which was thought to contain fertility properties. Midwives were frequently involved in heated disputes over the removal of the placenta, and there were different medical theories about its timing. In 1627 the French royal midwife, Louise Bourgeois, was involved in a controversy when the Duchesse de Montpensier died unexpectedly as the result of a fragment of placenta being left in her womb. There were mutual recriminations between Bourgeois and the duchess's doctor regarding who was responsible for the patient's plight. Eventually, Bourgeois lost out in the dispute, which resulted in damage to her reputation.

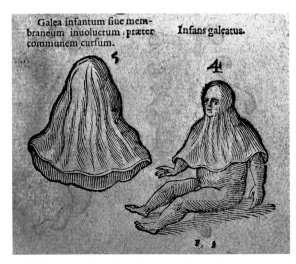

33 Illustration of a caul in *De natura divinis characterismus* by Cornelius Gemma, 1575.

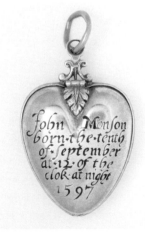

34 Locket containing caul, gold with black enamel lettering, English, 1597.

William Hunter (1718–1783), the eminent obstetrician to the royal family during the reign of George III, was the first to resolve the anatomy of the placenta.[40] He trusted to 'Dame Nature' and was reluctant and indeed nervous of removing the placenta too early. This meant that a number of deaths arose from infections caused by leaving the placentas too long inside the mother. Members of the aristocracy, such as the Countess of Suffolk, died as a result of this practice. It is significant that Hunter's allegiances were so powerful that these events did nothing to dent his reputation.

Mary Wollstonecraft (1759–1797), an early proponent of women's rights, also died in similar tragic circumstances after the birth of her second daughter by her husband William Godwin. Mrs Blenkinsop, chief midwife at the Westminster lying-in hospital, attended Wollstonecraft in her home as an outpatient, but left the placenta in too long, so that she fell seriously ill and died.[41]

Midwives witnessing the birth

In England during the seventeenth century it was against the law to deliver a child unless another woman was present to witness the birth.[42] The attendance of one or more midwives could be reassuring to some women, since, if a mother had to fend for herself, it immediately invited suspicion that her infant was illegitimate. Coping alone could also threaten not just her own but her baby's survival. Some unmarried mothers, however, preferred to take this risk rather than have a midwife present who might report them to the authorities.

Apart from physically helping with the delivery, the midwife was expected to provide an accurate eyewitness account when controversy surrounded a birth, such as uncertainty regarding paternity. Midwives, however, were easily blamed for any problems that might occur during the delivery by fathers, mothers and other relatives, regardless of whether they were guilty of negligence.

In Nuremberg in Germany during the sixteenth century midwives sometimes waited until the peak of the labour pain to demand the name of the baby's father. If the unmarried mother refused to disclose his name, she could be brought in chains to be interrogated publicly.[43] Moreover, regardless of whether a mother was a Christian or a Jew the midwife had to be prepared to testify regarding the infant's parentage,[44] and by the seventeenth century midwives' duties included giving evidence in cases of rape and infanticide.[45] In emergencies midwives were also required to baptise the baby, which meant that their religion was a factor in choosing them. In a French engraving entitled *Le Baptême administre par la sage-femme*, depicting a recent birth in a lying-in chamber, the midwife baptises the frail newborn baby who is lying on her lap in the foreground to the left (**fig. 35**). The baptism of the baby from a jug of

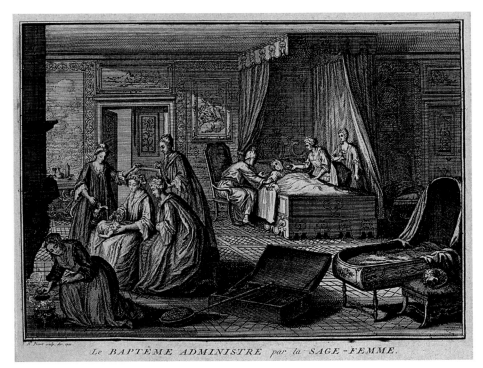

Le *BAPTÊME ADMINISTRE par la SAGE-FEMME.*

35 *Le Baptême adminstre par la sage-femme*, French engraving, 18th century.

water and the empty cradle to the right suggest a sense of urgency. The mother lies exhausted in bed and is coaxed to accept nourishment from a maid. Meanwhile the father, who wears a gown and paternity bonnet, sits at his wife's bedside clutching her arm.

Training, regulation and professionalisation

Formal regulation of midwives in Britain began only in the sixteenth century, when they had to take an oath. This included a declaration to disclose to the ecclesiastical court the details of anyone trying to conceal a birth or anyone whom they suspected of giving birth out of wedlock. The oath also required midwives to make every effort to discover the identity of the father when providing assistance at the birth of an unmarried mother. In spite of some regulation, however, midwives were not registered in Britain until the beginning of the twentieth century.

In seventeenth-century France the regulation of female midwives went hand in hand with a drive by the Church to insist on infant baptism. This led priests to take an interest in midwives' training and instruction, since the midwives might have the opportunity to promote or carry out baptism.[46] Compulsory examinations

were introduced, testing midwives' competency and character, which meant demonstrating that they were of good birth and lived respectably. Some French midwives, particularly those assisting at royal births, could command very high fees. Madame Peronne, the French midwife to Henrietta Maria, queen of Charles I (reg. 1625–49), was paid £1,000 for the successful delivery of their second child, a son who was the future Charles II.[47] One French training school for female midwives was set up by François Mauriceau (1637–1709), a renowned surgeon himself; it included training for fellow male surgeons in midwifery. Mauriceau also wrote an important midwifery textbook entitled *Les maladies des femmes grosses et accouchées*, which went into many editions and was translated into English, German, Dutch, Italian, Latin and Flemish. In the frontispiece he is surrounded on the right by the tools of his trade, which include forceps, scissors and a clamp (**fig. 36**).

Once French midwives had passed their registration exams they were entitled to advertise for work. Although registration was introduced relatively early, the national medical regulation of midwives was not imposed in France until the nineteenth century, which meant that the vast majority of French births were delivered by 'matrons' without any formal training. Meanwhile, female midwives continued unregulated from the sixteenth century to the eighteenth in Italy, Spain and the American colonies, where unlicensed midwives could operate openly with impunity.

In contrast, by the seventeenth century midwives in Germany were beginning to be licensed by the municipality and provided with professional training.[48] German

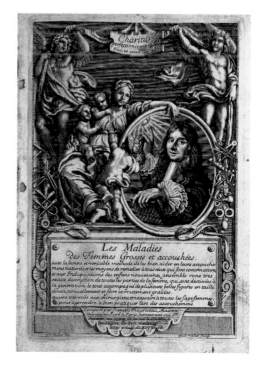

36 Portrait of François Mauriceau from *Les maladies des femmes grosses et accouchées*, 1688, frontispiece on title page.

midwives enjoyed a particularly high reputation for their efficiency and skill; this was acquired through a rigorous training under the tutelage of 'honourable women' and could last as long as five years. Apart from their skills they also sometimes provided for those in acute poverty by issuing hand-outs of items such as bedding, bread and lard.[49] Midwives were registered in the Netherlands in the second half of the nineteenth century and this, combined with their effective training, undoubtedly contributed to the decline in Dutch maternal mortality during this period, which was lower than in many other European countries.[50]

Male midwives

During the medieval period midwives were generally associated with normal births, and doctors were called in only when labour was difficult and required surgery. The 'man midwife' started to emerge in the seventeenth century, when they were also known as barber surgeons in England and *sage-femmes en culottes* (midwife in breeches) in France. There was considerable blurring of roles in certain areas. Both male and female midwives, for example, passed on birthing chairs down the generations. Both godsibs and physicians resorted to the ancient practice of bloodletting, otherwise known as phlebotomy or 'venesection', under the false impression that it would provide effective pain relief. Sometimes as much as a pint of blood was taken from the jugular vein, which could inadvertently cause death (**fig. 37**).[51] In addition, the male midwife's armoury of instruments included the crotchet and the 'squirt', boring scissors and the blunt hook also used by female midwives (see fig. 25). These were mainly used to destroy the foetus in the uterus when labour was protracted and delivery of a live baby was deemed impossible.

In spite of some women's dislike of having a male midwife at her *accouchement*, by the eighteenth century male midwives had gained popularity in western Europe, working with rich and to a lesser extent poor women.[52] The male midwife also sometimes played a subversive role by colluding with society ladies who wanted to cover up their illegitimate births, the results of adulterous liaisons. William Hunter was one of the physicians responsible for concealing the evidence of such illicit pregnancies.[53] He is also credited with making male midwifery (which he taught) both respectable and fashionable with royalty during this time, earning the confidence of Queen Charlotte, wife of George III. It also became fashionable to have a male midwife in the upper echelons of society, and when Georgiana, Duchess of Devonshire appointed the aspiring John Knyveton as a male midwife, he saw this as an opportunity to develop a smart clientele: 'I have been requested to attend upon the Duchess of Devonshire in her next confinement, which will be very soon now and if all goes well, as I humbly pray will be so, all fashionable doors will be opened to me.'[54]

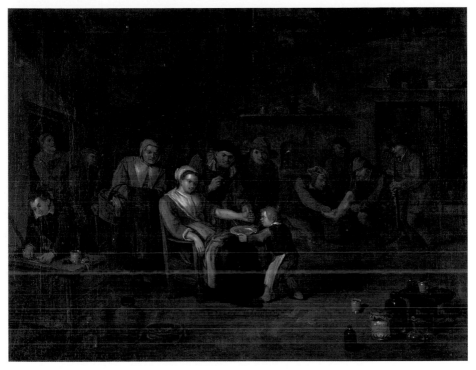

37 Interior of a surgery showing a woman having her blood let from the arm, by Egbert Van Heemskerck, oil, Dutch, 1635–1704.

Florence Nightingale (1820–1910) summed up the lack of choice in the sex of those who attended the confinements of both rich and poor women:'The rich woman cannot find fully qualified women, but only men to attend her and the poor woman only takes unqualified women because she cannot afford to pay well qualified men' (**fig. 38**).[55] This was confirmed in 1869 by the London Obstetrical Society, which claimed that poor women were delivered by female midwives regardless of whether they lived in rural or urban areas, whereas in wealthy districts it was mainly male midwives who attended births, with only 2 per cent of births attended by female midwives.[56]

Practices associated with male midwives

The use of the birthing chair in England and France had started to decline by the late seventeenth century. Male midwives, who were becoming more influential, preferred to deliver babies while the mother was lying down, since this was a more convenient position for the physician.[57] Essentially, the technical process of delivery to suit the male midwife was taking precedence over the woman's comfort. In seventeenth-

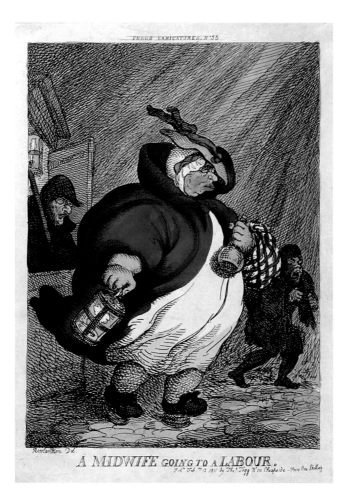

TEGG'S CARICATURES. N.° 56

A MIDWIFE GOING TO A LABOUR.

38 A midwife on her way to a labour in the early hours of the morning, coloured etching by Thomas Rowlandson, 1811.

century France François Mauriceau delivered women lying down in a special bed in a room called 'the stove', and once the birth was over patients were expected to walk to the recovery wards. In eighteenth-century London, male midwives delivered babies while the mothers were lying on their left side in bed.[58]

By the late seventeenth century Germany was producing convertible birthing chairs[59] that could be transformed into a delivery table, enabling the mother the option of lying down or sitting (**fig. 39**).[60] It is significant that even though birthing chairs still continued to be used, their height could now be adjusted. The highest level was about 25 inches above the ground and meant that the male midwife had less far to bend. By 1800 the birth chair could not only be adjusted to different heights but had a ratchet back that enabled a horizontal bed position to be adopted, reflecting the posture of ill health.[61] In addition, it had footrests and ankle and arm straps to restrain the mother. While the footrest undoubtedly served a useful purpose for the

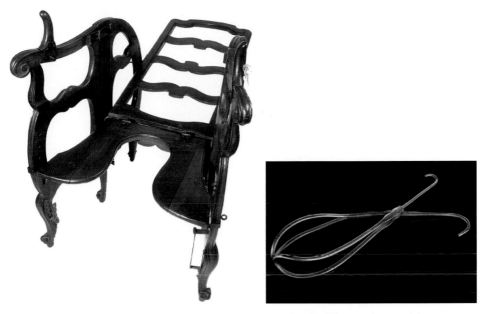

39 Adjustable birthing chair, wood, German, late 17th century.

40 Chamberlen-type obstetrical forceps, European, 1680–1750.

patient while trying to push out the baby, the ankle and arm straps are more likely to have alarmed rather than reassured the mother, accentuating her sense that she had no control over the delivery.

The forceps were invented by Peter Chamberlen (*c.*1560–1631), a Huguenot barber surgeon who had fled to England from the religious persecution of Protestants in Paris (**fig. 40**). After a brief skirmish with the English medical authorities, which resulted in a short imprisonment, he made a name for himself by attending Anne of Denmark (1574–1619), wife of James I, and Henrietta Maria when these queens were giving birth. The implement that he had invented was essentially a pair of tongs, but he so assiduously kept it secret that his female patients had to be blindfolded. The Chamberlen family maintained this secrecy over the generations, but by the eighteenth century knowledge of the forceps had leaked out and other male midwives started to adopt them. Even if they were not always used but kept in reserve, they began to occupy a more elevated – or some would say controversial place – in the midwives' repertoire of instruments. One eighteenth-century male midwife described them as 'my instruments of salvation and delivery'.[62] Some midwives, such as the famous physician William Hunter, were very reluctant to use them (**fig. 41**). He regretted that the forceps had ever been invented and pinned his faith on natural forces. Apparently, he displayed his rusty forceps as a deliberate statement to show his students that he never used them.[63]

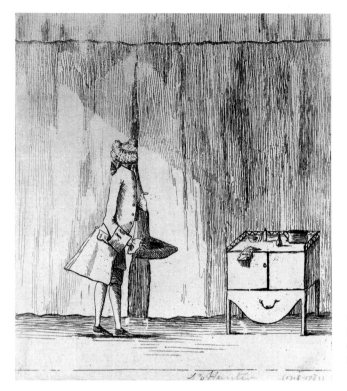

41 *William Hunter at a Confinement*, etching by an unknown artist, 18th century.

John Knyveton, a student of the surgeon John Hunter, brother of William Hunter, wrote a fascinating diary of his life as a male midwife, occasional grave robber, husband and father. He documented his criticisms of the sometimes savage methods used by male midwives when discussing the treatment his sister had received from one he dismissed as an 'ignorant butcher'. His contempt for the ready use of forceps was also expressed vividly when he described them as 'deadly tongs'. After witnessing midwives inflicting experimental procedures on women, he resolved to protect his heavily pregnant wife by not allowing certain interventionist techniques when the time came for her to be delivered: 'I will have no novel operations tried on one who has proved a dear and very loyal help-mate.'[64]

Sometimes lack of intervention preserved neither the life of the mother nor that of the child. Sir Richard Croft (1762–1818), physician to the ill-fated Princess Charlotte, was a follower of William Hunter, and it is arguable that by not interven-ing during her prolonged fifty-hour labour he was partly responsible both for her death in childbed and her son's stillbirth. Croft, however, was by no means alone in his reluctance to use forceps: in his popular *Advice to Mothers* published in 1812, the physician William Buchan was also an advocate of non-interference and dismissed forceps as 'instruments of death'.[65]

Preservation of modesty

Throughout the medieval period and indeed right up to the beginning of the twentieth century, semi- and total nakedness were considered beyond the bounds of decency during the confinement itself. Certainly, there is evidence from midwife manuals throughout sixteenth-century Europe that both male and female midwives had to conduct deliveries beneath the folds of the mother's robes (**figs. 42** and **43**). Moreover, in Germany and France the necessity for modesty required women to wear either a bonnet or a long veil during labour.

In order to gain women's confidence, male midwives had to make efforts to preserve their modesty and at times overcome their embarrassment. In the sixteenth century, to ensure that women's modesty was respected during labour, the birthing chair recommended by Jacob Rueff was designed with a black cloth curtain attached to the underneath which hung down to the ground: 'by that meanes that the laboring woman may be covered' (**fig. 44**). During the sixteenth century in France Julienne d'Estrées, Duchess de Villars, who features in a portrait sharing a bath with her

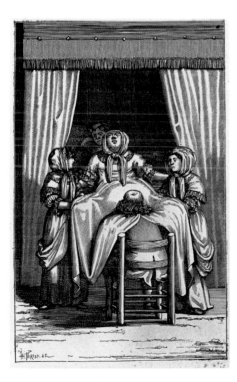

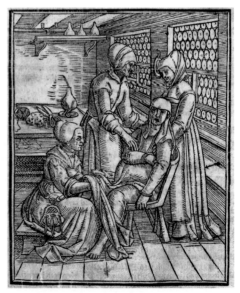

42 Birth scene, etching, Dutch, 17th-century, from G. J. Witkowski, *Histoire des Accouchements Chez tous les Peuples*, 1887.

43 Illustration of midwives attending a birth from *Ein Schön Lustig Trostbüchle von dem empfengknussen und geburten der Menschen* by Jacob Rueff, woodcut, 1554.

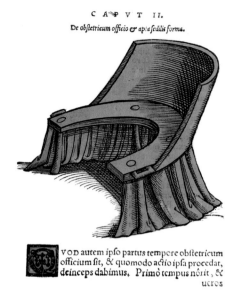

C A P V T II.
De obstetricum officio & apta sedilis forma.

V OD autem ipso partus tempore obstetricum
officium sit, & quomodo actio ipsa procedat,
deinceps dabimus. Primò tempus nòrit, &
ucros

44 Parturition chair with
curtain designed by Jacob Rueff
from his book *De conceptu
generatione hominis*, Zurich,
1554.

sister Gabrielle d'Estrées,[66] allegedly put a cover over her own head when a male
midwife attended her. This was to conceal her mortification at being seen by a man
so intimately in such a predicament.[67] In France Louis XIV seems to have taken
voyeuristic pleasure in enjoying the spectacle of labour by secretly watching women
of his court give birth. Moreover, he is credited with popularising the lithotomy
delivery position in which the women's knees are above her hips, which enabled
them to be seen by him without their knowing that they were being watched.[68]

When assisting at a birth William Smellie (1697–1763), 'the father of British
obstetrics', would preserve the mother's modesty by tying a sheet around both his and
the mother's neck to ensure that her body was concealed as much as possible.[69] This
habit effectively meant that the male midwife worked literally in the dark, relying on
his sense of touch.[70] Even when foetal distress occurred during labour, midwives still
had to struggle under the layers of women's clothing. The extremely difficult breach
delivery of the future Kaiser Wilhelm II in 1859 did not permit modesty to be aban-
doned, as his father Friedrich, the Crown Prince, testified: 'Dr Martin was working
with all his might under the flannel skirt.'[71]

Anaesthesia and pain relief

Physicians, who received more formal medical training, were more prepared to
experiment with new techniques of pain relief than female midwives because they
occupied a more secure position within society, so were more prepared to undertake

45 Portrait of James Young Simpson, stained-glass window, 1885.

the medical risks involved. Nonetheless this could generate great controversy, as James Young Simpson (1811–1870), professor of midwifery at Edinburgh, found (**fig. 45**). He initially arranged a trial of the effects of chloroform on himself and two dinner guests, who were also his assistants at the hospital. All three became comatose on the floor, and Simpson, who was the first to recover, immediately recognised the potential benefits of applying chloroform to relieve the painful contractions of childbirth (**fig. 46**). He then went on to develop his findings further by using his first female guinea pig, a doctor's wife, in 1847.[72] So delighted was she with the painless delivery that she named her daughter Anaesthesia.[73]

46 The effects of liquid chloroform on Sir J. Y. Simpson and his friends, pen-and-ink drawing, 1840s.

A physician's innovation was greatly helped if he could secure powerful alliances with the rich and powerful, especially royalty, who could help to dispel the suspicion surrounding his experimentation. Queen Victoria faced immense criticism among parts of the medical establishment for permitting her physician, Dr John Snow, to anaesthetise her with chloroform when delivering her eighth child, Leopold, Duke of Albany in 1853. One critical doctor likened taking chloroform to drunkenness: 'To be insensible from whisky, gin, brandy, wine, beer, ether and chloroform is to be what in the world is called dead drunk.'[74] The queen ignored this objection and defended her physician, insisting that her ninth child should also be delivered by this method, popularly known thereafter as *chloroform à la reine*.[75] Her subsequent successful nine confinements and her championing of the use of chloroform to ease delivery did at least help and inspire pregnant women within the upper ranks of society to have more confidence in the prospect of a successful outcome.

Indeed, so evangelical was Queen Victoria on the use of chloroform in childbirth that she sent her physician Sir James Clarke and her midwife, Mrs Innocent, along with a bottle of chloroform to assist at the first confinement of her daughter Vicky, wife of the Crown Prince Friedrich, in Berlin. The delivery was a fiasco, not helped by the belated application of the anaesthetic or by the clumsy intervention of the German physician, Dr Martin. The latter was unable to rectify the breech position, which meant that the baby's arm and hand were severely damaged and the infant, who was to become the future Kaiser Wilhelm, was permanently disabled.

While chloroform was adopted by western European doctors only gradually, in north-eastern America doctors were using it quite extensively during confinements by the 1850s.[76] Pain relief was by no means available to everyone and for many British working-class women it was still scarce by the end of the nineteenth century. Mrs Leyton, a member of the Women's Co-operative Guild, reminisced how, when her baby boy was delivered by forceps on 3 September 1883, she had a very difficult time and 'Had nothing to dull the pain, so had to feel all that was going on'.[77]

CHAPTER 3

Lying-in

The lying-in room is generally kept too warm, its
heat being in many instances, more that of an oven,
than of a room. Such a place is most unhealthy, and
fraught with great danger both to the mother
and infant.

Advice to mothers on the management of their offspring,
by Pye Henry Chavasse, 1839, p.50

In theory, lying-in was meant to follow three stages. The first was when the mother was expected to stay in bed for three days to a fortnight. This was then followed by the second stage of 'upsitting' or 'sitting-up week', which could extend beyond a week to ten days to a fortnight; in this period visitors could come and see the mother while she was still confined to the house in her room or private curtained-off space and her bed linen was changed. Changing bed linen could be contentious, since those who believed in strict compliance to the lying-in sometimes required a white sheet on the new mother's bed as a test of her sexual abstinence, since she was still expected to sleep apart from her husband.[1] Finally, the third stage followed when she was allowed to move around the house but not venture outdoors.

One commentator has suggested that, wherever possible, strict adherence to the lying-in period of three weeks was upheld by the lower ranks during the medieval period, since jeopardising this code of conduct could risk scandal and gossip.[2] Hence the expectation was that it would last for a month, and this was popularly referred to in America from the seventeenth century as women's 'month'.[3] It is difficult to establish how far the 'month' was complied with, but it is likely that for many women lying-in was short-lived. Given the urgency for the mother, particularly women from the labouring poor, to return to work, many new mothers would have resumed their domestic routine in spite of their physical exhaustion. Indeed, it has been suggested that during the seventeenth century the lying-in period may have lasted as little as a week or even on occasion a few days.

Given the protracted nature of some of the births, however, with no pain killers or anaesthetics and the loss of blood incurred, in many instances mothers would have needed at least a month to recover. Certainly, Alice Thornton's experience during the

seventeenth century testifies to the need for a period of recuperation: 'The weakness of my body continued so great after my hard childbirth of my son that it brought me almost into a consumption, not expecting for many days together that I should at all recover.'[4] Later, in the eighteenth century, Lady Mary Verney was likewise totally incapacitated and could barely sit up for an hour at a time, three weeks after the birth of her son Ralph.[5]

Gradually, rules of lying-in relaxed, which fostered an atmosphere of relative social informality and conviviality. Certainly, in the seventeenth century during Marie de' Medici's lying-in, members of the court who kept her company spent the time gambling.[6] This trend continued into the eighteenth century, and observers noted how upper-class women participated in playing card games as the lying-in period was drawing to an end. The writer and collector Horace Walpole (1717–1797) reminisced how he played the card game *loo* with Lady Hertford on the last night of her lying-in, but evidently the game continued into the next morning, by which time the lord and lady had long since retired. The game was so commonly played in lying-in chambers of the rich and well connected that Walpole joked how William Hunter (**fig. 47**), obstetrician to many society hostesses, could be a great source of gossip regarding where *loo* was being played in high society.[7] Moreover, Josiah Wedgwood (1730–1795) reflected in his letters that 'Ladies of fashion could be seen in their carriages without shame ten days to a fortnight after their delivery.'[8]

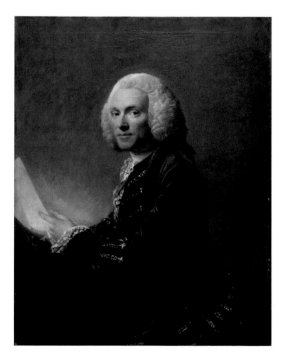

47 *Portrait of William Hunter*, by Allan Ramsay, oil, Scottish, 1764.

Although in nineteenth-century America some unscrupulous employers undoubtedly breached this recuperative lying-in period, efforts were made to comply with the time period of a month.[9] In Britain the Factory Act 1891 prohibited women from resuming work within a month of their confinement, but although this was an official acknowledgement of the need for a month to recuperate, it was not enforced by employers.

Moreover, the Act only permitted leave without pay, making it very difficult for working women to remain at home until they recovered, because their absence from the workplace meant loss of earnings. Mrs Leyton was typical of many nineteenth-century working-class women when she admitted that she was up after the seventh day of her lying-in. She nearly died, however, her condition aggravated by insufficient nourishment throughout her pregnancy and lack of attention during her confinement and lying-in.[10]

Privacy and witnessing the birth

There were many official witnesses at a royal birth from the medieval period to the nineteenth century. Their role was to ensure that the royal birth was legitimate, although where these dignitaries waited in relation to the royal lying-in chamber changed over time when husbands were allowed more intimate, exclusive access. Increasingly, there was an expectation that the witnesses who had previously crowded the lying-in chamber should be relegated to the adjoining closet or anteroom.

With the increase in privacy, both royalty and the upper ranks of the nobility used the antechamber or closet adjoining the lying-in chamber as a type of reception room or semi-public space where the formal announcement of the birth took place. This enabled the lying-in room to become more of a private sanctuary. As the time approached, James II's wife Mary of Modena had sixty witnesses congregated in the lying-in chamber, standing close to the end of the bed; they included the Tuscan ambassador, Privy Councillors and the Lord Chancellor. Hugh Chamberlen, a 'man midwife' and a descendant of the inventor of the forceps, was too late to deliver the infant, so a female midwife was assigned to this role instead.

Interestingly, the birth of Mary's and James II's son, James, was one of the most contested births in British history. Protestant opponents to the Catholic James tried to discredit the legitimacy of the birth by spreading a number of false allegations. They claimed that the baby had not only been smuggled into the lying-in chamber in a warming pan by a maid but that the baby was a changeling. Other theories were that a miller's wife had substituted her own baby and that Father Edward Petre, Mary's confessor and member of the Privy Council, was the true father. The latter theory was the subject of a Dutch satirical cartoon, which, had it been produced in

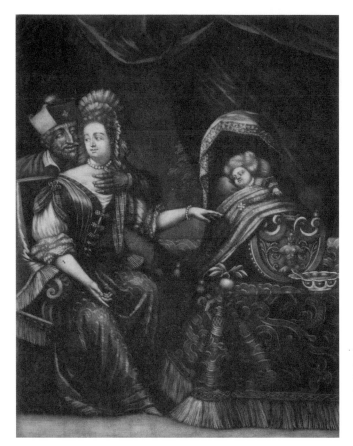

48 Satire of Mary of Modena rocking a cradle containing James Edward Stuart, Prince of Wales, mezzotint attributed to Pieter Schenk, 1688.

England, would have been deemed high treason. In this print Father Edward Petre is depicted as a sinister presence with his hand clasped round Mary's neck, while the baby James lies in a cradle (**fig. 48**).[11]

In spite of these allegations of deception, the birth was very public and the only concession to the queen's privacy was a screen that partially shielded her from the gaze of these notables. Mary, the king's elder adult daughter, who was very put out by the news of the birth of the new heir to the throne, spread rumours that there had been reports that the curtains of the queen's bed had been drawn during the labour, preventing the witnesses from seeing anything.[12] In due course this was refuted by the midwife.

Likewise, Marie de' Medici's *accouchement* when she gave birth to the future Louis XIII in 1601 was very public. The court painter Rubens perpetuated the public aspect of the birth by depicting it in an idealised way as part of a set of paintings that were subsequently reproduced by many print makers (**fig. 49**). The queen was attended by the famous midwife Louise Bourgeois, who successfully delivered the

49 Allegory of the birth of Louis XIII, engraving by Benoît Audran the Younger after a painting by Peter Paul Rubens, undated.

heir to the throne in the Oval Room at Fontainebleau.[13] The king's brothers and sister were given front-row seats directly facing the queen, giving the impression of an audience in a theatre rather than witnesses to a royal birth. There were two hundred further witnesses waiting in the antechamber adjoining the lying-in chamber. Marie de' Medici was appalled by the public nature of the birth and had to be reassured by her husband, Henri IV, that this degree of scrutiny was necessary for the sake of the 'grandeur' of the office that she and her son held. Evidently, the lying-in chamber became so crowded that the queen fainted, and attempts to move her from the birthing chair to her bed were thwarted by the sheer numbers of people. Indeed, efforts by the midwife to curb the groundswell of witnesses and well-wishers was met by a peremptory dismissal by the king, who told her to hold her tongue and allow everyone the opportunity to rejoice. Even when the midwife had to check on the condition of the queen two days later, she had to force her way through crowds to get into the lying-in chamber.[14]

At Marie-Antoinette's first birth, a girl born on 19 December 1778, and attended by the king, Louis XVI (reg. 1774–1791), and other members of the royal family

and court, some eager sightseers breached security and managed to get through to the inner apartments.[15] Even though they were perched high up, the delivery room was so full of witnesses that they were unlikely to have caught a glimpse of the birth. This very public event was in contrast to the queen's mother Maria Theresa's experience of childbirth, for she had successfully banished her courtiers to the adjoining room. By the eighteenth century the convention of using the closet or antechamber was reinforced by many images, particularly prevalent in France, of the nurse standing in the room holding the newborn baby and announcing to the new father, who is seated on an elegant chair, the good tidings of the successful delivery of his infant son (**fig. 50**). Indeed, the use to which the closet accompanying the lying-in chamber was put during childbirth challenges the notion of its secret, private nature.[16] Far from providing a secret space for women after the birth, the closet was used as a public forum permeable to the world outside.

Many notables, such as the ladies of the bedchamber and even the royal obstetrician, Dr William Hunter, congregated in this adjoining room in 1762 while waiting for Queen Charlotte to be delivered of her first infant by Mrs Draper, the midwife; only the Archbishop of Canterbury and Queen Charlotte's mother were in attendance at the birth itself, of the Prince of Wales, the future George IV.[17] At the birth of Napoleon's son, the infant king of Rome in 1811, twenty-two people were

50 *It's a Boy, Monsieur!* engraving by Jean Charles Baquoy after Jean-Michel Moreau le Jeune, *c.*1774–83.

assembled in the adjoining apartment to witness the birth. Queen Victoria objected to the number of official witnesses to the royal birth and relegated the dignitaries to the room adjoining the lying-in chamber so that she could just be seen through the door without compromising her privacy completely.[18]

Public display

After an heir to the throne had been born and the official witnesses had left, the royal infant was displayed publicly in a 'cradle of estate' in sumptuous surroundings. This cradle played a similar symbolic role to the state bed, underlining the power and continuity of the family. The medieval aristocracy had different types of beds – one for sleeping in and the other used when they granted an audience to guests – and cradles for infants of the nobility and royalty mirrored this adult fashion. These cradles were placed in the dressing room or closet adjoining the lying-in chamber where the birth had been announced or sometimes in a drawing room that was temporarily designated for this purpose. Cradles, like state beds, were symbols of luxury, and were sometimes embellished with bed hangings and curtains. The ostentatiousness could be extraordinary, as is testified by the grand cradles used by royalty and the aristocracy during the medieval period. Isabella of France, wife of Edward II (reg. 1307–27), owned a cradle of gold and a cradle of silver. Luxurious coverlets for the cradle were also often common for an infant born into affluence, while poorer households had to make do with coverlets cut down from full-sized bedclothes.[19] The inventory for the lying-in chamber of Margaret of France, queen of Edward I (reg. 1272–1307), lists many fur and rabbit coverlets for the cradle of Thomas of Brotherton, born in 1300. In 1474 Eleonora of Aragon ordered a white damask and taffeta coverlet fringed with gold and silk for her baby's cradle.

In 1430 Marguerite of Burgundy (1393–1442) instructed that her dressing room should be set aside for the reception of visitors on the day of her child's baptism, and furnished with a large canopied bed in which the infant could be displayed.[20] Once Queen Charlotte had recovered sufficiently from the birth of the Prince of Wales in 1762, she received the congratulations of select audiences in the Great Drawing Room at Buckingham House, where she was ensconced on a great royal bed. The young prince was displayed alongside her in a relatively simple cradle, consisting of a rustic wickerwork basket embellished by strings of gold lace, which could be pulled to assist his rocking. However, while the cradle was modest, the setting was grand, since it was placed on a small elevation under a canopy of state. Here the prince was paraded before forty ladies at a time and to official visitors for six afternoons. The nurses who were responsible for rocking the royal cradle were known as 'rockers', and were part of the royal household.[21] Queen Charlotte also used them for ceremonial

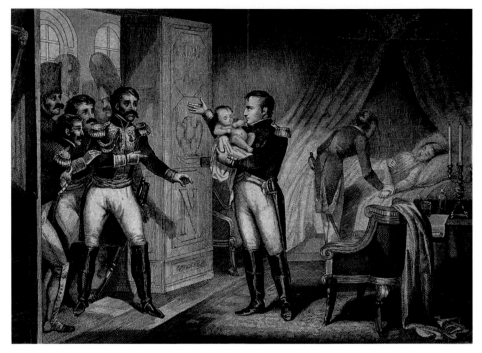

51 Napoleon presenting his new-born son, engraving by Mme Lessueur after Alphonse Testarde, 1811.

purposes when displaying the infant. They stood on the elevation on either side of the cradle, where each one was described as 'a fair mute employed as occasion required to rock the infant asleep'.[22]

The birth of Napoleon's son, the King of Rome, in 1811 was so tied up with the emperor's virility and the heroic image he wished to project to his army that a popular print was produced showing him presenting the baby to his officers shortly after the birth (**fig. 51**). Unable to parade his infant son in front of his regular troops while he was at war in Russia, Napoleon did the next best thing: he displayed his son's portrait by Gérard outside his tent in Moscow, where it is alleged that veterans of the Guards 'cried with joy'.[23]

At home, Napoleon had a number of grand cradles in which to display his heir. One of these was presented to him as a gift in 1811 by the City of Paris. This flamboyant cradle, inlaid with silver and mother-of-pearl, had motifs embodying war and peace with a gilded eagle at its far end and a wreath of olive leaves at its head. It was carried down daily from the nursery to Napoleon's study, where he would allegedly play and sit with his child until he slept.[24] In 1819 the Duke and Duchess of Berry, who were members of the Bourbon dynasty, commissioned the making of a flamboyant, grand cradle or *berceau de parade* for their children, Marie Louise and

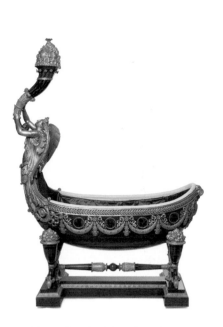

52 The Duke of Bordeaux's cradle, cabinet maker Félix Rémond and bronze maker François Matelin, oak, ash, elm, walnut and gilded bronze.

53 Henri-Charles-Ferdinand d'Artois, Duke of Bordeaux and Marie Louise, d'Artois, Duchess of Parma at the Tuileries by Louis Hersent, oil, French, 1820.

Henri Charles Ferdinand, Duke of Bordeaux which was designed to be placed on a platform and to be presented during official visits (**fig. 52**). The body of the cradle resembles a hull of a boat and is supported by 4 horns of plenty, symbols of the prosperity that it was anticipated would accompany the restoration of the Bourbon monarchy. In 1821 the painter Louis Hersent completed a double portrait of the two infants (**fig. 53**). In the painting he also depicted a cradle with rich hanging that looks remarkably similar to figure 52. The extreme grandness of the cradle together with the magisterial painting emphasized the power and influence of their family, who were seeking to restore the Bourbon monarchy after the death of Napoleon.

The lying-in chamber

The prospective mother was allowed to select the chamber and indeed in some cases the actual property, which was often the maternal home, for her lying-in. This was to ensure that the lying-in chamber became a sanctuary from the outside world, at least for the upper ranks. The decor of royal lying-in chambers during the medieval period was usually extravagant. Queen Margaret, wife of Edward I, had striped woollen wall hangings lining her bedchamber with matching striped bench covers. Her bed also had curtains around it and a hanging with the English and French coats of arms.[25] In 1434 Marguerite of Burgundy gave instructions to her sister-in-law, in

whose house the birth was to take place, regarding the decor for the occasion. She chose green silk and other rich fabrics from Reims for her lying-in chamber, which was also surrounded by tapestries and embellished with her coat of arms. Carpeting was also considered important to complete the furnishings.

Since many of the items associated with lying-in were handed down, the impression of luxury was tempered by the sometimes broken and threadbare character of the contents. In Renaissance Italy the lying-in chamber, while sparsely furnished, contained painted tables, ornate tablecloths and embroidered sheets and pillows.[26] Jane Seymour, Henry VIII's third wife, who died in childbed in 1537, occupied a flamboyant lying-in chamber surrounded by cushions of crimson damask with gold brocade. Marie de' Medici gave birth in the Oval Room at Fontainebleau, in which two pavilion tents were erected and the walls lined with a green material.[27] The pavilions were made from Holland cloth stretched by cords, and inside the smaller tent (the larger one was for the king's immediate family) there was a bed and birthing chair draped in crimson velvet.

In representations of the birth of John the Baptist (see fig. 26) and the baby Virgin Mary, the lying-in chamber is usually depicted with a vast, often raised bed, sometimes with curtains around it, while numerous servants are seen to wash, dress and swaddle the infants in the foreground (see fig. 27). By the seventeenth and eighteenth centuries in the Dutch Republic and France religious compositions of St Anne and St Elizabeth recovering from the *accouchement*, attended by female attendants, had gradually become superseded by secular depictions of the wives of the merchant class either giving birth or recuperating in the lying-in chamber within the well-furnished domestic interiors of the emerging *bourgeoisie* (see fig. 29).

Given the amount of time a woman from the upper ranks was expected to reside in the lying-in chamber, it was felt worthwhile to invest money in making it as comfortable as possible. Moreover, there were often specific instructions relating to how the chamber should be decorated and furnished, and if it was not a separate room, curtains around the bed and hangings would have ensured that it was a private place, set apart from the rest of the household.[28] Indeed, in Tuscany during the Renaissance period the bed or space surrounded by curtains was actually defined as a room. In western European Catholic households, pictures of the Holy Family or other devotional images were lit by candles and frequently hung on the wall of the lying-in chamber as objects of contemplation for the mother, enhancing the impression of a private sanctuary (see fig. 21). In addition, the impression of a sacred space was conveyed by a holy water container, often hung on the wall. Since in the sixteenth and seventeenth centuries it was believed that a woman's pregnancy was strongly influenced by her environment, the mere sight of an aesthetically pleasing object was thought to have a positive effect on the embryo.[29] In Marie de' Medici's lying-in

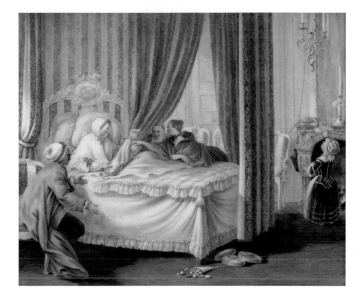

54 Sèvres soft-paste porcelain plaque painted in enamels by Charles Nicholas Dodin, French, 1765.

chamber in 1610, the almost religious atmosphere, was compounded by placing a relic of a fragment of St Margaret's girdle on a nearby table covered with a carpet.[30]

Ostentatious lying-in chambers for royalty and the aristocracy continued during the eighteenth century. Georgiana, Duchess of Devonshire occupied a lying-in room for her second child that was decorated in white satin with a vast bed embellished by enormous paper flowers and silver ribbons and crowned with a gold canopy.[31] Marie-Antoinette also reinforced this fashion for luxury during her lying-in by commissioning a special mechanical table constructed and designed by Riesener and Merklein. This table could be raised and lowered noiselessly, enabling her to eat in bed during the lying-in after her *accouchement*.[32] A luxurious eighteenth-century French lying-in chamber is clearly depicted in a plaque painted by the French porcelain painter Dodin to celebrate the birth of the grandson of the director of the Sèvres porcelain factory in 1764 (**fig. 54**). The impression of luxury and conspicuous consumption is reinforced by the traditional French gift of sugared almonds languishing half-opened on the floor while a toddler plays with an exotic tropical bird in the background.

Changing mats were more mundane, but nonetheless essential items that furnished the lying-in chamber. Images of nurses using them for changing their charges out of their swaddling and 'tail clouts' go back to the medieval period; they become almost a feature of affectionate domesticity in many Dutch seventeenth-century paintings. The Dutch *bakermat* was another item that furnished the domestic interior (**fig. 55**). It was a very low wickerwork or rush chair resembling a dog basket with a curved back to support the woman's back while her legs were stretched out

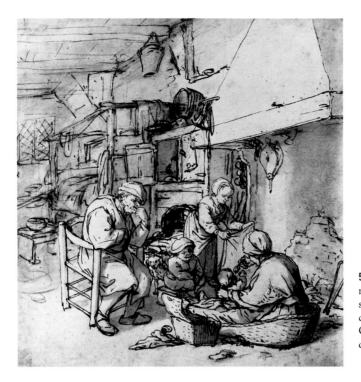

55 Mother feeding a newborn baby with a spoon, pen-and-wash drawing by Adriaen van Ostade, Dutch, 17th century.

in front. This convenient device enabled women to feed, swaddle and change the infants' tail clouts without straining their backs. A handle at its base allowed the *bakermat* to be hung up on a wall when it was not being used and carried from room to room.

Far from being in pristine condition, the furniture of the lying-in chamber often consisted of heirlooms. Vicky, Queen Victoria's oldest daughter, gave birth to the future Kaiser Wilhelm II on the bed where her father-in-law had been born, and Queen Victoria lent the bed that she had used for all her confinements to her daughter Princess Alice for her lying-in.

Light, heat and ventilation

The emphasis on keeping all doors and windows tightly closed in the lying-in chamber regardless of the weather was premised on the notion that draughts and 'noxious miasmas' from outside needed to be excluded since they were thought harmful to health.[33] This concern was reinforced by the belief that opening windows allowed evil spirits to enter.[34]

Another rationale for keeping everything warm with blazing fires, heavy curtains and hot drinks was that it helped to sweat out any poisons lingering after delivery.

Covering up was partly for modesty's sake but also because it was thought that one should not allow cold to enter the womb.[35] This fashion for keeping lying-in chambers warm and shuttered up meant that the oppressive stuffiness sometimes became intolerable for the patient. Marie-Antoinette allegedly fainted during the birth of her first child and her attendants tore down the nailed-up shutters to let in the winter air to help her breathe.[36]

The practice of closing all the windows had started to decline by the nineteenth century, when medical opinion and household management manuals recommended ventilation and maintained that keeping the room too warm could jeopardise the health of the mother and child.[37] This represented a significant shift away from treating the lying-in chamber as a sick room. There were, however, still those who believed that everything should be kept warm to take the chill off things, as the domestic commentator Elizabeth Halford observed: 'Every care should be observed that the lying-in patient does not handle anything cold: even the knife and fork etc. should be laid before the fire, for whatever produces a chilliness is improper.'[38]

Natural light in the lying-in chamber was considered detrimental to an infant's eyesight and windows were well covered. During the medieval period the infant's eyes would be shaded from the light by a piece of linen placed on the baby's front.[39] It was also thought that if babies looked into the fire or at candlelight it would not just weaken their eyesight but also potentially inflame their eyes. Queen Victoria claimed that her daughter Vicky did not wish to send a daguerreotype of her first grandson, Wilhelm, for fear of exposing him to unnecessary illumination during the photographic process.

Dress codes

Female lying-in clothing for the nobility was merely an extension of the luxurious interiors of fourteenth- and fifteenth-century Italy. Moreover, there was not only a dress code for the mother during the *accouchement* but also for the servants in attendance and the baby, and sometimes even for the father as well. Women wore cloaks ranging from very basic coverings to ones coloured a rich red or pink, often lined with fur or silk and fixed by a jewelled clasp. Medieval queens and female nobility who had given birth wore similar robes for the churching or purification ceremony, which marked the end of the lying-in period. For her purification ceremony Queen Margaret, wife of Edward I, wore a robe comprising two lengths of red twilled silk with fur trimmings and a fur hood. Jane Seymour wore a mantle of crimson velvet edged with ermine for her confinement, enhancing the sumptuousness of the furnishings.

In the eighteenth century women from 'polite society' in America and France wore bonnets sometimes in the shape of turbans.[40] There was also a popular custom in seventeenth- and eighteenth-century France and the Netherlands for the new father to wear a 'paternity bonnet' to represent his new status. The mother who is the daughter of the director of the Sèvres factory depicted in the Sèvres porcelain plaque wears a cape and bonnet and proudly shows off the baby, while her husband sits at her side wearing a paternity bonnet (see fig. 54).

The Layette

In Catholic countries throughout Europe it was traditional for the mother to bring the linen she intended to use for her lying-in to be blessed at shrines associated with the protection of mothers and small infants. The mother was discouraged from physically working on the baby's layette during pregnancy since this activity was considered bad luck. The layette's size and quality tended to reflect the affluence and status of the infant's family and was often part of a woman's dowry. Indeed, the size and spaciousness of the layette cupboards that furnish Dutch lying-in chambers reflect the large quantity of the layette (**fig. 56**).[41]

The layette and accompanying objects were frequently handed down, borrowed or bought second-hand. Indeed, in poorer households the midwife herself often gave or lent the initial linen required for the baby. Lending boxes of baby clothes donated and managed by philanthropic ladies also ensured that the newborn had items to wear. In the case of orphans, foundling hospitals or workhouses provided for those infants who either had no clothing or were short of them.[42] Charles Dickens' character Oliver Twist was put into faded calico cast-off baby clothes by the workhouse midwife shortly after his mother's death.[43]

To ensure that layette items were at the disposal of patients in lying-in hospitals, inmates were also often made to mend linen. In nineteenth-century France it was estimated that almost all mothers who abandoned their infants were able to clothe them, however minimally, and that only 15 per cent of abandoned babies were brought to foundling hospitals in rags.[44]

The fashion for elaborate clothing for babies was beginning to decline by the eighteenth century and George III's fifteen infants were as unadorned as their rank would permit.[45] For the upper classes this simplicity reflected a fashion rather than a lowering of living standards. Indeed, an increasing proportion of parents' expenditure went on their infant's clothing, while by the mid-eighteenth century tailors were producing baby clothes for sale in bulk in the latest fashion.[46] By the nineteenth century American milliners were also advertising ready-made suites of childbed linen and baskets of clothing for the mother and baby.[47]

56 Layette cupboard, walnut and oak, Dutch, 1650–75.

The rural peasantry and labouring classes

Throughout western Europe in rural, peasant households and in urban areas where the labouring classes were concentrated lying-in mainly took place in the home. During the seventeenth century in England the urban poor and unmarried women did not even enjoy the luxury of a straw mattress, and in exceptional circumstances were forced to give birth in the streets or in outlying fields surrounding cities.[48] Escape to the hinterland of cities, to areas such as West Ham, which was on the outskirts of London, was to avoid detection by the city authorities. Elsewhere in

the country, in order to avoid jurisdiction, single mothers were compelled to migrate between county boundaries.[49]

The communal room or the parlour or even the stable were typical locations for the birth and provided makeshift lying-in chambers. Here, the flooring would have been extremely basic, consisting of straw scattered around to absorb the blood and bodily fluids. Where there was an upstairs bedroom, the preparation for the birth would involve bringing the bed downstairs and setting it up in the parlour, where a fire could be made and plenty of candles lit.

By the nineteenth century the increasing medicalisation of birth within the lying-in chamber coincided with the fashion for greater privacy and fewer family and friends surrounding the mother at home. Now people from more modest backgrounds could expect a more solitary experience of childbirth in the home, as this popular nineteenth-century childcare and nursing manual makes clear: 'Endure in silence, trust your doctor and nurse, allow no one else in the room at all under any circumstances and keep your grip on yourself and then all will be alright.'[50]

Lying-in hospitals and charities

The first lying-in hospitals were set up in the medieval period, specifically to provide sanctuary for women who were about to give birth out of wedlock. However, while both St Bartholomew's and St Thomas's hospitals in London had endowments to provide for unmarried mothers, they had only a limited number of beds. Hence, provision could be offered to very few unmarried mothers, who were otherwise at the mercies of their families, and these were very often reluctant to take them in and liable to disinherit any daughter who became pregnant out of wedlock.

If unmarried mothers had economic resources at their disposal they could pay for anonymity by seeking refuge in one of the twilight lying-in establishments existing in most European cities in the sixteenth and seventeenth centuries. Courtesans of the Stuart court had their babies delivered in such an institution at Stratfield Leys outside Oxford.[51]

In Germany during the sixteenth century many poor unmarried mothers were ineligible for public assistance immediately after the delivery of their infants and so were regularly sent to prison in chains, where they remained for three weeks, living on bread and water. To offset this dire predicament, an alternative refuge was provided by 'harbourers', who established an informal network of safe houses for unwed mothers.

By the eighteenth century voluntary-funded and religious lying-in hospitals had been introduced in cities across Europe to improve the conditions under which

57 The City of London Lying-in Hospital in the background with a mother breastfeeding and two children at her feet, engraving by Robert Mylne, 18th century.

For I have heard a voice as of a woman in travail, and the anguish as of her that bringeth forth her first child. *Jeremiah, 4. v. 31.*

mothers in modest economic circumstances gave birth. In Britain at the same period there was a concentration of lying-in hospitals founded in London that served the 'deserving poor', because general hospitals excluded women during childbirth.[52] These lying-in hospitals, however, catered for a very small proportion of deliveries; it was estimated that as few as 3.5 per cent of births were taking place in lying-in hospitals by the nineteenth century.[53] Lying-in charities also assisted home births through an outpatient service, providing midwives who were attached to and trained in these specialist hospitals.

The engraving in **fig. 57** encompasses symbols that are likely to have had a particular resonance for potential donors and subscribers to the City of London Lying-in Hospital, which would have depended on their charitable donations. The horn of plenty to the left and the figure of Charity with her children would perhaps have appealed to their charitable leanings, and the quote from Jeremiah emphasising the pain of childbirth perhaps enlisted their religious impulses and sense of duty.

Within the lying-in hospitals nourishment could be good, providing mothers with a heavy and plentiful diet to combat the weakness that accompanied childbirth, enabling them to breastfeed more easily. Good food was crucial, since physicians at lying-in hospitals insisted that women patients should suckle their own infants wherever possible.

Rather than protecting the sections of the community they served, however, lying-in hospitals posed a real health risk to women who had recently given birth

Hide not thy Face from thine own Flesh.

Britannia *seated under an Oak, amidst the Symbols of War, Agriculture & the Polite Arts, receives from the hand of Minerva the original Proposals for the Institution of the* WESTMINSTER NEW LYING-IN HOSPITAL, *by her side stands Charity, who expatiates on the Utility of the Design & points at a Perspective Elevation of the Hospital. Pendant on the Oak is a Tuscan Shield with the Arms of Earl Percy who generously patronized the first Undertaking, & at the Top are placed the Arms of the City of Westminster.*

58 *The Westminster Lying-In Hospital, Lambeth,* engraving on silk by C. Grignion after S. Wale, 1786.

because those who resided in their wards were particularly at risk of puerperal fever, an often fatal and extremely painful bacterial infection that attacked the uterus or vagina. Once this disease had reached epidemic proportions throughout Europe in the eighteenth and nineteenth centuries, women were fortunate if they survived a stay in a lying-in hospital. Destitute, single mothers in England could, as a last resort, seek refuge during their confinement in the lying-in ward of the workhouse, but deterrents were imposed to ensure that their stay was extremely brief by making it as uncomfortable as possible and providing a meagre diet of gruel.[54] In Germany, too, there were strict conditions for lying-in wards. Homeless single mothers were granted permission to have their babies delivered in lying-in wards providing that they were prepared to become wet nurses.[55] Interestingly, Florence Nightingale observed how much safer home deliveries were than lying-in hospitals; she commented that the rate of puerperal fever was lower in the lying-in ward of the workhouse than in the lying-in hospital. Indeed, she had been forced to close her model lying-in hospital when puerperal fever swept through the building in 1867.[56] The better track record of the lying-in ward of the workhouse was attributable in part to

fewer people inhabiting the wards and a faster turn-around of inmates, which meant there was a lower risk of infection and disease.[57]

In the light of the increasing medicalisation and institutionalisation of the birth process, the sociable side of lying-in was sacrificed in favour of greater privacy. It was certainly difficult for the father to gain access to obstetric wards in lying-in hospitals. Strict visiting conditions were imposed in London hospitals, which meant that a husband could not be present when his wife was giving birth. A week after the delivery of the infant and only after a written application, visitors who were granted permission were reduced to having a snatched half-hour visit in the hallway. Not only were friends and relatives forbidden to enter the ward, but husbands were as well.[58] Only in extremis and after careful consideration from either the Board or a physician could an anxious relative or friend – or even a husband – be allowed access to the ward where the mother was recovering (**fig. 58**).[59]

CHAPTER 4

Rites of passage, ceremonial and gifts

And she shall then continue in the blood of her
purifying three and thirty days; she shall touch no
hallowed thing, nor come into the sanctuary, until
the days of her purifying be fulfilled. But if she bear
a maid child, then she shall be unclean two weeks
as in her separation: and she shall continue in the
blood of her purifying three score and six days.

Leviticus 12vv4–5, Authorized Version (King James Bible)

The quarantine period

The quarantine period of a woman's lying-in (discussed from a more social perspec-
tive in the previous chapter) was enshrined in the Old Testament book of Leviticus.
It was expected to last for thirty-three days if the mother gave birth to a son, and
twice as long if she gave birth to a daughter, since it was believed that uncleanness
attached to the female infant as well as to the mother, while the male child was
deemed intrinsically purer (**fig. 59**). Hence, the mother was effectively put into iso-
lation and removed from undertaking domestic duties and partaking in sex. The
near-incarceration of the mother during the lying-in period derived from a literal
interpretation of Psalm 21: 'The sun shall not shine on thee by day, nor the moon by
night.' By the seventeenth century Protestant reformers were challenging the lying-in
period, which effectively imprisoned women from the outside world. The Anglican
and Catholic churches certainly expected lying-in to be respected, but there was a
divergence of views concerning to what extent mothers should obey the quarantine
restrictions.

Purification and thanksgiving

In Judaism the mother was deemed impure after childbirth, and was required to
undergo a ritual physical cleansing as set out in Leviticus. In Christianity, however,

59 A woman deemed impure recovers from childbirth, illustrating Leviticus 12vv4–5 etching by Philip Gottfried Harder, 1731.

the analogous ceremony focused on thanksgiving and blessing, its elements drawn from the presentation of the infant Christ in the Temple. The churching ceremony in western European Christian households, originally known as purification or *relevailles* in France, marked the end of the quarantine period for the mother. Sometimes this occurred as late as six to eight weeks after the birth and the baptism and was technically the first time a woman ventured out of the house after her lying-in.

During the sixteenth and seventeenth centuries the Church of England did not specify when the mother should be churched and indicated that she could enter the church for this purpose whenever she wished. The churching ceremony generally only lasted about ten minutes with the woman 'decently apparelled' and was conducted in a church or, exceptionally, at home. The need to segregate the mother from the rest of the congregation was sometimes expressed in the seating arrangements of the church. A special pew known variously as the 'midwives' pew', the 'childwife's pew', the 'churching seat' and the 'sickwife's stall' was assigned for the churching of women.[1]

There was a strong difference of opinion regarding the necessity for churching among Protestants, Anglicans and Catholics, and some denominations rejected it.[2] While it was common in fifteenth-century Germany it was not obligatory, and Lutherans, like many other Protestants, were not happy with the notion of a rite of purification since it conflicted with their doctrine of original sin, which was premised on the belief that it was faith alone which could deliver souls from hell. Catholics, however, did not uphold it as an essential rite either. But where churching was required in some Anglican churches, compliance was strict and failure to attend the ceremony could result in excommunication.[3] Protestant reformers were the most opposed to it, and in England they considered it the most disgraceful popish survival in the Church of England.[4]

From the end of the sixteenth century it was customary in Britain for a woman attending churching ceremonies in the Anglican Church to receive an offering of a white handkerchief to symbolise her cleansing.[5] By the end of the sixteenth century in England the chrism cloth in which the child's head was wrapped at its baptism was given to the mother and treated as an offering during her churching ceremony. In addition, sometimes the offering took the form of money. The chrism cloth and any money were then dropped into a wooden box in the church. One beautifully carved example of such a box from this period still survives in St Clement's church, Outwell, Norfolk (**fig. 60**).

60 Chrismatory from St Clement's church, Outwell, Norfolk, wood, late 16th century.

The churching ceremony in Anglican and Catholic churches has been described as having taken on a 'semi-magical significance'.[6] The ritual most commonly involved covering the mother's head with a white veil and blessing her with a sprinkling of holy water. However, by the mid-seventeenth century there was increased emphasis on the thanksgiving aspect of the ceremony, which involved offering up a lit candle and receiving communion. But Laud, Archbishop of Canterbury (1633–45), insisted while he held this office that a penitential feature of churching should be retained by women wearing a white veil or handkerchief at the ceremony. There was resistance to his proposal by some women who had recently given birth in regions where his influence was strongest, in south-west and south-east England. They protested because they believed it demeaning and rejected the idea that churching should be a form of penitence.[7]

In England, the ecclesiastical courts penalised flagrant infringements not just of the quarantine period of lying-in but also for breaches of the rules accompanying the purification ceremony. In 1530 Ralph Blundell admitted to 'impregnating' Alice Marsh, who had stayed with him for a fortnight during her lying-in and spent the night with him immediately after her purification, which was deemed unseemly to the point of sacrilege. Blundell was immediately ordered to bear a lighted candle before the procession at church the next Sunday, 'in penitential fashion'. After appeal, however, this penalty was commuted to the culprit offering up the candle to the priest during Mass, and on Friday the accused was required to fast on bread and water.[8]

In England during the sixteenth century there was particular reluctance to undertake the churching of mothers of illegitimate children within the Anglican and Catholic Churches. This meant that these women were often driven into the privacy of the home for the purposes of churching. Later, in the seventeenth century, there was an interesting example of a single mother who was churched in an inn by a parish clerk who had been granted licence to do so by the curate.[9]

In seventeenth-century America the unchurched mother was deemed a potential threat by many Protestant sects, capable of bewitching both people and animals and inducing unwanted pregnancies. Any woman who had given birth but had not been initiated by this ceremony was nicknamed a 'green woman', since it was thought she could kill the grass she stepped on.[10] While by the eighteenth century in England the religious significance of churching had begun to decline, it was still treated as a social milestone since it signalled the reintegration of the mother into daily life by enabling her to resume sexual relations with her husband.[11]

By the nineteenth century families in the upper ranks of society were increasingly dropping churching as a ritual, preferring to opt for a thanksgiving at home with a minister presiding over prayers. Churching still remained a popular rite of passage

amongst other sections of society throughout the Anglican churches in Britain and the United States, although gradually its religious significance declined and fewer women were undertaking the ceremony by the start of the twentieth century.[12]

Baptism

Baptism was a very significant rite of passage. The Catholic Church taught that it was the essential sacrament of salvation, but after the Reformation there were divergent views: many Protestant communities regarded it as merely symbolic, and a few rejected infant baptism altogether. Nevertheless, baptism was still the public face of childbirth. Unlike the woman's churching ceremony, it was a male-focused occasion, and provided the opportunity to consolidate and extend dynastic and familial ties through the selection of godparents (**fig. 61**).

Under normal circumstances baptism was conducted three days to one week after birth. At medieval baptisms the ceremony started in the church porch. After entering

61 A baptismal procession (middle image) from *The Compleat Midwife's Companion* by Jane Sharp, woodcut from the frontispiece, English, 1724.

the church the baby was immersed three times in a font of holy water.[13] This consisted of one immersion on each side and one face downwards;[14] later, the practice of pouring holy water from a pitcher or bowl over the child became more common. The child could also be anointed with holy oil (made from olives) and balsam known as chrism (or myrrh) kept in a vessel called a chrismatory, which was often elaborately made and richly decorated. At the Reformation, the practice of immersing the child in a font was rejected by many Christians, and in England the Puritans especially objected strongly to the use of fonts, along with other 'popish' baptismal practices such as godparents.

Many mothers were too exhausted to participate in the baptism. Anne Boleyn, second queen of Henry VIII, was too weak to be present at her daughter Elizabeth's christening in 1533, but lay in state in a crimson velvet mantle lined with ermine. In the engraving *Le retour du baptême* by Abraham Bosse (**fig. 62**), the baptismal party visits the mother after the ceremony, which she has missed. Similarly, Queen Charlotte was not present when her first-born, George, Prince of Wales, was baptised privately, but she attended the churching ceremony, described as a service of thanksgiving, five days later.[15] Those women who did struggle to attend the baptism or who

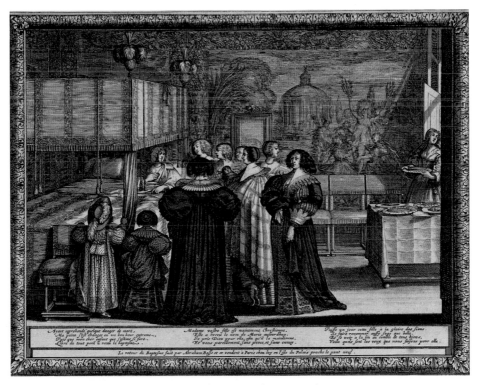

62 *Le retour du baptême*, engraving by Abraham Bosse (1602–1676).

63 *Christening of the Heir* by William Redmore Bigg, oil, English, 1799.

managed to attend the short churching 'cleansing' ceremony were often decidedly weak. Four days after his birth in 1537, Jane Seymour attended her son Edward's christening, which was attended by more than three hundred guests.[16] Sadly, she died twelve days later of complications.[17] Throughout the eighteenth and nineteenth centuries women continued to struggle to attend their infant's baptism; many paintings depict them seated looking exhausted while the rest of the congregation is standing (**fig. 63**).

The practice of anointing an infant in sacred water to ensure that they were protected from harm has roots that go back to classical antiquity. There was also a belief in the curative powers of baptism, and some claimed that blind infants had their eyesight restored after receiving the sacrament.[18] A curious practice developed in some Catholic baptismal services during the sixteenth and seventeenth centuries that involved the priest completing his anointment of the child by spitting into its mouth. Mary, Queen of Scots pre-empted this happening during the baptism of her son James in 1566 by insisting that no 'pocky priest' should be allowed to do this to her child.[19]

Not every Christian household chose to baptise its children in church. The English diarist John Evelyn (1620–1706) famously chose a private baptism for his children, reflecting the contemporary fashion amongst the upper ranks, particularly the defeated Royalist elite, to choose private baptisms at home in the

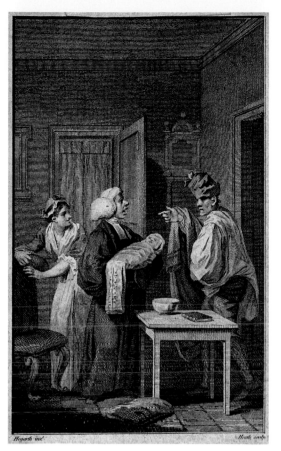

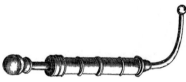

64 *An Anglican baptism at home*, etching by J. Heath after W. Hogarth, 1780.

65 Intrauterine baptismal syringe, French, 17th century.

mother's bedchamber.[20] Private baptisms continued to be fashionable in the eighteenth century and the first son of George III was baptised privately. This fashion for private baptisms was evident in America too and it was not until the 1850s that church christenings regained their popularity.[21] An amusing etching (**fig. 64**) depicts a private Anglican baptism. The minister is poised to anoint the infant with holy water from a bowl when the father, having overslept, bursts in late, half-dressed, his shirt tails out and his nightcap askew.

It was considered to be urgent to baptise a Christian child when the infant's life was hanging in the balance. This meant that baptisms had to take place as soon as possible at the bedside and if there was a prospect of a stillbirth, any protruding limb could be baptised.[22] More dramatically, when the mother had died it was advised that she should be cut open and the body of the baby extracted and baptised immediately. In seventeenth-century France a syringe was sometimes used to administer intrauterine baptism (**fig. 65**).[23] Given the urgency, perhaps it is no coincidence that the 'godsibs' were originally selected to be the child's godparents. Even lying-in hospitals during the eighteenth and nineteenth centuries considered baptism as part of their duty, and would not discharge infants until they had undergone this rite of passage.

The King of Rome, son of Napoleon Bonaparte, received an *ondoiement* or emergency baptism probably because of fears surrounding his delicate health and possible death on the day of his birth on 20 March 1811 in the chapel of the Tuileries.[24] To underline his royal status he was later baptised in a more public fashion in the cathedral of Notre-Dame in Paris. On this occasion he wore a cloak of silver material lined with ermine and was led in a procession through Saint-Cloud in a gilded baby coach drawn by two milk-white sheep.[25]

Jewish rituals

In Jewish communities, circumcision or *brit milah* took place eight days after birth when the baby boy was healthy. It was the Jewish equivalent to Christian baptism as a rite of passage, but its underlying intention was to protect the male baby from harm and incorporate him into the Jewish community.[26] In this ceremony the *mohel*, the ritual circumcisor, inflicted small incisions on the foreskin of the baby boy with a small knife (**fig. 66**), and most importantly some small amount of blood loss was required. It was originally required for the *mohel* to suck the blood to cleanse the wound, known as *metzitzah b'peh*, but by the 1890s this traditional

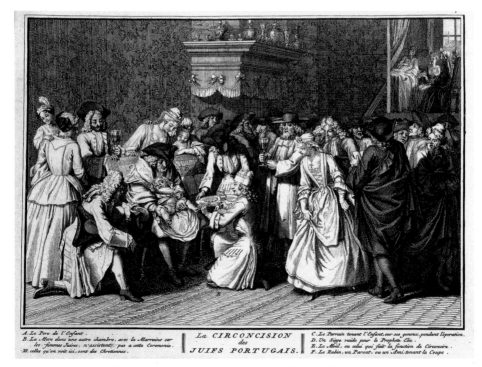

66 A Portugese Jewish circumcision, engraving after Bernard Picart, French, 1741.

method had been dropped and a glass tube was used for oral suction to extract drops of blood.[27]

During the medieval period all Jewish infants in Germany, regardless of sex, underwent a naming ceremony or *Hollekreisch*, a term derived from the name of the demon witch Holle. The *Hollekreisch* meant the fending off of evil spirits, and took place four to five weeks after birth. Apart from providing a name during the ceremony, it was a custom to put the Book of Leviticus under the infant's head as a form of spiritual protection.[28]

Christening and circumcision garments

During the christening ceremony, a chrism cloth would sometimes be wrapped around the baby's head after it had been baptised. This could either be a simple linen cloth or, for nobility and royalty, it might be encrusted with pearls and jewels.[29] There were also ceremonial shawls or 'bearing cloths' popular from the fourteenth to eighteenth centuries traditionally used by the gentry and those of middling rank in western Europe and America. Frequently red in colour, they were made from a multiplicity of rich fabrics such as silk and extravagantly decorated with features such as brocade (**fig. 67**). Sometimes the length and the heaviness of the material required numerous people to carry the train of the mantle or bearing cloth. In 1486 Prince Arthur, eldest son of Henry VII, wore a long christening mantle made of a crimson and gold material that was lined with ermine and was carried by the Marchioness of Dorset and Sir John Cheyne.[30] The Tate's double portrait of the Cholmondeley

67 Bearing cloth, embroidered silk with silver-gilt bobbin lace, Italian, 1620–1650.

68 Christening robe, lawn overlaid and trimmed with lace, hand-sewn, English, 1884.

69 *James Edward Stuart, The Old Pretender, on a Velvet Pillow*, mezzotint by Peter Schenk after Sir Godfrey Kneller, Dutch, 1675–1719.

sisters (see endpapers) feature infants who are wrapped in bearing cloths similar to that depicted in fig. 67. Christening robes, traditionally white, were then worn underneath 'bearing cloths' (**fig. 68**). From the seventeenth century, infants of royal birth were also often placed on cushions during the ceremony (**fig. 69**). Two centuries later the future Kaiser Wilhelm II was put on a silver brocade cushion that had all his ancestors' names stitched in gold.

The significance that baptism assumed within families meant that many of the garments worn for this occasion, if they survived, were passed on from generation to generation. In the late nineteenth century J. M. Barrie (1860–1937), author of *Peter Pan*, reminisced how all his extended family and many family friends had worn the christening robes that he had always assumed had been worn only by his dead brother: 'but I knew later that we had all been christened in it, from the oldest to the youngest between whom stood twenty years, hundreds of other children were christened in it also, such robes being then a rare possession, and the lending one of my mother's glories'.[31] This christening robe (**fig. 68**) was made for a boy in 1884 and was later passed on to other members of his family.

For four hundred years the 'binder', a form of swaddling band, held a particular significance in the Jewish religion since it was used as a form of thanksgiving after the circumcision ceremony. Made from swaddling cloth, it was traditionally embroidered by the mother during her lying-in, and included the name of the son and the father.[32] Once completed, it was donated by the father to the synagogue and made

into a Torah scroll, or *mappati* in Hebrew. Apart from a symbol of thanksgiving these binders were stored in the synagogue as a form of registering the male birth, but this practice had declined by the twentieth century.

Drinking and feasting

From the medieval period indulging in communal feasting and drinking formed an important part of celebrating a birth. Once the baby had been born, drinking and carousing provided a relief after the often-tense atmosphere before and during the birth. Drinking was also part of the baptismal ceremony. The congregation were served wine and spices inside the church beforehand and drinking continued at home throughout the day until evening.

In the thirteenth century music, dancing, eating and drinking were integral to the vigil before the circumcision, known by Ashkenazi Jews as the *wachnact*. The revelling associated with this vigil became so intense in the Rhineland, however, that the Jewish community issued rulings to restrict the celebrations.

In Christian households in southern Germany during the fifteenth century it was the custom for the woman's father to send several buckets of wine to her to celebrate the birth of his grandchild. The expression 'Wetting the baby's head' in seventeenth-century Lancashire did not just refer to the baptism of the infant, but to the rounds of drink purchased by the father and godfather for the assembled neighbours and friends.[33]

Parties celebrating the birth were by no means always restrained affairs, but were often associated with a certain amount of sexual repartee and raucousness.[34] Sometimes the festivities lasted for as long as six weeks. The main occasion was known as the 'puerperal feast', and in Germany it acquired a notorious reputation, which one midwife testified as being 'A constant source of debauchery among womenfolk and the ruination of midwives.'[35]

An illustration of a birth scene in Jacob Rueff's classic obstetrics textbook *The Expert Midwife* shows the midwife in the background to the right regaling herself with ale from an extremely large tankard (**fig. 70**). Indeed, the authorities in medieval Konstanz were so alarmed by the lavish expense and lack of decorum of these 'childbed ales' that they prohibited them.[36]

In New England in the seventeenth century eating formed an important part of welcoming the newborn. Here the mother would host a 'groaning party' for all those who had assisted in the birth.[37] The term evidently referred both to the groans of labour and the groaning of the table under the weight of the food. Throughout America during the eighteenth century it was popular to invite friends to share plum cake and cordial (usually wine) to celebrate the birth.[38] Sometimes it was the new

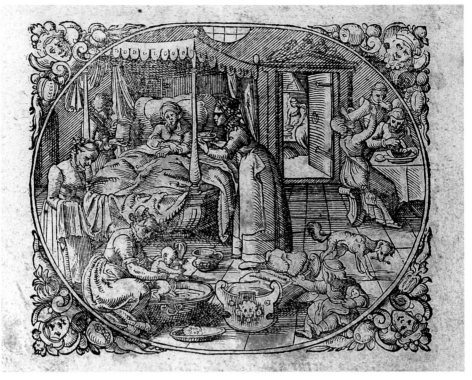

70 Jacob Rueff, frontispiece from *De conceptu et generatione hominis*, Frankfurt, 1580.

father that was toasted, which in Scotland would consist of a 'groaning malt'. In addition a special birthing cake might be served in his honour.[39]

Each time Queen Charlotte gave birth to one of her numerous offspring members of the public were famously regaled in the queen's apartment with cake and the alcoholic drink known as caudle (**fig. 71**). Caudle recipes varied according to the wealth of the family, and for the upper ranks would often consist of rich ingredients; one common caudle recipe comprised a combination of eggs, milk, sugar and lacings of alcohol. In 1762, after the birth of Queen Charlotte's first child, 500 pounds weight of cake were eaten and 80 gallons of caudle drunk each day by visitors to the mother.[40] This old ceremony, however, had near fatal consequences after the birth of her first daughter, Charlotte, in 1766. The public's eagerness to participate in the caudle and cake celebrations at St James's Palace meant that a crowd developed and some women were nearly crushed to death, resulting in the Yeoman of the Guard abruptly shutting the gates on the disappointed crowd.[41] It was also traditional at the time for the monarch to distribute large quantities of liquor amongst the populace, and George III's generosity was particularly remarked upon after the birth of his third son, William, Duke of Clarence in 1765.

71 Caudle cup and
saucer, soft-paste
porcelain, Worcester,
circa 1770.

The tradition of toasting the newborn continued into the nineteenth century
amongst the English country gentry, and caudle was still being consumed amongst
the upper ranks when they entertained and provided an open house for visitors
to view their newborn. When describing the celebrations around her birth, the
Dowager Countess of Jersey recalled: 'I was born at Stoneleigh Abbey on October
29th 1849 – I suppose the next day – I was held up at the window for the members
of the North Warwickshire Hunt to drink my health.'[42]

Gifts, almsgiving and mementos

Well before babies were born, women received gifts on marriage that anticipated
their future progeny. During the seventeenth century the mundane gift of nappy-
drying sticks was received by newly married Flemish women, presumably as part
of their dowry.[43] Sometimes godparents used the christening as an opportunity to
contribute to the infant's future dowry and gave such items as a horse or a wedding
dress.[44] Another present for a male infant whose joys were deferred until adulthood
was the custom firmly established by the late nineteenth century in which a godpar-
ent would lay down port or wine.[45]

Almsgiving to the poor was also part of the post-baptismal ceremonial of English
medieval royal births, and this tradition of almsgiving continued amongst royalty
throughout western Europe right up to the eighteenth century.[46] This was exempli-
fied by Marie-Antoinette celebrating her daughter's birth through almsgiving to the
poor and donating to appropriate charities. One of these charities provided dowries
for 'poor and virtuous' girls to ensure that they married respectable working men.[47]

In Renaissance Italy and other parts of western Europe gifts covered a wide range
of household goods, including silver forks and spoons, fabric and goblets. Sweet-
meats such as sugared almonds, known as *dragées* in France, were also popular

traditional gifts to new mothers (see fig. 54). It was common too for the godparents to slip coins into the swaddling bands during the baptism. In Renaissance Italy, it was considered perfectly acceptable to return the gift to the donor if and when a child was later born into the gift giver's household.[48]

Salt cellars were popular gifts throughout western Europe, and given the life-sustaining qualities of salt, they also made a traditional christening gift particularly popular from the medieval period. It was considered important, however, to wait until after the baby was born before some gifts were given. Pincushions, a traditional English gift, were thought to increase the pain of childbirth if they were given to the mother before labour began (see fig. 20).

The fashion for memorialising the infant by carving, painting, engraving or embroidering the name and birthday is found on many gifts associated with babies. There was a tradition in England from the seventeenth century of presenting the parents and child with the modest gift of a pottery cradle, often with the child's birth dates and initials painted on it or bearing decorative motifs such as the alphabet (**fig. 72**). Loving cups were also traditional gifts for celebrating the birth of a child. They were originally associated with communal drinking and were made from salt-glazed stoneware or silver engraved with the infant's initials, and for the socially elevated included their coat of arms as well.

Rattles were also traditional baby gifts and were handed down as heirlooms. They were made out of pieces of ivory or coral, set in silver and hung from a ribbon or chain known as a chatelaine. Rattles were frequently combined with teething rings or sticks (**fig. 73**). The latter were very popular for children of the aristocracy throughout western Europe from the sixteenth century to the eighteenth, and amongst

72 Staffordshire earthenware cradle with slip decoration, 1700–10.

73 Rattle and teething stick, silver-plated and coral, 1750.

the upper ranks of society in eighteenth-century America.[49] They were sometimes extremely extravagant. The eldest infant son of Marie-Antoinette received a coral and diamond rattle from the Tsarina of Russia,[50] while Lady Charlotte Finch, governess to Queen Charlotte's children, gave a silver filigree rattle to the royal nursery in 1763. This was handed down the generations to Queen Victoria's family.[51]

A more personal way of memorialising the infant was to cut off a lock of his or her hair and send it to a relative. Queen Victoria received the gift of a lock of hair of her first grandson, Wilhelm, son of her daughter Vicky, in the absence of a photograph or actually seeing him soon after his birth. The queen also commissioned casts of her infants' limbs. These were sculpted in white marble and laid on red velvet and were presented under glass domes. After her death they were sent to Osborne House, her holiday residence on the Isle of Wight.

Unbaptised and uncircumcised infants

Some families believed that if the pregnant mother had received Communion her child would not need to be baptised, but this view was rejected by the Catholic Church. The most common reason for not baptising an infant was that the baby had been conceived and delivered out of wedlock. It has been suggested that while baptism was treated as a token of civic belonging, it was feared that illegitimate babies might pose a potential financial burden on the community.[52]

Even when illegitimate babies were baptised, however, both Catholic and Protestant authorities had ways of officially stigmatising them that no doubt discouraged some parents from initiating their illegitimate infants into this rite of passage. To underline the shame attached to 'bastards', Lutheran Church officials in Nuremberg, Germany, during the seventeenth century recorded the names of illegitimate babies upside down in baptismal registers.[53] Sometimes more toleration was exercised by Lutherans after an illegitimate child had died than when it survived. This was exemplified by their allowing church burials for infants who had not been baptised.

Baptism involved expense, and there is evidence that the poor often postponed baptising their infants until their budgets allowed it. While postponement technically risked punishment, some leniency was exercised by the ecclesiastical courts if a household was in financial hardship.[54]

Sometimes it was thought that unbaptised babies were pursued by demons into Limbo. Here the infants were then changed into hounds in order to tackle the demons.[55] In fifteenth-century Italy, in contrast, demons were thought to replace unbaptised babies in their cradles with changelings. This event is depicted in a powerful fifteenth-century painting of St Stephen as a baby being abducted by the devil from his cradle and replaced with a changeling (**fig. 74**).[56] The latter were usually

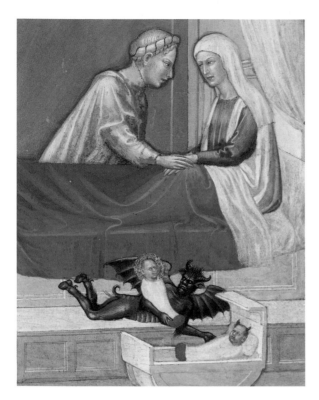

74 *The Commutation and Abduction of the Newborn St Stephen* by Martino di Bartolomeo, detail from an altarpiece, mixed media on poplar wood, 1390.

male children with either behavioural problems or physical disabilities who were considered in some way to be bewitched. It was often convenient for parents who were reluctant to take responsibility for infants with severe learning and physical disabilities to declare their baby to be a changeling. Moreover, the Catholic Church in particular actively promoted the idea that changelings existed,[57] so would have colluded with rather than condemned parents who ostracised their 'changeling' children. This belief that infants could be abducted by malign forces and exchanged for changelings persisted right up to the nineteenth century throughout western Europe,[58] including the Highlands of Scotland, where there was a long-standing tradition of belief in changelings.[59]

Protection of infants against demons and evil forces was ensured by the protective powers of baptism for Christians and circumcision for Jews, so unbaptised and uncircumcised infants were left particularly vulnerable. In northern Europe fairies and elves were believed to abduct unbaptised infants and replace them with changelings. In Germany, unbaptised and uncircumcised infants were thought susceptible to the sinister influence of Frau Holle, a demon who was thought to wander through the forests and snatch babies.[60] However, some aspects of possession by the devil were seen as positive. For example, in Ireland during the seventeenth century an

infant's right arm was deliberately left free of baptismal immersion and anointment so that it would preserve the belligerent side of the infant.[61]

Popular customs and beliefs

To this day infants in Castrillo de Murcia in Spain during the festival of El Colacho are submitted to a terrifying practice that harks back to the sixteenth century.[62] A man delivers them from original sin by dressing up as Satan and jumping over a large clutch of small babies who lie exposed on the ground. The *Couvade* ritual also involved dressing up and play-acting, and was pervasive in southern Europe during the medieval period. It was based on the belief that, by pretending to be the mother, the father could defend the infant from the demon intent on harming it. This ritual inversion of sex roles or 'magical transvestism' has many manifestations in different cultures, and served not just to ward off demons but malignant fairies as well both before and after birth.[63]

Women were not exempt from ritualised sex role reversal either. Expectant mothers temporarily adopted masculine clothing by wearing their husband's breeches, or their paternity bonnet inside out, in order to protect their infants in the womb just before and during labour. In some parts of rural France the pinning up of the father's breeches was thought to deter evil spirits.[64] Fairies were also thought to be repelled in rural parts of western Europe when the infant was dressed in his or her 'first shirt', cut down from the father's shirt. Those 'first shirts' that survive from the seventeenth and eighteenth centuries consist of single piece of linen folded at the top to form the basis for sleeves and then slit down the front to provide an opening. Their simple design made them easy and cheap for poor households to produce and they continued to be worn by infants up to the nineteenth century (**fig. 75**).[65] Through its adult associations with the father, the shirt was believed to bestow later sexual attractiveness on the child.

A ritual involving the first shirt was attended by members of the French court and officially recorded shortly after the dauphin, later to become Louis XIII, was born in 1601. The short ceremony consisted of the dressing and undressing and handing over of the 'first shirt' by the *remeuse* or dresser, who ensured that the infant was protected from evil by making the sign of the cross over him.

Unbaptised babies were thought to be particularly prone to evil spells while lying asleep in their cradles. Sometimes, however, a spell could be reversed. A circle of egg-shells, for example, was thought to discourage changelings.[66] In the fairy tale of the *Sleeping Beauty*, the baby princess is put under a spell by an evil fairy just before her christening. The good fairy godmother who breaks the evil spell reflects the actual role of godparents, which is to renounce the devil and evil influences on the child's

75 First shirt, diaper linen, British, 1875.

behalf.[67] Indeed, the Book of Common Prayer enlists the godparents' support when the minister intones these words during the baptismal ceremony: 'Dost thou, in the name of this child renounce the devil and all his works?'

Those attending the vigil *Wachnact* before the Jewish circumcision ceremony deterred harmful demons by remaining awake and vigilant and lighting candles and lamps.[68]

The precautions taken against such supernatural forces as fairies abducting the baby consisted of bolting all the doors and the midwife drawing a pentagram on the threshold.[69] Other deterrents against fairies consisted of sprinkling salt on the baby, a popular custom before the Reformation, as well as tying a bag of salt around an abandoned infant who had not yet been baptised.[70] Putting a bible inside the cradle was also thought to combat evil forces. Other tactics included leaving a piece of red thread next to the child, or a piece of iron, or else finding some berries from a mountain ash to put alongside the baby.[71] A cradle made from ash, birch, elder or oak was believed to ensure further protection to the sleeping infant, since these woods were deemed sacred in ancient Christian tradition: it was believed that Christ had been washed before a fire created out of sticks made from an ash and elder from which the Cross would be made. In Cambridgeshire as late as the nineteenth century some households upheld a superstition that consisted of placing a silver coin on the buttocks of newborn babies, which it was believed would drive away the devil.[72]

The dead were also susceptible, it was thought, to evil forces. For this reason in the Basque Country and in many other areas of Europe there was a custom of burying the corpses of unbaptised children in the house, on the threshold or in the garden to protect them from malign influences. This was probably attributable to the Catholic Church refusing church burials to unbaptised infants.[73]

CHAPTER 5

Milestones

In all matters of development it is better to follow
nature's lead than to press her forward.

The Care of Infants by Dr Sophia Jex Blake, 1903, p.55

Crawling

'Creeping' or crawling was not originally considered an important milestone. From the medieval period to the end of the seventeenth century, and sometimes even beyond, crawling was considered to display the more animal side of a child's development and therefore to be unworthy of humans. Crawling babies began to feature in portraits only towards the end of the eighteenth century, suggesting a greater acceptance of this developmental stage by parents, who usually commissioned the portraits. One example is David Allan's conversation piece of the Halkett family dated 1791 (**fig. 76**) in which a crawling baby features. Apart from a few such enlightened parents in Europe and America,[1] crawling was not considered a 'natural' development but rather denied, ignored or disapproved of right up to the nineteenth century, and few infants were encouraged to crawl before they could walk.[2]

Elizabeth Halford, an expert on infant care writing in 1828, criticised crawling for being injurious to the body, promoting what she deemed unnatural growth and soiling clothing. She even recommended that it should be prevented from occurring.[3] Some years later the novelist Elizabeth Gaskell wrote a detailed diary of her daughter Marianne, who was born in 1834. This traced her infant's development from six months to six years and reveals Mrs Gaskell's efforts to apply Halford's advice. She did this by ensuring that her daughter remained inactive before she learned to walk: 'She is very strong in her limbs, though because she is so fat, we do not let her use her ankles at all and I hope she will be rather late in walking that her little legs may be very firm.'[4]

Towards the end of the nineteenth century advice and attitudes towards crawling began to shift and it was increasingly recognised as a stage of development through which all infants passed. Dr Peter Braidwood, who wrote on the domestic management of children, advised parents that 'Nature directs children first to crawl, next to stand, and attempt to walk aided by some support.'[5] Mothers documenting their

76 *Lady Halkett and Family,* by David Allan, oil, Scottish, dated 1781.

infant's development in diaries of the period often revealed their pride in their children crawling for the first time.[6]

Standing and walking

During the medieval period standing upright and walking were promoted over crawling, and the baby walker reflected the adult preoccupation with ensuring that infants stood upright. Medieval religious iconography depicted the infant Jesus standing propped up by a baby walker to emphasise his relationship with humanity and the support that it was believed that God provides, rather than those more basic traits that he shared with the animal kingdom.[7]

In manuscripts and woodcuts from the medieval period infancy was frequently depicted as the first stage in the Four Ages of Man, and rather than lying down or crawling the infant was shown standing in or pushing a baby walker (**fig. 77**).[8] This was often constructed as a crude wooden frame on wheels known in France as a *youpala* design (**fig. 78**), and it was also prevalent in Germany.

By the eighteenth century many childcare experts were preoccupied by posture and standing upright, as indicated by the fashion for stays constructed of linen, stiffened by whalebone and bound with leather for infants as young as three months, since it was believed that these would help them to develop straight backs.[9] Another

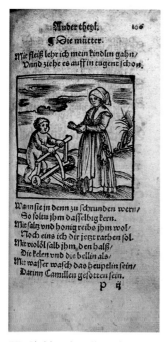

77 Child with walking frame, woodcut in Eucharius Rösslin's *Hammenbuchlin, Von der Menschen,* 1565.

78 'Les âges de l'homme', from *Le livre des propriétés des choses* by Barthélemy l'Anglais (d. 1272). French illuminated manuscript, 15th century.

device used for keeping infants propped upright was the standing stool. This was usually homemade, with shorter legs than a stool, and had a hole in the top into which the child was placed. It looked a bit like a crinoline while allowing limited freedom for the infant's legs (**fig. 79**). Versions of these standing stools were common items amongst the poorer classes living in rural areas in both America and Europe.

Felix Würtz, a sixteenth-century barber surgeon from Zurich, believed that infants under six months should not be made to stand and argued that standing stools were so bad for an infant's development they should all be burned.[10] A version known as a go-cart was made by rural householders with willow rods without castors, and during the eighteenth century this was also adopted by more affluent families keen to embrace the rustic idyll. The standing stool was particularly suitable for families such as weavers, whose looms might fill the whole of the dwelling, since this device allowed the infant restricted movement in the top half of their body but they were unable to walk in them. By 1830 they had declined in popularity in America, although they continued to be used in less industrialised European countries such as Italy for considerably longer.

79 *The first steps* by Marguerite Gérard, oil, French, 1788. (the companion painting to fig. 96)

In contrast, a 'go-gin' or baby runner allowed the infant to walk (albeit in a restricted fashion) and was made by English cottage dwellers and French peasants.[11] This homemade contraption was made from the rough-trimmed bough of a tree and could be produced fairly easily.[12] It resembled a treadmill, and comparisons have been drawn with the operation of a cider press or an old donkey wheel for extracting water from a well.[13] It consisted of a vertical pole or tree branch that was pivoted at the top and bottom (in the ceiling and floor) and had a horizontal pole attached to it at child height containing either a metal or a wooden hinged ring that was sometimes padded with leather or velvet. The small child was put into this ring suspended from a harness, so that he or she could walk only within the radius of a circle with the vertical pole at its centre.

William Cadogan (1711–1797), childcare expert and physician to the Foundling Hospital in London, had a particular interest in children walking. He believed that regular exercise was essential to an infant's health and argued that by the age of three they should be able to walk two miles without tiring themselves.[14] Writing a century later, Elizabeth Halford conceded that infants should not be forced on their feet too early. Above all, she perpetuated the age-old belief that 'walking erect is one of the most distinguishing privileges which man receives from his beneficent Creator, giving him dignity which is enjoyed by no other animal'.[15]

Reins, known as 'leading strings', became popular throughout western Europe from the sixteenth century and were used not only to prevent the child from falling but also to help them to walk and to restrain them.[16] Given the importance attached to the infant's first steps, cutting leading strings off clothing once infants could walk unaided was considered an important physical milestone. For some parents it was a rite of passage symbolising their infant's greater independence. Louis XIII of France had leading strings attached to his garments when he was nine to ten months old that were ritually dispensed with when he reached the age of three. This tradition for the French royal family to use leading strings was continued by Madame de Ventadour, the royal governess who is represented in a painting escorting the infant Louis, Duke d'Anjou into a room by his leading strings, presided over by the infant's great grandfather, Louis XIV (**fig. 80**).

Dispensing with the leading strings was considered a sufficiently significant event to warrant Lady Anne Clifford (1590–1676) writing to her mother to describe the occasion and how Margaret, her daughter, had withstood a few falls immediately afterwards.[17] Nor was the pride expressed at the infant's first steps restricted to the

80 *Madame de Ventadour with Louis XIV and his Heirs*, French school, oil, 1715–20.

mother at this period, as is testified by Nathaniel Bacon (1647–1676), who also felt it a topic worthy of writing to his wife about.[18]

One type of leading string consisted of a band round the waist and two loops on either side that were attached to the front, which the adult held in his or her hands. Another type was a scarf that was looped round the baby's waist to support it while the adult held on to the two loose ends (see fig. 79). Sometimes leading strings were made from ribbons, which were notoriously flimsy.[19] Although Queen Charlotte recommended this style, some childcare experts disapproved of it. In 1785 Charlotte used a more sophisticated version in the form of silver leading strings for her daughter, Princess Mary. Many American parents during the eighteenth century, however, preferred that infants learned to walk by clinging on to furniture.[20]

An aversion to leading strings grew in the nineteenth century because it was believed that they impeded growth and weakened limbs, and so the formal dispensing of leading strings died out.[21] One reason for this may have been that medical opinion had shifted away from promoting standing and walking as soon as possible towards recognising crawling as a natural developmental stage that should be encouraged before infants embarked on their first steps.

Headgear was sometimes employed to protect infants from knocks when learning to walk. This included the reinforced hat (**fig. 81**). A metal hat resembling a crash helmet had been advocated by the surgeon Omnibonus Ferrarius in his sixteenth-century medical textbook on childcare that was first published in northern Italy.[22] In spite of his recommendations, however, it never gained popularity. A more successful piece of head protection was the 'pudding', which was a padded hat made out of cotton and tied under the chin (**fig. 82**). Its name was attributed to its close resemblance to a kitchen pudding mould, and it was easy and cheap to make for toddlers who were learning to walk. Interestingly, it also became a fashionable accessory for much older girls to wear.[23] The pudding began to be used in the sixteenth century

81 *De arte medica infantium* by Omnibonus Ferrarius, etching, 1577.

82 Pudding hat, glazed cotton, English, 1775–1800.

and was particularly popular in the Dutch Republic during the seventeenth, reaching the height of its popularity in western Europe during the eighteenth century. It was controversial, however, when it was first introduced, and many critics believed that it could do more harm than good by not toughening up children sufficiently to prepare them for the outside world. For instance, the philosopher John Locke (1632–1704), author of *Some Thoughts Concerning Education*, was in favour of infants having an exposed head, considering that their hair was sufficient protection. By the nineteenth century American milliners were riding on the crest of the popularity of the pudding hat by selling ready-made versions of it,[24] but it had virtually disappeared from use in western Europe by the early nineteenth century.

Weaning

Weaning took place in medieval Europe between the ages of eighteen months and three years, which meant that many children would have developed teeth well before the process got under way.[25] Medieval physicians recommended different weaning practices for boys and girls. Boys, it was argued, should be weaned three or six months or even one year later than girls on the grounds that they were the 'stronger sex' and were therefore considered to be entitled to a longer period on the breast; this meant that girls who resided with a wet nurse were returned sooner to their family homes than boys.[26]

Numerous techniques were employed to accustom the child to coping without the nurse's or the mother's breast. One medieval physician recommended smearing mustard on the nipples. Another practice that was quite widespread in the sixteenth century was applying wormwood, a bitter-tasting herb, to the breast; this was used by the wet nurse when weaning Juliet in Shakespeare's *Romeo and Juliet*.

Breastfeeding continued into toddlerhood, which meant that weaning also took place late by modern standards. In France during the seventeenth century Louis XIII's doctor claimed that his patient was not weaned until well after the age of two. By the eighteenth century many parents in France were sending their infants to be weaned by specialist *sevreuses*, illustrated by Jean-Baptiste Greuze in his painting of 1765.[27] Likewise, American women during this period went on 'weaning journeys', in which infants were dropped off to wet nurses with the specific intention of being effectively weaned over the period of a fortnight. In America at this time weaning occurred between the ages of one and two. Climate was a consideration in determining when to begin weaning, and in the American South the extreme cold from December to February and the heat between July and September meant that the process was often postponed to avoid these times, and this was the reason it could run into the second year.[28]

Teething

While the first tooth was sometimes a source of celebration, the onset of new teeth was commonly anticipated with apprehension. When the apothecary was dispatched to Henri IV's residence at Fontainebleau to announce the appearance of his son's first tooth, it was considered a joyous occasion.[29] Many centuries later Queen Victoria celebrated the appearance of the first tooth for each of her children by placing them once they had fallen out in a golden casket lined with blue velvet.[30]

From the sixteenth century surgeons proposed fairly drastic measures as remedies for teething; they mistakenly believed it to be partly responsible for the high infant death rate. To mitigate the painful effects of teething, surgeons used techniques that involved leeches, blistering and bleeding. Lancing was also believed to facilitate teething and required the use of a small knife called a gum-lancet to cut the gum down to the tooth.[31] By the eighteenth century the physician William Cadogan represented a minority who believed that teething was entirely natural. Other measures employed to assist teething and soothe gums were simple teething sticks unadorned by a rattle and made from a calf's, colt's or wolf's tooth (**fig. 83**).[32] These rattles and teething sticks were also often made from coral, which was believed to contain magical qualities. This was attributable to a classical legend where it was alleged that coral

83 Amulets to ward off teething pain, including a calf's tooth, woody nightshade necklace and piece of flint, 19th century.

developed from the drops of blood that sprang from Medusa's head.[33] Since coral was considered to ward off the evil eye or *malocchio*, it was often used in amulets. However, while the use of coral teething sticks (see fig. 73) had declined and was discredited by the nineteenth century, chewing on food such as bread or some hard object such as bridle leather or India rubber was deemed perfectly acceptable.[34] In parts of America medical experts attributed the cause of most infant diseases to teething right up to the nineteenth century.[35]

Potty training

During the medieval period infants were encouraged to relieve themselves outside as soon as they were beginning to walk. If by chance they needed to urinate or empty their bowels inside, they were often encouraged to use a shared chamber pot made out of ceramic or wood.[36] In a poor household a handful of hot ashes might be thrown over the baby's excrement on the floor or ground so that it could be swept away.[37] In sixteenth-century Germany Martin Luther proudly dispatched a letter to a friend to herald the good news that his infant son, Hans, had controlled his bowels for the first time, which his father described as his first 'shit'.[38] It is not known how old Hans was when he was potty-trained but it is clear that this infantile demonstration of self-control was a source of considerable paternal pride. In contrast, there was a decidedly relaxed attitude towards the potty training of infants at the French court during the seventeenth century; the dauphin, later to become Louis XIII, was allowed to defecate and urinate in public spaces indiscriminately.[39] Wet nurses in France also tended in general to be fairly relaxed about starting potty training and it was only towards the end of the second year that they began such a programme for their charges.

The beginning of a shift in attitudes to personal cleanliness can be found from the sixteenth century. Dutch painters, rather than recoiling in disgust, celebrated wiping the baby's bottom as one of the many mundane events associated with childcare in rural domestic life and within the Dutch domestic interior (**fig. 84**).[40] Interestingly, John Locke reflected this trend in improved personal cleanliness by recommending an organised regime of toilet training, imploring parents and carers to 'stool' the infant daily after breakfast, a discipline that, if imposed regularly, would soon, in his view, come naturally to the infant.[41]

Once infants were beginning to be potty-trained the Dutch had an ingenious device prevalent during the seventeenth century that mitigated the problems of infants being caught short. This was a potty that formed part of a close-stool or commode, known in the Netherlands as the *kakstoel*, which often had a space at its base to accommodate a hot brick to keep the child's feet warm. The *kakstoel* was

84 A man washing a child's bottom, engraving by Philippe le Bas, circa 17th century.

85 *Unknown Woman and Two Children*, by Gawen Hamilton, oil, English, 1700–50.

86 Pulpit commode chair, oak, English, 1790.

often combined with a *speelstoel* or play chair featured in an English portrait of a mother with her children (**fig. 85**). It could be moved from room to room like the baby walker and often had a tray in the front for holding toys. Its great virtue was that it combined practicality with privacy, since the potty was discreetly hidden from view by an external design that resembled a pulpit (**fig. 86**). This design, reminiscent of a church interior, was perhaps an unconscious reminder to parents and other visitors to the household that cleanliness was next to godliness. It also maintained genteel appearances and ensured that it was not out of place in rooms as diverse as the music room and the bedchamber.[42] The wicker commode chair was particularly popular since it was claimed to bring about early success in potty training, which was very attractive to those who wanted to avoid the labour-intensiveness of changing and washing nappies. Indeed, the popularity of this chair suggested an over-enthusiasm on the part of parents and servants to control their charges' bowels as early as possible. It was even alleged that during the late eighteenth and nineteenth centuries infants as young as one week old were sometimes placed in them, raising the issue of whether it was appropriate or desirable for the infant's health. Nonetheless, the architect John Claudius Loudon maintained that 'for cleanliness and decency' it deserved to be imitated everywhere, which presumably meant that its use should be extended to the nurseries of the upper ranks.

87 *The Comforts of Industry* by George Morland, oil, English, about 1790.

A wicker commode chair features in the foreground of a picture by George Morland, painted in 1790 and a parable of the domestic virtues of hard work, self-control and regular habits (**fig. 87**). Morland depicts a neatly dressed family of modest means in a humble, rural domestic interior. The mother's apron and the infant's long robe are pristine white, reflecting their successful efforts to maintain respectability and cleanliness in spite of their lowly means. The absence of a safety bar across the front of the wickerwork chair implies that the infant requires no physical restraint because he or she is successfully potty trained and socialised into 'regular habits'.

The cult of breastfeeding

Of all the sights that this world affords, the most
delightful in my eyes, even to an unconcerned
spectator is a mother with her clean and fat baby
lugging at her breast.

Advice to Young Men by William Cobbett, 1829, p.217

The iconography of the breast

Breastfeeding has a fascinating iconography, particularly because its medieval history is bound up with images of the Virgin Mary.[1] Catholic belief in the virginal conception of Christ emphasised her purity and meant that unlike ordinary women she did not partake in sexual intercourse or undergo labour in childbirth. One exception to these bodily activities associated with childbirth that she did undertake was breastfeeding. The image of the Virgin breastfeeding was promoted by the Church as a metaphor for life, and great efforts were made to emphasise the essential relationship of the breast to human survival.[2] The Church commissioned artists and craftsmen to create sculptures and pictures testifying to the lactating Virgin Mary. Moreover, there were many claims of the miraculous appearance of the Virgin's milk in a number of churches. Indeed, Laon Cathedral claimed to have preserved milk from the Virgin in a reliquary that was believed to have curative powers.[3]

In addition to religious representations and memorials that depict women breastfeeding there were also allegorical representations of its necessity for survival. This is poignantly conveyed in a sixteenth-century German medallion representing the *Allegory of Vanitas* by Lorenz Rosenbaum. It links breastfeeding, the fragility of a baby's existence and the transience of life by depicting a mother breastfeeding her infant with an hourglass in the background and a skull and crossbones on the right (**fig. 88**). The emphasis on the essential, life-giving function of breastfeeding is also shown in the widespread representation of the heavenly virtue of Charity as a woman either dispensing alms to the poor or breastfeeding them or doing both.[4]

The portrait of Gabrielle d'Estrées, mistress of Henri IV, was painted in 1598–99. The rose she holds and the pearls around her neck suggest a figure resembling Venus. This impression is enhanced by the way in which she stands in the foreground

88 *Vanitas* by Lorenz Rosenbaum, German, lead medallion, 1535–40.

with only a transparent veil wrapped around her naked body. She stands in what was probably a milk bath with a clothed wet nurse standing modestly behind her (**fig. 89**).[5] The wet nurse dispatches the essential task of nourishing Gabrielle's child, by exposing one of her breasts, traditionally a symbol of maternity throughout Western

89 *Gabrielle d'Estrées au Bain*, oil, French school, 1598–99.

art.[6] Gabrielle d'Estrées bore Henri IV many children, but what is significant in this painting is that it is the wet nurse's breast and not the mother's that provides the essential life-giving milk to the infant, Alexandre de Bourbon, born in 1598. Her older son, César, the future Duc de Vendôme, is depicted in the background grabbing some grapes, a symbol of fecundity and a reminder that Gabrielle had borne fruit in the form of her offspring. Sadly, she died later in 1599, giving birth to a stillborn child, but it is not known if this portrait was painted before or after her death.

Interestingly, from the seventeenth century in Britain there was a proliferation of church monuments depicting mothers' breastfeeding their infants. This is somewhat of a paradox, since all the women died in childbirth or shortly afterwards, yet they are depicted as embodying life through the nursing of their infant, as in the monument to Lady Elizabeth Mydlleton, wife of Sir Thomas Mydlleton (**fig. 90**). While her baby son rests on her right arm she tenderly directs her nipple towards his mouth. Elizabeth died aged twenty-two, several days after her only child, Thomas, was born. Her half-closed eyes, recumbent pose and the drapery wound round her body have parallels with contemporary sculptures of Venus. Her unfastened dress and disarrayed gown suggest not just feeding but also the traditional mourning practice of rending clothing associated with ancient funeral rites.[7]

Memorials depicting a mother breastfeeding endured into the nineteenth century, as in the powerful memorial of 1821 by the sculptor Francis Chantrey dedicated to Anna Maria Rooke Greaves, who died in childbirth: 'at the age of 27 years leaving

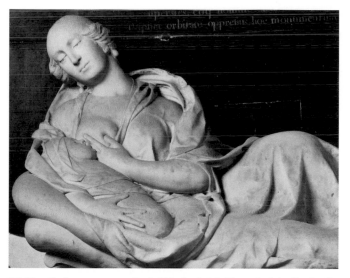

90 Detail of monument to Lady Elizabeth Mydlleton by John Bushnell, St Mary's church, Chirk, Wrexham, *c.*1676.

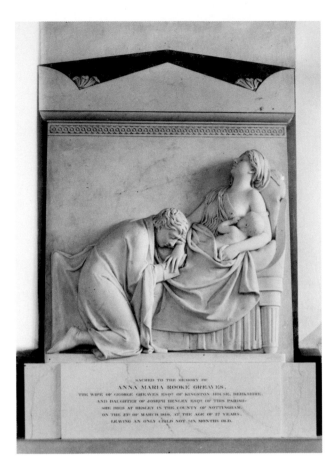

91 Memorial to Anna Maria Rooke Greaves by Francis Chantrey, St Mary's church, Waterperry, Oxfordshire, 1821.

an only child not six months' (**fig. 91**).[8] The top of her dress is undone, partially revealing her left breast, while her infant snuggles up to her and her husband kneels grief-stricken by her side. The juxtaposition of the figure of the mourning husband next to the wife imparting life to their son is very moving and maintains the conceit that the mother is still alive. It shifts the viewer's thoughts away from the mother, whose life has been cut short, and underlines the injustice of a life being torn away from the son and husband.

Women's godly duty

By the seventeenth century Puritan ministers in England were vociferous in their insistence that it was a woman's godly duty to nurse her own children and that it was the role of a true and 'natural' mother. Across the Channel, the eminent French physician Ambroise Paré (1510–1590), whose works were translated into English, endorsed the Catholic Church's position on breastfeeding by arguing that mothers who did not nurse their infants could not rightfully call themselves mothers. The Dutch were also at this time keen to emphasise the benefits of maternal breastfeeding

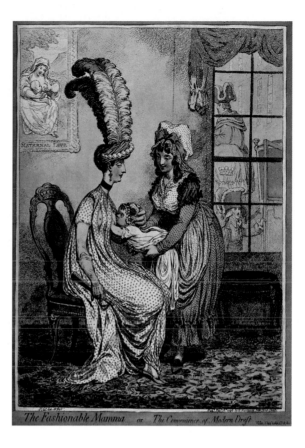

92 *The Fashionable Mamma; or, The Convenience of Modern Dress*, stipple hand engraving by James Gillray, 1796.

and there is plentiful evidence that they practised what they preached, since the Dutch Republic was unusual amongst European countries in having very few wet nurses.

The new fashion for breastfeeding by some upper-class mothers in Britain in the eighteenth century was satirised in political cartoons and celebrated in the decorative and fine arts (**fig. 92**).[9] An eighteenth-century porcelain group of a mother breast-feeding her infant while one toddler sleeps in a chair behind her and another eats from a bowl is quite typical of the period (**fig. 93**).

These representations of mothers and wet nurses breastfeeding their charges were often affectionate and idealised. Around 1770 Johan Zoffany, court painter to George III and Queen Charlotte, painted *Beggars on the Road to Stanmore*,[10] which depicts the mother in the group breastfeeding her rather large infant in a pose reminiscent of *Charity*. Zoffany was very conscious of fashion amongst his rich clients and members of the court, so he would have known that the composition of a breast-feeding mother with a child and an old man, commissioned by a rich banking family, the Drummonds, would probably attract a sympathetic audience when it was exhibited at the Royal Academy in 1771.

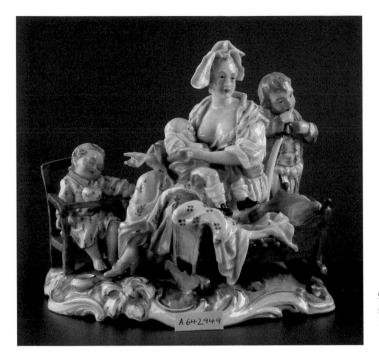

93 A breastfeeding mother, porcelain, 18th century.

Erotic depictions of mothers

In the painting of Gabrielle d'Estrées her naked breasts are presented to the onlooker as objects of sexual desire, underlining her status as mistress to Henri IV (see fig. 85). What is significant in this painting, however, is the separation of sexual desire from maternity, which by the eighteenth century had been so eroded that depictions of the mother increasingly embodied both erotic and maternal features.

Maternal breastfeeding with erotic overtones in eighteenth-century France is eloquently reflected in Greuze's painting of *La mère bien aimée* (**fig. 94**), which was exhibited at the Paris Salon (1769) and praised by the philosopher Diderot as embodying the values of domestic harmony.[11] The painting was commissioned by Jean-Joseph, Marquis de Laborde, a very rich court banker, who according to Diderot never appeared without 100,000 francs worth of diamonds and jewels on his person.[12] Hence, Greuze used considerable artistic licence to transpose Laborde's circumstances to a more modest, rural domestic setting, depicting bare floorboards and undecorated walls. Laborde's newly rebuilt country château at La Ferté-Vidame must have been far removed from the plain decor depicted in the painting.[13] The father is based on Laborde himself, who returns from a hunt with his dogs and gun to greet his wife. He finds her distracted, the room in disarray with a small child's corset and discarded dress lying on the floor. Madame Laborde, who is depicted

94 *La mère bien aimée*, engraved by Jean Massard after Jean-Baptiste Greuze, 1755.

resembling *Charity*, is overwhelmed by their children's affectionate physical overtures towards her. Significantly, the offspring ignore their grandmother, Madame de Nettine in the middle of the painting, whose hand rests on the layette basket, highlighting her previous role as mother. Interestingly, since the person who breastfeeds the children is their mother rather than a wet nurse, the tradition of featuring the wet nurse is dropped in favour of depicting the grandmother.

The mother's low-slung dress and exposed breast suggests an invitation to the children to suckle and implies their fondness for the maternal breast. Yet, there is also something erotic about the mother, as Diderot observed with reference to this particular painting: 'that half-open mouth, these swimming eyes, that relaxed position, that swollen throat, that voluptuous mixture of pain and pleasure, obliges all decent women in the place to lower their eyes and blush with shame'.[14] Ironically, the artist's model for Madame Laborde in this painting was his wife, Madame Greuze, who was allegedly extremely attractive and acquired notoriety for seducing her husband's sitters. Moreover, the painting was produced by the artist at a time when his

marriage was collapsing, adding an extra level of irony to the composition, which was known in Britain as *Nuptial Felicity*.[15]

Representations of wet nurses

The abundance of representations of wet nurses can be at least partly explained by the fact that during the medieval period noblewomen rarely suckled their infants, preferring to keep wet nurses in the home. Blanche of Castile (1188–1252), mother of Louis IX of France, was unusual in breastfeeding her son. One possibly apocryphal story relates to an incident when she discovers that a strange wet nurse has breastfed Louis. Appalled, Blanche forces her finger down the throat of her infant son, compelling him to regurgitate the milk.[16] Apart from a few isolated examples of noblewomen breastfeeding their infants, the tradition of wet nursing continued into the eighteenth century, and the wet nurse became an increasingly popular theme for artists throughout Europe.

The sixteenth-century French potter Bernard Palissy represented a child feeding from the breast of a wet nurse, and there were many imitators continuing into the eighteenth century (**fig. 95**). Increasingly, the wet nurse was depicted with both her charge and the infant's mother.[17] In these paintings the child is represented physically gravitating to the mother as though to allay any feelings she may have entertained that the baby was ambivalent towards her and preferred the wet nurse. In *The First*

95 *The Nurse and Child* by Joseph Willems, Chelsea porcelain factory, 1749–52.

96 *The First Steps* by Jean-Honoré Fragonard and Marguerite Gérard, oil, French, *c.*1786.

Steps by Fragonard and Marguerite Gérard, painted around 1780–85, the aristocratic French mother is paying a visit to the home of the wet nurse, who is caring for her toddler in the countryside (**fig. 96**). The wet nurse looks on in the background while the mother, dressed in an elegant yellow silk dress, stretches out her welcoming arms to her half-naked infant, who toddles unaided towards her. Far from treating the mother as a stranger, the painters depict the infant as unhesitatingly drawn to its mother, implying that the maternal bond transcends the foster care of the wet nurse.

There was also a genre of paintings and engravings that implicitly conveyed the tension between biological mothers and wet nurses. *Les adieux de la nourrice*, engraved by Robert De Launay in 1776–77, emphasises the strong bond that has been built up between wet nurse and infant, revealing the reluctance of the infant to return home to its mother (**fig. 97**). George Morland picked up this theme in Britain, depicting a visit to the wet nurse by the mother of the child, a grand lady in a large feathered hat. The cottage is dark and humble, and the small child clings on to the nurse as the mother crosses the threshold stretching out her hand to touch

97 *Les adieux de la nourrice*, engraving by Robert De Launay after Etienne Aubry, French, *c*.1776–77.

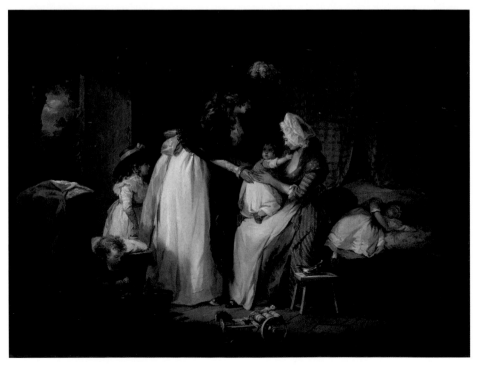

98 *Visit to the Child at Nurse* by George Morland, oil, English, *c*.1788.

her child, who recoils from her overture (**fig. 98**). While this painting was more a visual moral parable than a reflection of social reality, there is no doubt that a new set of relationships was developing between parents and their offspring. Infants were having to navigate emotionally around the issue of effectively having two sets of parents, who often lived a considerable distance from one another.

Opposition to wet nursing

In many western European countries the Catholic Church forbade couples from having sexual relations while the woman was breastfeeding, a period that could last from eighteen months to two years, until the child was weaned. It was thought that failure to comply might corrupt the milk. For this reason some authors have suggested that husbands exerted social pressure on their wives to refrain from breastfeeding.[18] It might also explain why some wet nurses were kept isolated to prevent them from resuming sexual relations while the child was being breastfed. Furthermore, in Renaissance Venice wet nurses were prosecuted for endangering the health of their nurslings by having sex.[19]

Certainly, there is little evidence to suggest that breastfeeding was a widespread practice amongst Puritans in England. Elizabeth, Countess of Lincoln (c.1574– c.1630) wrote a popular pamphlet in which she extolled the virtues of breastfeeding, in spite of not practising it herself on her eighteen children. Nevertheless, her use of wet nurses did not prevent her from launching a diatribe against them, revealing that, in her view, only two out of all the wet nurses who had served her progeny were adequate.[20]

Many men also argued against wet nursing and in favour of maternal breastfeeding during the eighteenth century.[21] While Rousseau is probably the most enduringly famous of these exponents of breastfeeding, and was very fashionable in his day, he was only one of many writers who addressed this topic. Across the Atlantic, Benjamin Franklin and William Buchan, whose work *Domestic Medicine* ran into twenty editions, argued that mothers should nurse their own children. In Britain, William Cadogan, physician to the London Foundling Hospital, promoted maternal breastfeeding, as did William Cobbett (1763–1835), the working-class radical.[22] In his *Advice to Young Men* Cobbett was passionately opposed to wet nursing or what he called 'the hireling breast', and claimed that it was every infant's birth right to be breastfed whenever possible by his or her mother. He reinforced the Christian belief that endurance of suffering in the interests of children was integral to motherhood, invoking the martyr-like example of his wife: 'No mother ever suffered more than my wife did from suckling her children. How many times have I seen her when the child was beginning to draw, bite her lips, while the tears ran down her cheeks.'[23]

In spite of the maternal fashion for breastfeeding in Britain amongst a section of the social elite, wet nursing continued and no single custom prevailed.[24] In 1786 the women's rights campaigner Mary Wollstonecraft entered the fray, condemning wet nursing and promoting breastfeeding because she believed that it was in the best interests of both mother and child.[25] Eight years later she was living in France during the Terror, under the Republic. The new regime promoted breastfeeding as a national policy and in 1793 issued a decree that allowed destitute women state support only if they suckled their infants. Mary gave birth to her first child, a daughter by her lover, Imlay, while she was still living in France in 1796, and only narrowly escaped being arrested. The prevailing Republican ethos, combined with her own strong views on the subject of mother's nursing their infants, no doubt contributed to her decision to breastfeed her first daughter. Interestingly, though she shared Rousseau's conviction of the importance of breastfeeding, she disliked his attitude towards women, which she believed demeaned them – as she outlined in a diatribe against him in her *Vindication of the Rights of Women*.[26]

Fig. 99 shows a popular engraving that was produced around the same time as the decree of 1793.[27] The subject relates to an initiative by Beaumarchais, the French revolutionary and polymath, who donated the proceeds of his play *The Marriage of*

L'ALAITEMENT MATERNEL ENCOURAGÉ.

Un Philosophe Sensible indique à la bienfaisance les objets sur les quels elle doit verser ses dons ,
la Comédie sous la figure de Figaro, tient des gros Sacs . Elle en répand un aux pieds de plusieurs mères qui donnent le sein
à leurs enfans . Au dessus du Philosophe est la Statue de l'Humanité, portant ces mots : Secours pour les Mères nourrices.

99 *L'alaitement maternel encouragé*, engraving by E. Voysard after A. Borel, *c.*1793.

Figaro to the cause of promoting maternal breastfeeding.[28] Since the conditions of wet nursing in France were a public scandal, it was thought that his gift would contribute to the new Institute of Maternal Welfare in Paris, which provided subsidies to assist those impoverished women who were forced either to send their infants out to wet nurses or to become wet nurses themselves.

In the engraving an Enlightenment philosopher in a toga stands next to the figure of Charity, who also wears classical robes and has one breast exposed. The philosopher points to the breastfeeding mothers before them who will shortly receive her donation – the gold coins being emptied from a horn of plenty to the right. Meanwhile Figaro (born a foundling), wearing a large brimmed hat with flowers, helps to distribute Charity's largesse from a sack. At the top right the figure representing Humanity holds up a stone tablet inscribed 'Succour for nursing mothers'. At the far left a Bastille-like fortification looms, with a sign on its entrance entitled 'Debtors for wet nursing fees'. The portcullis is open and masses of people, presumably debtors, pour out, seemingly liberated. This idealised scene suggests the generosity of the French state personified by the figure of Charity as a foster mother exposing one breast to reveal her status as matron and nurturer.[29]

Although the Revolution was a dramatic break with the past, it is interesting that popular prints still invoked classical and Catholic images of motherhood.[30] The playwright Beaumarchais' philanthropic donation to breastfeeding mothers is symbolised by the appearance of his fictional character Figaro showing benevolence. While the techniques to encourage the breastfeeding women might be questioned, what is significant is that the experiment did apparently contribute to a decline in infant mortality.[31]

In 1871, 80 per cent of wet nurses in London were recruited from Queen Charlotte's Lying-in Hospital, which allowed (first-time) mothers of illegitimate infants through their doors. This factor aroused considerable concern amongst childcare experts, many of whom were physicians, about the moral character of wet nurses. They expressed their anxiety in terms of the moral contamination of the sanctity of the home and the potential threat to marriages by the potential temptation of the wet nurse to husbands. Opinion, as ever, was divided. Some moral crusaders such as William Acton believed that prostitutes could be redeemed and rescued through wet nursing, to the horror of Mrs Mary Anne Baines, a vigilante from the Ladies' National Association for the Diffusion of Sanitary Knowledge, who campaigned against wet nursing in general and the recruitment of wet nurses from the 'fallen' in particular. She was also a governor of the British Lying-in institution, where she was instrumental in insisting that all applications from wet nurses should require a doctor's certificate to prove that they were not sacrificing feeding their own child in order to breastfeed others.[32]

By the nineteenth century considerable emphasis was being placed on wet nurses assuming simplicity in dress and demeanour. Reflecting this tendency, one childcare expert objected to women being recruited to wet nursing if they had a profusion of curls and wore well-fitted, fashionable outfits.[33] The concern underlying these puritanical proscriptions was to avoid a wet nurse who might be 'loose in morals', with a history of either having an illegitimate child or a previous stint at prostitution.

Family pressure to employ a wet nurse

Amongst both rich and poor, the decision whether to employ a wet nurse was generally taken by the family, and would not have been based on the mother's wishes alone. Fathers, fathers-in-law and grandfathers appear to have been the most vociferous opponents of maternal breastfeeding in the medieval period and featured as major players in their families' decisions. Their preference for wet nursing may be attributable to the fact that maternal breastfeeding could reduce fertility, and so would be seen as a factor potentially thwarting the prospect of a male heir.

100 *Emile*, illustration of front cover engraved by E.J.N. de Ghendt after C. P. Marillier, Paris, 1793.

Elizabeth, Countess of Lincoln implied in a veiled fashion that her family had lent on her to refrain from breastfeeding: 'Partly I was overruled by others in authority.'[34] In spite of this opposition by many men, there are examples of women risking censure and going against their family's wishes. Georgiana, Duchess of Devonshire defied the wishes of her in-laws, the Cavendish family, who put considerable pressure on her to employ a wet nurse so that she could produce a male heir more quickly.[35] If she influenced the maternal breastfeeding movement amongst the upper classes in Britain, it was by daring to defy her powerful family. In America, fathers of mothers who had just given birth also often championed wet nurses in their anxiety for heirs. In 1759 the daughter of Dr Richard Hill defied her father and aroused his strong disapproval when she rejected his advice to employ a wet nurse, insisting that she should breastfeed her infant herself.[36] Queen Caroline, wife of George II (reg. 1727–60), was also reputed to have breastfed all her children, an interesting departure for royalty that was not maintained by subsequent English queens. While her daughter-in-law Charlotte, who married George III, owned a copy of *Emile*, Rousseau's famous book which promoted breastfeeding (**fig. 100**),[37] Charlotte did not breastfeed 'à la Jean Jacques', preferring to employ the services of a Mrs Muttlebury to breastfeed her fifteen children. While we do not know if Queen Charlotte actually read *Emile*, we know that she was a conscientious mother, as is reflected in this contemporary popular rhyme:

> With all my heart – the Queen they say
> Attends the nursery every day
> And, like a common mother, shares
> In all her infant's little cares[38]

While Queen Charlotte was undoubtedly devoted to her infants, she did not see breastfeeding as part of her domain, unlike her friend Marie-Antoinette, who is believed to have declared: 'I want to live like a mother, nurse my child and devote myself to their upbringing.'[39] The French queen was partially successful in her determination to breastfeed her own infants and was able to do so for her first-born, a daughter, but she experienced considerable disapproval from her mother, Maria Theresa, Empress of Austria, who maintained that it was up to her son-in-law, the king, and the doctor to decide who breastfed the royal infants.[40]

Marie-Antoinette appeared to revere the teachings of Rousseau. Indeed, her devotion extended to visiting Rousseau's home in Ermenonville, and making a pilgrimage to his grave located on an island in the middle of a lake. Here, there was a bench specifically designed for mothers to nurse their infants.[41] By the time her second child, the dauphin Louis Joseph, was born in 1781, however, the queen had yielded to the pressure imposed on her by her family and employed a wet nurse

101 'Bol Sein' or breast and nipple cup in hard-paste porcelain designed by Fumez, 1788.

nicknamed 'Madame Poitrine' to breastfeed the new heir to the throne. Undoubtedly, Marie-Antoinette's disappointment at not feeding her son herself was compounded by the publication of a print provocatively entitled *Maternal Love*.[42] Here the royal wet nurse is depicted breastfeeding the dauphin in a *decolleté* dress, exposing both her pert breasts coquettishly to the viewer.

Intriguingly, Marie-Antoinette's husband, Louis XVI, allegedly immortalised his wife's breasts, which are documented as being of ample proportions, by commissioning Sèvres in 1788 to manufacture four round porcelain cups in the Etruscan style (**fig. 101**).[43] These, it is claimed, were moulded to her 40-inch breast specifications replete with nipples at the base.

Breastfeeding methods and accessories

Apart from bottles, there were a number of methods used to assist and supplement breastfeeding if it was difficult to maintain a continual supply of milk. Nipple shields were introduced to counteract soreness, and during the eighteenth century they became the rage for ladies of the upper ranks, combining fashion accessory with nipple protection so that they were not forced to give up nursing their infants.[44]

Where breasts were engorged a 'sucking glass' was employed to relieve them and provide milk to the infant when the mother was absent (**fig. 102**). The sucking glass appeared as early as the sixteenth century and continued to be used during the eighteenth. It involved the mother sucking on one end of a glass tube to extract the milk from the breast. By the nineteenth century the technology involved a hand pump (**fig. 103**), which according to the advice writer Elizabeth Halford was thought 'preferable to that of having the breast drawn by the mouth of an adult'.[45] This happened in nineteenth-century France, where there was a celebrated 'suckler', a terrifying red-bearded peasant who wandered from village to village attending births and

Die alten haben den newgebornen kindlein vor aller anderer speiß reyn geleutert vnnd verscheumpt Honig eingeben/ aber kein butter/wie etlicha pflegen/dann solichs dem magen schädlich vnd zu wider ist/ Nach solchem honig sol man jm ein wenig honig waffer eingieffen. Dann sol die mütter erstlich die grob milch wol auß den brüsten saugen laffen/ oder mit solchem Instrument selber saugen/wie es hie verseychnet stehet.

Die brüst sol sie mit warmem waffer wol beben/daß solche milch deffer flüffiger werd/vñ were beffer daß dz kind vor dem dritte tag von der mütter nit

102 Sucking-glass in *Frawen Rosengarten*, woodcut, Frankfurt, 16th century.

103 Breast pump, glass and metal, European, 1771–1830.

offering his services, which consisted of sucking on the afflicted breast to relieve engorgement.[46]

Conditions of employment for wet nurses

Throughout the medieval period in Italy, the father of the family drew up the terms and conditions of employment for the wet nurse. Either the wet nurses were waged or they were slaves installed in their employers' homes. Most infants in Italy were cared for by wet nurses who lived in their own homes in the country, where their charges resided too. The babies lived with them for an average of ten months before being returned to their biological parents.

There was stiff competition for the post of royal wet nurse and there was a panel of doctors to select prospective candidates. Louis XIII brought together a commission of seven doctors to examine wet-nurse candidates for his son, the future Louis XIV.[47] Although the selection process was in the main very rigorous for royal wet nurses, there were exceptions. The wet nurse to James I, for example, was frequently drunk, which meant that the supply of milk he received was low in nutrients, and it is alleged that this contributed to rickets, which delayed his walking until the age of five.[48]

There were also inherent problems with the conditions of employment. Wet nurses were prone to continual scrutiny and could be expected to provide round-the-clock suckling, which was exhausting. Moreover, once appointed a wet nurse could be summarily dismissed and swiftly replaced by another if her milk ran dry or she was found wanting in some other respect. Henri IV had eight wet nurses, and Louis XIV drained his first wet nurse, Elisabeth Ansel, dry, as well as the second and the

third, and went through a total of nine wet nurses by the time he was weaned. The wet nurse to Queen Anne's son, the Duke of Gloucester, was dispensed with at short notice for allegedly having nipples too large, and her replacement was dropped after six weeks when her charge had a fit of convulsions. Moreover, if a baby under their charge died wet nurses were the first to be blamed. Alice Thornton was a member of the minor Irish landed gentry and in 1668 wrote her autobiography in which she described the death of her third child at sixteen months and attributed it to the two wet nurses responsible for feeding the baby.[49] There were unrealistic demands too. Sometimes wet nurses were expected to compensate for the innate physical disabilities of infants. It was hoped that the well-endowed Westphalian wet nurse Caroline Hagedon would reinvigorate the infant Wilhelm (later Kaiser Wilhelm II), who suffered from a crippled arm and extreme thinness. Needless to say, she made no inroads in this respect.

The wet nurse enjoyed a high status, similar to that of the midwife, in royal and aristocratic households, often receiving extravagant gifts from parents as a token of

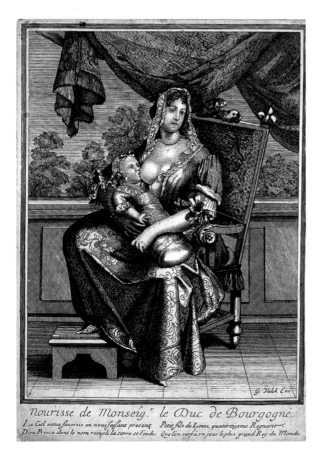

104 Wet nurse to the infant duke of Burgundy, engraving published by G. Valck, 17th century.

their gratitude.[50] Edward VI's wet nurse was granted land in acknowledgement of her services, while Mrs Muttlebury, wet nurse to George III's children, was granted the large pension of £100 per annum after she had ceased her services.[51] There were other privileges as well, such as enjoying better accommodation within the household than other servants.

Wet nurses were expected to conform to a strict dress code, reflecting the wishes of the mother in particular. The wet nurse to the infant duke of Burgundy, grandson of Louis XIV, is depicted in a court portrait sitting in an elegant chair holding him in her arms with one breast exposed. She is portrayed as a handsome, dark woman with a necklace round her neck, a lace mantilla framing her face, smartly dressed in patterned silk and lace with ruched sleeves embellished by bows at the elbows (**fig. 104**). In Britain, Queen Charlotte insisted that her wet nurse wear similar clothing to herself, embellished with brocade with lace ruffles. This smart uniform is suggestive of their high status within the household in which they served.

It is intriguing to speculate how women breastfed, given the elaborate nature of their clothing. During the nineteenth century in America and Europe bodices of dresses were made with loose panels consisting of flaps that could be unfastened at the waist and raised for nursing. Kerchiefs were also used to cover bare breasts while breastfeeding.

Decline and regulation of wet nursing

By the 1840s many French doctors believed that maternal breastfeeding was preferable to other forms of feeding, even though it required medical management, given that it did not always come naturally or easily to mothers. Dr Donné, however, a famous French pioneer of infant feeding and researcher in the microscopic analysis of human milk, conceded reluctantly, given the prevalence of wet nursing, that a hired nurse might be a 'necessary evil'.[52] In the 1840s it was estimated that 50 per cent of Parisian babies were wet-nursed.[53] This was considerably less than the previous century, when 95 per cent of the infant population were fed either by wet nurses or raised by hand or other artificial means of feeding.[54]

During the nineteenth century wet nursing had become much more organised in France and Belgium, with a system of registration and inspection of wet nurses employed by foundling hospitals. Although inspections were carried out, wet nurses at the Hôpital des Enfants Trouvés in Paris were severely overworked, with as few as seven to eight wet nurses having to feed as many as two hundred infants.[55] There was also a Bureau de Placement in Paris, an agency that served wet nurses and parents (**fig. 105**). The babies were then conveyed by cart to the home of the wet nurse in the countryside by middlemen known as *meneurs*.[56] In spite of greater

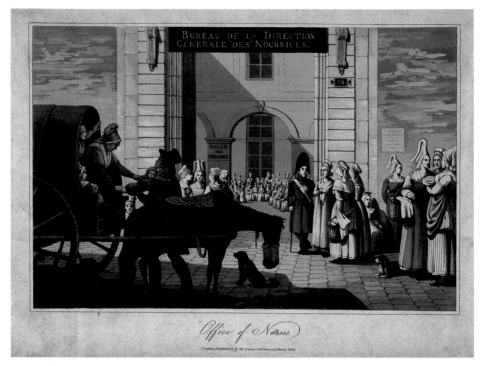

BUREAU DE LA DIRECTION
GENERALE DES NOURRICES.

Office of Nurses.

105 *Office of Nurses*, published by W. Sams, aquatint, 1822.

regulation of wet nursing in France by the late nineteenth century, wet nurses were treated with contempt by society and it remained an occupation of last resort that was extremely low paid.[57]

Wet nursing was more popular in other European countries than in Britain, where it was rapidly on the decline by the 1860s. This meant that alternatives to wet nursing such as feeding by hand had, by the nineteenth century, become much more popular there than on the Continent. The increasing safety of bottle feeding and the British medical profession's disapproval of wet nursing contributed to the latter's decline. Above all, mothers could now use a bottle themselves or delegate this function to a nurse or relative without jeopardising the life of the infant. Queen Victoria's refusal to breastfeed and her expressed repulsion at the notion meant that some childcare experts now felt more confident in arguing that it was both cruel and unnecessary for a mother to nurse the baby herself, and it would also ruin her appearance.[58] (**fig. 106**) This cartoon satirises Queen Victoria's decision to delegate breast feeding to a wet nurse. Certainly, the domestic writer Mrs Beeton (1835–1865) did not make breastfeeding very attractive to her large female middle-class readership when she pointed out that mothers would necessarily have to undergo a certain amount of pain and discomfort when breastfeeding, which she characterised,

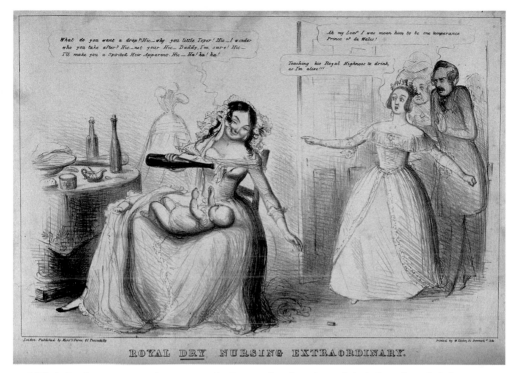

106 A drunken wet nurse about to give the Prince of Wales a drop of alcohol as a horrified Queen Victoria and Prince Albert burst in. Lithograph, printed by W. Kohler, 19th century.

like the Protestant and Catholic churches before her, as a period of privation and penance.[59]

Artificial means of feeding

Artificial methods of feeding using a variety of vessels such as pap boats, spoons and bottles containing cows' or sheep milk were resorted to throughout western Europe when the mother could not breastfeed her infant or where a wet nurse could not be secured for a foundling. From the thirteenth century 'hand rearing' consisted of using polished cows' or rams' horns for feeding (**fig. 107**). A small hole was pierced at the tip and a later refinement consisted of attaching a stitched teat of linen or leather stuffed with cotton to the hole. The use of the horn persisted right up to the eighteenth century and was immortalised in the following nursery rhyme:

> Little boy, little boy, where wast thy born?
> Far away in Lancashire under a thorn
> Where they sup sour milk in a ram's horn.[60]

107 Cow's horn for infant feeding, 18th century.

After the use of the drinking horn had declined, the feeding bottle developed, made out of pewter or glass in an upright form with a bulbous body and a narrow neck, often with a screw top.

By 1777 Dr Hugh Smith had invented the 'bubby pot', initially for his family, but then it caught on. He drew parallels between it and the coffee pot to which it bore a close resemblance, although it had a metal or silver attachment to the spout to help pour milk into the infant's mouth.[61] Moreover, because these pots were also made out of Queen's Ware, which was cheap to produce, they became accessible to the poor. The bubby pot was also made from crude tin and was known in America as the 'little breast' or 'little mother'; it had been introduced by German settlers in Pennsylvania during the eighteenth century and continued to be used there as late as 1868. By the end of the eighteenth century 'hand' feeding was developed further with the introduction of an earthenware gondola-shaped feeding bottle with a hole in the middle to regulate the flow of milk. It was also made in porcelain by companies such as Spode, as well as being produced in glass, and could easily fit into the hand.[62]

The invention of the rubber teat in America in 1845 coincided with the first patented feeding bottles. This was a significant landmark in the history of bottle feeding, since it made the process potentially more hygienic. Earlier, teats had been made either from silver, pewter, leather, ivory or wood or from a pickled cow's teat. Feeding bottles made of long rubber tubes, however, were not foolproof. Introduced in 1864, this type was nicknamed the 'killer' bottle since the long tubes were notoriously difficult to clean, which meant that they were a haven for lethal bacteria; indeed, it acquired a reputation for providing a bacterial paradise. Yet, in spite of the their notoriety the American Sears Roebuck catalogue was still promoting 'killer bottles' in 1897, and they was still being advertised in Britain as late as 1914.

In time, the patented feeding bottle developed a more practical shape that could be cleaned more easily, and this provided a more reliable alternative to previous forms of artificial feeding. Before sterilisation, many infant deaths occurred as a result of digestive disorders, particularly in the summer months when heat fostered bacteria. By the 1880s, however, at least in Britain, the importance of sterilising the bottle was accepted. This meant that the wet nurse could be dispensed with and replaced by an ordinary nurse or nanny, baby farmer or mother, who could feed their charges by hand with a sterilised bottle in the confidence that it was reasonably safe.

Pap, a substance containing flour, water and sugar, sometimes acted as a substitute for maternal or wet-nurse milk. This often provided starch too early and deprived infants of proteins and vitamins, as well as natural immunities. In spite of these concerns, however, the French male midwives Ambroise Paré (1510–1590) and François Mauriceau (1637–1709) recommended starting pap in the second week of birth and the third month respectively. This was poured or spooned down the baby's mouth from pap boats shaped like sauce boats – little jugs made from silver, pewter, wood, glass, bone, earthenware or porcelain. Sometimes the pap boat took the form of a bird with a beak as a spout (**fig. 108**). These continued in use up to the second half of the nineteenth century, and were also used to supplement breastfeeding as well as for weaning.

Dummies, pacifiers or 'soothers' are as old as breastfeeding. An early rustic version consisted of a piece of pork on a string attached to the infant's toe. Sucking bags were used either to supplement or provide a substitute for breast milk. These sucking bags were common in Germany and France, where they were known as *sucettes*, and enabled nurses to quieten their charges. Essentially, they were rags soaked in wine,

108 Feeding bottle in the shape of a bird, glass, 18th century.

milk or water from which infants sucked. By the beginning of the twentieth century in France anti-dummy lobbyists succeeded in getting the government to prohibit the sale of the *sucette*.[63]

In Britain the use of the sucking bag grew with the rise of the baby farmer and usually consisted of pap. A modified version was known as the 'sugar tit', consisting of a piece of rag with sugar in it, laced with rum. The more modern version of the dummy was a by-product of the invention of the rubber teat. By the early twentieth century it was described as 'an invention of perverted American ingenuity', and the use of dummies in many parts of Britain had declined by then. Health visitors such as Helen Cooper Hodgson were concerned with upholding standards of hygiene and considered dummies a nuisance, declaring: 'There's enough dirt in most babies' dummies to give an army diarrhoea. Mothers think a dummy only cost a penny. But it costs many a baby's life.'[64]

When a breastfeeding mother's supply of milk was becoming low it was not unknown in western Europe for it to be supplemented with animal's milk such as that from an ass or mare.[65] In the classical world animal milk was considered to confer super-human qualities on mortals, and this reverence for this type of milk persisted.[66] In the eighteenth century Lascazes de Compayne argued that breast-feeding by aristocratic mothers could be as harmful as being fed by wet nurses, and proposed animal milk as the only responsible option.[67] Meanwhile, the French

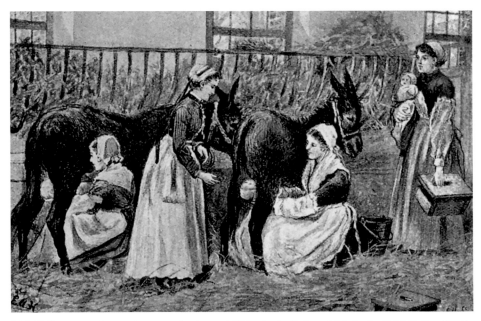

109 *L'allaitemenet des nourissons par les ânesses à l'Hospice des Enfants Malades*, by S. H. Sadler, 1895.

physician Alphonse Le Roy (1822–1896) from Aix pioneered a new method of artificial feeding and experimented with feeding foundlings directly from the udders of goats and asses (**fig. 109**).[68] The writer Victor Hugo (1802–1885) followed this fashion by nourishing his first-born from a goat that he kept in his garden, but sadly the infant died of diarrhoea three months later.[69] In Italy as late as the turn of the century an Italian aristocratic family housed a donkey to feed their infants on the grounds that it was safer and more nutritious than other types of milk. By the 1860s the growth in branded baby foods combined with improved standards of safety, hygiene and design of the feeding bottle meant that this method of feeding was becoming a more attractive alternative to breast feeding.

CHAPTER 7

Accidents, abuse, fatalities and abandonment

The expense is not great: laudanum and treacle
administered in the shape of some popular elixir
[which] affords these innocents a brief taste of the
sweets of existence keeping them quiet, preparing
them for the silence of the impending grave.
Infanticide is practiced as extensively and as legally
in England as it is on the banks of the Ganges.

From *Sybil* by Benjamin Disraeli, 1845, p.234 [**fig. 110**]

Infants in the artisanal home

Throughout Europe the poor were constricted by shortage of space within the domestic interior and often lived in one room (see fig. 55). This consisted of a communal room or parlour where all aspects of domestic life took place, from sleeping, eating and entertaining to major rites of passage such as birth and death. Since infants were integrated into the daily routines of their parents, the design and contents of the peasant's and the artisan's domestic interior posed considerable challenges. This is partly attributable to the communal room also often serving as a workshop. Inevitably it presented an array of safety hazards, so infants were often imprisoned in cradles and other artefacts while the adults worked. Typical crafts undertaken in the rural home were handloom weaving, with spinning nearby.

With increasing industrialisation and mechanisation, small children were either involved in the division of labour, such as in pillow lace making, where infants as young as three would handle the bobbins, or they were boarded out to a wet nurse or 'baby farmer' because of the risks of accident at home.[1] In the French silk industry, for example, open vats of hot water used for softening silk cocoons posed an obvious source of danger to infants.[2]

Within the communal space of the domestic interior babies were subject to hazards such as fire, animals, falling, constriction, suffocation and the risks associated with sharing a bed, to name just a few.[3] From the medieval period small children as young as three or four were sometimes deputed to supervise their baby siblings;

110 *The Poor Child's Nurse*, from *Punch*, 1849.

not surprisingly, their often reckless custodianship resulted in fatal accidents.[4] For the mass of peasants and emerging working class in Europe who had to make a living, physical strategies were developed for protecting infants within the home. It was no coincidence that during medieval baptismal ceremonies the clergy emphasised the godparent's responsibility to ensure that parents guarded their children from fire, water and other threats.[5]

Even adults could fail in their duty and responsibility of supervision. For example, if servants were present infants could be neglected and harmed, as William Cobbett pointed out in the following tirade: 'And, good God, how many are the instances of deformed bodies, of crooked limbs, of idiocy, or of deplorable imbecility proceeding from young children being left to the care of servants.'[6]

In addition, infant neglect by wet nurses who operated from their own homes could cause not just the premature death of the infant in their charge but also that of their own child (**fig. 111**). Flaubert, in his novel, *Sentimental Education*, exposed the poor conditions in which wet nurses and their charges often subsisted in France in 1848: 'And she showed him the child, who was lying in a cradle by the fire. She had found him looking so ill that morning at the nurse's house that she brought him

111 'La mort de l'enfant', from *Danse macabre*, French, illuminated manuscript, 15th century.

back to Paris. His limbs had grown extraordinarily thin and his lips were covered with white spots.'[7]

Fire

Leaving infants in their cradles by the fire was the cause of the most common form of accidental death during the medieval period. It was particularly dangerous for the infant when fires were located in the centre of a peasant's home, a practice that persisted in certain rural regions right up to the nineteenth century. Yet, in spite of the clergy's insistence that babies should be strapped into their cradles, tragedy ensued when a cradle was placed too close to the fire, setting bedclothes alight, or when the cradle tipped up so that the baby rolled into the flames.[8] On each side of this wooden cradle are 4 wooden pegs which enabled a restraining band to be attached so as to prevent these accidents from occurring (**fig. 112**). The wickerwork cradle[9] acquired a reputation for being unstable, and could easily be dislodged and knocked over when placed on two chairs or on a separate stand with rockers.[10] Measures used from the fifteenth century to prevent infants from falling out consisted of a wooden frame. Another technique used from the medieval priod up to the nineteenth century was to find a convenient nail from which to hook the infant's swaddling bands

112 Rocking cradle, oak and pine, European, 1750–1850.

113 *La comédie humaine*, by Honoré Daumier, coloured lithograph, *c.*1850.

(**fig. 113**). Rousseau was highly critical of how babies were hung up, 'like a bundle of clothes and left crucified while the nurse goes leisurely about her business'.[11]

By the nineteenth century Karl Marx's collaborator, the entrepreneur Friedrich Engels (1820–1895), was particularly concerned by the high incidence of accidents caused by parents leaving their infants at home on their own or with child minders or baby farmers when they went out to work in cities and towns throughout Britain. He mentioned the large numbers of children run over, as well as those killed by

falling and drowning, but identified burning as a particular problem: 'Deaths from burns and scalds are especially frequent, such as occurring every week during the winter months in Manchester, and very frequently in London though little mention is made of them in papers.'[12]

Animals

Animals were another source of fatal accidents for children. During the medieval period infants were particularly prone to being bitten or mauled by pigs wandering into the home and overturning their cradles.[13] Indeed, given the harm that they could inflict, pigs were strictly forbidden from wandering the streets of London. In rural parts of western Europe the poor also had to share their sleeping arrangements with their animals, in Alpine regions the sheep sometimes sleeping under beds to keep the family warm. Domestic interiors in single-storey dwellings in rural districts throughout Europe often housed numerous small children who were tended by their family under the same roof as pigs and chickens.[14] Where households shared a living space with animals, a screen was sometimes erected or a simple hammock suspended above the parents' heads, as in Italy, to separate the humans from the animals and to prevent the infants from being trampled.[15] The common practice of placing the box or boat cradle on a chest was also employed to reduce risks of the infant either falling into the fire or becoming prey to animals, but it is not known how effective this method was in practice.

Restraints and restrictions

With the prevalence of rough earth floors in both urban and rural dwellings, the accumulation of rubbish and dirt presented real obstacles to infants' safety. It is therefore not surprising that, in order to protect their infants, parents encouraged the child to stand or sit rather than scrabble about on all fours in the midst of the flurry of dirt, domestic work and passing animals. Moreover, the dangers that a baby was exposed to, together with the social pressure for the child to contribute to the household income, meant that some infants were encouraged to sit up and stand as quickly as possible.

Where infants were boarded out to a wet nurse, physical restraints were sometimes imposed within the home to prevent them wandering off on their own and falling down. Moreover, where conditions were cramped, improvisation and the use of basic devices from local materials prevailed. In very poor households, for example, where space was at a premium and restraint was required, children were sometimes confined within the stretchers of the legs of a chair upturned on its back.[16]

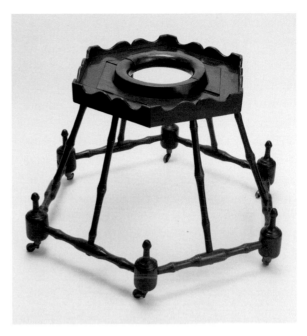

114 Baby walker with hexagonal tray, mahogany and painted ash, English, 1700–1750.

A restrictive but simple device known as the walking frame or baby cage was extremely useful. It was used to encourage infants to stand up throughout western Europe and persisted in Italy right up to the twentieth century.[17] The frame was made out of planks of ash, oak or fruitwood and consisted of a sliding board in a frame measuring on average about 4 feet 8 inches in length. The child was held in a hole at waist height and restricted to walking the short length of the frame.[18] A tray for toys was sometimes attached as a concession. This was a useful device for wet nurses and other working parents who worked in close proximity to children. Easily constructed, given its basic design, it imposed physical boundaries on the child while allowing them a restricted space for exercising their limbs.

The tendency to prop up in a standing position or sit an infant down for long periods of time while the parents were working did not escape the notice of the medical profession, and the physician William Buchan[19] was critical of those who kept infants standing up in go-carts or baby walkers so long that they often fainted through tiredness.[20] (**fig. 114**) There were also other items of children's furniture that provided a temptation both to neglect infants by leaving them alone too long in them and to push them too quickly to the next stage of their physical development. One nineteenth-century childcare expert struck a note of concern about the way infants were left seated in wicker commode chairs: 'The practice of leaving a child fastened to a wicker chair for a length of time is highly improper and injurious and should not be suffered.'[21]

Constriction and changing

From the medieval period babies were wrapped in swaddling bands from birth for approximately nine months; these long bands were made from linen or cotton and were wound round the infants' bodies to form a warm cocoon (**fig. 115**). There was considerable national and regional variation concerning their style and whether they were used on their own or in conjunction with underclothing such as nappies, 'tail clouts' and a linen 'first shirt'. Some rural communities, however, as in Ireland, did not use swaddling bands at all, preferring to leave their infants naked.[22]

Infants were often swaddled too tightly, their movements not only constricted by the bands around their heads but by the straight-jacketing of their arms, some midwives recommending that the arms should be released from the swaddling bands only in the fourth month. The bands were also sometimes laced through a series of holes or knobs at the side of the cradle, which effectively

115 Swaddling bands made from linen with cutwork border, Italian, 1600–25.

pinned down the baby and forced it to lie face upwards (**fig. 116** and see fig. 112). Another method used in France consisted of tying the hands of babies to the cradle, effectively immobilising them.[23]

Felix Würtz, who practised in Zurich and Strasbourg during the sixteenth century, was probably the first critic officially to raise the issue of the harm that swaddling could inflict, particularly if infants were swaddled too tightly. In spite of his entreaties to cease this practice for fear of deforming the baby, however, it persisted throughout western Europe. The seventeenth-century French writer Pierre Choderlos de Laclos was also a fierce opponent of swaddling and invoked examples from Africa to illustrate how much better it was for the infant to be free.[24] Swaddling had become even more controversial by the eighteenth century and William Cadogan, physician to the Foundling Hospital in London, forbade its use on the children there.[25] Certainly, Rousseau believed that swaddling legitimised neglect:

> A child unswaddled would need constant watching, well swaddled
> it is cast in a corner and its cries are unheeded. So long as the nurse's
> negligence escapes notice, so long as the nursling does not break an
> arm or legs, what matters if it dies or becomes a weakling for life, its

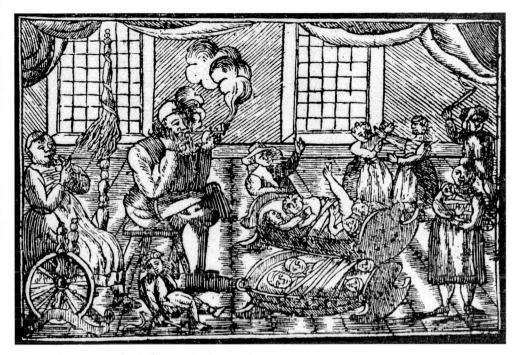

116 Swiss peasant family from a calendar, woodcut, 1783.

limbs are kept safe at the expense of its body, and if anything goes
wrong it is not the nurse's fault.[26]

Interestingly, the abandonment of swaddling became so much a symbol of Rous-
seau's back-to-nature philosophy that his tomb at Ermenonville depicted a number
of *putti* or naked children burning babies' swaddling clothes.[27]

In spite of these polemics, swaddling persisted in rural districts of France well
into the nineteenth century. In Britain, in contrast, it was abandoned much earlier,
a fact attributed partly to growing economic prosperity and increased consump-
tion of baby clothing.[28] Swaddling was also a forgotten practice in America by the
mid-nineteenth century.

Changing swaddling and tail clouts was also part of the daily domestic routine,
and this process often resulted in neglect. The tortuousness of putting on swad-
dling bands, for example, led to a reluctance to change babies' tail clouts more than
was absolutely necessary. Indeed, it allowed infants to languish in their own urine
and excrement, creating at times a severe nappy rash. This neglect led to entreaties
by midwives in the seventeenth century to change babies often to prevent discom-
fort. The problem continued throughout the eighteenth century when the physi-
cian William Cadogan (**fig. 117**), who played an important role in improving infant

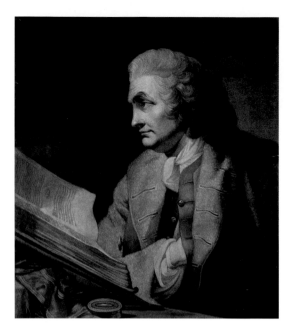

117 Portrait of William Cadogan, mezzotint by W. Dickinson after R. E. Pine, 1769.

hygiene, urged that nappies 'cannot be changed too often and we would have them clean every day as it would free them from stinks and sourness'.[29]

Another contentious practice was the use of binders or 'swathers', which were effectively shorter versions of swaddling bands, consisting of broad bands of flannel, linen or woollen cloth wrapped or sewn round the infant's body from breast to navel. Often one of the items that seventeenth-century midwives provided for their clients' babies, they also were criticised for constricting the baby unnecessarily. Both John Locke and William Cadogan condemned them, but they continued to be popular.

At the end of the nineteenth century Dr Humphrey argued that, in addition to serving no useful purpose, these items, now known as 'belts', could potentially deform babies, creating pigeon chests and constricting essential organs (**fig. 118**).[30] There was also a reaction in both Europe and America against layers of complicated clothing held together with pins, and childcare experts promoted simplicity of dress for babies based on scientific and rational principles.[31] The domestic commentator and writer Mrs Beeton was part of this movement, and appealed to mothers' better judgement:

> We beg mothers to simplify their baby's dress as much as possible, and
> not only to put on as little as is absolutely necessary, but to make that
> as simple in its contrivance and adjustment as it will admit of, to avoid
> belly-bands, rollers, girths and everything that can impede or confine
> the natural expansion of the digestive organs.[32]

118 Elasticated belt for babies, 1880–70.

Stifling

One problem associated with wet nurses was stifling or suffocating their charge. The danger was exacerbated by the overcrowded homes in which they lived. During the medieval period the wet nurse often shared a bed with her employers as well as with the baby, but even when she cared for the infant in her own home, usually in the countryside, she would frequently share her bed with both her husband and her charge. In the process of feeding the baby inadvertent suffocation, known euphemistically as 'overlaying', could occur. It has been estimated that 17 per cent of infants put out to nurse in fifteenth-century Italy died in the care of the wet nurse. Out of all the deaths in their care, 15 per cent was attributed to suffocation.[33]

To protect the Italian child from being suffocated from its mother or nurse rolling over it in bed, the baby was placed next to them inside an intriguing wooden cage-like device called an *arcutio, archetto, arcuccio* or *archioni*.[34] This was used from the sixteenth century by Florentine wet nurses who could be excommunicated by the Church if they did not use it, although it is not known if this ruling was ever enforced. Wet nurses in the foundling hospital in London were also urged to use an *arcutio*.[35]

The frequency of overlaying made it a crime in the eyes of the Church, for which women throughout medieval Europe had to do public penance. Most cases of overlaying in fifteenth-century Italy were attributed to the wet nurse's negligence. Even though it was a frequent practice for infants to share a bed with the wet nurse's husband as well as the nurse, only one in nine cases of infant deaths through overlaying was attributed to the husband. In Scotland in 1586 Marjorie Anderson allegedly suffocated two infants who were in bed with her. Her punishment was to attend the kirk the following Sunday and stand on the 'stoole of repentance' clothed in sackcloth, 'bare footed and bare legged', with a paper stuck on to her head that listed the cause of her offence and her confession.

By the seventeenth century overlaying or overlying had become one of the most frequent causes of accidental death amongst infants throughout western Europe and America. The Catholic and Protestant churches, physicians and midwife manuals denounced the practice of parents sleeping with infants because they believed it could lead to suffocation and infant death, and recommended separate sleeping arrangements for the child.[36] The French obstetrician François Mauriceau implored nurses and mothers not to sleep with their charges for fear of overlaying. To offset this problem the French government introduced legislation that required wet nurses to provide cradles for the infants in their care. In the Hôtel Dieu where Mauriceau worked, women sometimes slept four or five to a bed, so there was a real prospect of overlaying the infants. As a remedy, separate cribs were introduced. The British midwife Jane Sharp no doubt also had overlaying in mind when she stated in her midwife manual of 1671 that wet nursing exposed the infant to too many hazards.[37] These warnings to mothers and nurses not to sleep with their infants continued unabated, yet the practice continued throughout western Europe and America.[38]

In the 1860s Dr Julian Hunter revealed that fen women employed as casual gang labour in East Anglia were prone to overlaying or 'overlying' their infants, with fatal consequences. This was attributed to the women's opium addiction, taken initially to ward off fenland malaria, which rendered them oblivious to suffocating their babies inadvertently.[39] Some childcare commentators became concerned that this problem could become more widespread, given that fashions were changing and there were those who were now recommending that newborn infants could sleep with their parents. The domestic writer Ada Ballin, writing at the turn of the century, struck a cautious note and was deeply opposed to the dangerous practice of mothers sleeping with their babies.[40]

Cot death

There is some evidence to suggest that cot death or sudden infant death syndrome existed in the seventeenth century. The position of an infant within its cradle or cot can, when distress occurs, have a determining influence on the child's survival, but it took many centuries for this to be recognised.[41] The distress suffered by parents or by servants when their babies or charges died suddenly[42] and inexplicably is eloquently illustrated by the iconography of the sinister spectre of devils, demons and the forbidding skeletal figure of death itself (see fig. 111)[43] taking away babies, suffocating them or sucking their blood.[44] In Alsace there was a belief that the *Erdmännchen* landed on the infant's breast and sucked her blood and the *schratzmännel* sat on top of children and suffocated them. Unlike advice today where it is recommended to lay

babies on their backs, in the nineteenth century this was deemed dangerous and it was understood to be better on health grounds to lay babies on their sides.[45]

Sexual abuse

Incest was one aspect of sexual abuse with which the Church and physicians were concerned. Punishment was severe in certain parts of Europe such as Germany during the sixteenth century, where, if incest was discovered, the penalty could be death at the stake. Where there were no beds infants had to sleep on the ground with their parents and siblings on bare earth, straw mats or rushes. In rural parts of northern England, individual mats, shaped like shallow troughs and plaited in straw by rural labourers such as shepherds, were sometimes put on the floor for small children or servants to sleep on.[46] This meant that a hierarchy and segregation was imposed that informed the sleeping plan, usually determined by age and sex, but a shared room with a mixture of sexes was unlikely to have prevented sexual abuse occurring.

In medieval France guests were also often invited to share a bed during their visit, creating opportunities for child abuse. The prospect of an inappropriate sexual relationship developing was certainly increased with the rise in overcrowding amongst the poor, but these relationships were not just the preserve of the poor. This was testified to by the well-known Victorian childcare expert Mrs Panton, whose views were echoed by American experts as well. She warned her middle-class readership: 'Under no circumstances should the nurse be allowed to take the child into her own bed. This should be strictly forbidden for more reasons than one.'[47]

There was one excellent compromise that enabled wet nurses and other adults to sleep separately from infants: the truckle bed, also known as the trundle, pallet bedstead, wheel or 'hurley' bed, which featured in many Elizabethan inventories and was used throughout Britain and America. This piece of furniture was particularly practical where space was at a premium since it could be pulled out from under the main bed and enabled children and their parents or nurse to sleep separately from each other while remaining close by. They were convenient in rooms where dining and sleeping were combined, since they rested on four wheels and could be pushed under a poster or box bed when not in use.[48]

Abandonment

Since infanticide and abortion during the medieval period were always considered very serious crimes, punishable by death, abandonment was sometimes a safer option for mothers. The reasons were economic and social, often occurring when families were suffering such economic hardship that they could not afford to maintain their

infants. Moreover, it was often the result of unmarried mothers being stigmatised by the Catholic and Protestant churches, their employers and by their own families. It was also likely to occur when a woman had been raped or deserted, commonly by soldiers, or disowned by a lover or parents on becoming pregnant. Apparently, the fathers of most abandoned infants in England during the medieval period were either already married or clerics.[49] Baby girls were also more likely to be abandoned than boys, since they were more expensive to maintain, requiring a dowry.

To deal with the growing problem of abandoned children, foundling hospitals were established in Italy in the fifteenth century. In addition to the hospital of Santa Maria della Scala in Siena,[50] there were orphanages in Florence, Rome and Venice. By the seventeenth century there were also foundling institutions supported by the Catholic Church in Lisbon, and in Amsterdam. All these organisations in their different ways provided a refuge for foundlings.

The Catholic Church viewed abandonment as a sin, and a plaque placed outside the Venetian church of the orphanage of the Pietà sets out the Papal Bull issued in 1548 threatening excommunication and 'maledictions' (a kind of curse) to those who had the means to rear a child but abandoned their infants.[51] Moreover, city and parish authorities were continually vigilant to the potential financial burden that they might have to shoulder if a baby were abandoned by its mother within their boundaries.[52]

Mothers might abandon their babies, known as 'laying the child', in locations ranging from shop stalls, churches and magistrates' doors. This inevitably aroused suspicion, since parishes and institutions often treated the place of abandonment as evidence of paternal responsibility.[53] Not surprisingly, the most obvious location for depositing babies was the alleged father's doorstep. While many women hoped to name and shame the culprit, sometimes they were reluctant to disclose who the father was for fear of retribution from him.

In Leicestershire in 1519 a man strongly denied an accusation that he had fathered the child left at his door. This meant that the orphan was reduced to homelessness and at the mercy of the parish, which refused to take financial responsibility for the foundling.[54] In Germany in 1604 a single mother left her infant under the pulpit in a church, but it is not known if this was because the pastor was the father or if she considered this a convenient reception point, where the child would be discovered at the next service. In 1670 the Hôpital des Enfants Trouvés was founded in Paris by Louis XIV in response to the growing problem of abandonment. St Vincent de Paul and the Daughters of Charity were crucial to its foundation since earlier in 1638 they had been actively rescuing abandoned infants in Paris.

Abandoned infants who came from rural areas in France frequently died before they reached their destination, a city foundling hospital. This was because traffickers or *meneurs*, the middlemen paid to transport foundlings to the towns, inflicted

appalling conditions on them. Not only did they submit the children to a gruel-ling, lengthy journey, they also neglected to feed them, and packed them together so tightly that they suffocated en route. Even if foundlings survived this perilous journey their chances of survival in the foundling hospital were as low as 68 per cent in 1751.

In a few instances infants were later reunited with their parents. Jean Le Rond d'Alembert, the famous French philosopher and mathematician, was abandoned in 1717 on the steps of the church of St Jean-le-Rond (from which he took his name) near Notre-Dame in Paris. He was later reunited with his father, who placed him in the home of a glazier's wife with whom he lived for fifty years. His father paid for his education but did not want his paternity recognised. Fathers in England also tended to deal with their 'bastards' by abandoning them to overworked wet nurses, who would then proceed to neglect their charges, who would often die in their care.[55]

In 1739 Thomas Coram (*c.*1668–1751), a childless sea captain, established the Foundling Hospital in London, which from the outset was secular in nature (**fig. 119**).[56] It was a response to the abandonment of infants in England, which continued

119 Thomas Coram with an abandoned infant in a Moses basket, engraving by J. Brook after B. Nebot, 1741.

to be a chronic problem. This is vividly illustrated in the novel *Tom Jones* by Henry Fielding, published in 1749, in which Deborah recommends that the foundling is left at the churchwarden's door:

> It is a good night, only a little rainy and windy: and if it is well wrapt in a warm basket, it is two to one but it lives till it is found in the morning. But if it should not, we have discharged our duty in taking proper care of it: and it is perhaps, better for such creatures to die in a state of innocence, than to grow up and imitate their mothers; for nothing better can be expected of them.[57]

This illustrates poignantly how mothers in this predicament were perceived and how they were thought to have a morally contaminating influence on their children. Not every child taken in by the Foundling Hospital, however, was an offspring of an unmarried mother, since there were couples who were forced to give up their infants as a result of poverty. Whatever the reasons for abandonment by a parent or parents, there was no doubt that considerable emotional suffering was involved in the separation, and few were reunited with their children. Some consolation could be found in the reassurance that at least their infants' physical needs would be met. Once accepted by the Foundling Hospital, babies were usually placed with wet nurses to be fostered until they returned to the hospital between the ages of three and six. Interestingly, during the eighteenth century the infant death rate in the Foundling Hospital in London was 40 per cent, which meant that it improved the life expectancy of destitute orphans significantly[58] compared with workhouses, where infant mortality could be as high as 100 per cent.[59]

Infanticide

Accidents within the home were the most common cause of death once babies had survived childbirth. Of course, sometimes 'accidents' masked infanticide. In these circumstances a desperate mother might be trying to escape poverty, or having been raped or the stigma of bearing a 'bastard'. Alternatively, sometimes a wet nurse or baby farmer wanted to get rid of an unwanted child that had been abandoned. One reason for infanticide was a female baby. The combination of the failure to produce a male heir and the financial burden of having to provide a dowry for a girl meant that parents sometimes resorted to desperate measures.

The punishment meted out for carrying out infanticide in medieval France consisted either of being buried alive or burnt to death, while in Germany it was dealt with by execution.[60] The severity of punishment for what was deemed a very serious crime might partly explain why there was considerable subterfuge to conceal evidence,

so that its occurrence might be dismissed as an unfortunate accident. According to the seventeenth-century astrological physician Richard Napier, who treated many women patients who had mental health problems, those women who had recurring fantasies about committing infanticide may have been possessed by the devil.[61]

In England, in order to combat infanticide, which was notoriously difficult to detect, the 1624 Infanticide Act was introduced. This made it a capital offence to conceal a birth and required a witness to declare if a child was stillborn. Unmarried women who committed infanticide during this period were represented in street literature as unnatural monsters and sexually promiscuous. By the eighteenth century infanticide was still considered a serious crime, but judges in England were unlikely to hang women (particularly if they were married) for this offence. Mothers were more likely to be acquitted under the 1624 statute if they could demonstrate that they had prepared for the birth of their baby by assembling a layette in advance, which was considered a mitigating factor in their defence. The overwhelming majority of those few women who were prosecuted under this act were unmarried women deemed sane and criminal, many of whom were servants living in agricultural communities.[62] The next largest group of people prosecuted were widows. Conversely, out of all those charged with infanticide married women were most likely to be pardoned as insane.[63]

The physician William Hunter was concerned by the harsh treatment meted out to unmarried mothers and launched a polemic against those whom he thought were the real perpetrators of the high rates of abortion and infanticide. He claimed: 'In most of these cases the father of the child is really criminal. Often cruelly so: the mother is weak, credulous and deluded. Having obtained gratification he thinks no more of his promises.'[64] In general, this kind of protestation against the fecklessness of men was the exception and, while implicated in many instances of infanticide, fathers were rarely prosecuted.[65]

Such sympathy towards women who resorted to infanticide out of desperation was echoed by other high-profile figures during the eighteenth century such as Thomas Coram, founder of the London Foundling Hospital. In 1746 the artist Joseph Highmore had not only been appointed as a governor but had been commissioned to decorate the Foundling Hospital with his paintings, together with many other eminent artists. Highmore selected the Old Testament story of Hagar and Ishmael as one of the themes for the paintings to be hung on its walls. This is the moment when Hagar, maidservant to Sarah and mistress to Abraham, has been cast out with her illegitimate, dying child Ishmael into the wilderness by the elderly, jealous Sarah, wife of Abraham. An angel of mercy intercedes to show the distraught Hagar where she can find water to save her son. Since adultery between a servant and her master and the abandonment of illegitimate infants were topics that would

have had considerable contemporary resonance, the moral overtones of forgiveness and redemption represented by the angel of mercy would not have been lost on visitors to the hospital.

In the same or subsequent year Highmore painted a far more contentious painting, acclaimed as unique in eighteenth-century Western art for showing the contemporary reality of maternal infanticide.[66] It again depicts the angel of mercy, but this time in a contemporary setting with the building of the Foundling Hospital in the background. The angel rescues an infant with the figure of a woman wrapped in a dark shroud-like costume looming in the shadows, possibly depicting death or a figure resembling Mary Magdalene. The angel interrupts a shocked mother (very respectably dressed) in the midst of strangling her infant with a thin terracotta-coloured ribbon while the baby rests perilously on her lap (**fig. 120**).

The composition mirrors the *Hagar and Ishmael* painting in certain respects. Ishmael wears a terracotta-coloured silk wrap around his navel while the infant about to be murdered, depicted below, has a terracotta ribbon around its neck. This ribbon is similar to those used as tokens by mothers to identify their children abandoned as infants in the Foundling Hospital.[67] In both paintings the mothers prepare for their infants' imminent death brought on by the shame of giving birth

120 *The Angel of Mercy* by Joseph Highmore, oil, British, 1746.

121 *The Foundling Hospital*, etching by François la Cave after William Hogarth, 18th century.

to an illegitimate child. What is significant is that the *Angel of Mercy* painting was ultimately rejected by the Foundling Hospital while Highmore's more respectable biblical interpretation of abandonment in the form of *Hagar and Ishmael* graced the magisterial walls of the courtroom where the governors of the Foundling Hospital met. Coram offered a humane explanation for why mothers were reduced to committing infanticide by suggesting that their motives were the shame and anguish of not being able to support their offspring.[68]

In an engraving of the foundling hospital Thomas Coram is depicted saving an infant from a tearful mother who was about to kill it with a dagger that she has dropped in front of her. Coram, who is holding the Royal Charter of the Foundling Hospital, hands the baby over to the safekeeping of his beadle who is carrying a mace, while happy foundlings play in the hospital grounds in the background (**fig. 121**). While Coram tried to address this difficult problem, his solution involved rescuing the infant while the mother remained ostracised. As it was he faced considerable opposition to his plans by those who claimed that by providing shelter for 'bastards' he was promoting promiscuity in women.[69] The Westminster Lying-in Hospital in contrast explicitly tried to address the problem of women committing infanticide and suicide in its admissions policy by including those 'Such as are deserted and in deep distress, to save them from despair and the lamentable crime of suicide and child murder'.[70]

Interestingly, an engraving of the newly built Westminster Lying-in Hospital has a quote from Isaiah at the top of the picture: 'Hide not thy face from thine own

Confession & Execution
OF
M. WATERS,
The Baby Farmer,
At Horsemonger Lane Gaol, on Tuesday, October 11th: *1870*

This morning, Tuesday, the wretched woman, Margaret Waters, the notorious baby farmer, underwent the extreme penalty of the law, at Horsemonger Lane Gaol, for the murder of a child named Cohen, at Brixton.

The prisoner, since conviction, made a statement, in which she denied all intention of committing murder, but said she gave the children all the nourishment she could, as far as her means would allow. She acknowledged to having left some of the babies in the care of children in the street, and then went away, so that they might be taken to the workhouse, and then then she would be rid of them. She also said, that being so poor, that when any of them died, she packed them up in brown paper, and left them in different parts of the town, where any rubbish was accumulated. She acknowledges to nearly twenty bodies.

Since her condemnation, the prisoner has been very ill, and for the last four or five days has been confined to her couch. Her brothers visited yesterday, and the parting scene was an extremely painful affair. The worthy chaplain has been unremitting in his attentions to her,

and has showed the evil course of her life, and tried his utmost endeavours to bring her to a state of mind so that she might fully understand the awful position in which she stood, and in which he fully succeeded.

The sheriff having arrived, at once, with the other officials, proceeded to the condemned cell. The executioner having been introduced proceeded at once to fasten the prisoner's hands, arms, and legs, so as to prevent her struggling at the gallows. Everything being in readiness, the procession was formed, and then it was found necessary to obtain a chair as the prisoner was too feeble to walk, they then began to move forward through the various passages of the prison towards the yard where the gallows was erected; which having arrived, the prisoner fainted away, and appeared to be entirely overcome, after a few minutes she revived, and thanked the whole of the officials for their kind attention to her. The cap was then drawn over her face, the rope adjusted, the bolt drawn, and the wretched creature was launched into eternity.

You feeling hearts I pray draw near,
 Of high and low degree,
Especially you mothers dear ,
 Pray listen unto me ;
The Baby Farmer, Waters,
 To women a disgrace,
For the fiend-like acts that she has done
 At last has met her fate.

 The Baby Farmer, Waters,
 Upon the scaffold high,
 For murdering of those children dear
 A felon's death did die.

This monster did in Brixton dwell,
 As is well-known to all,
Her wicked deeds are known full well,
 And for indignation calls ;
How those darling children she ill-used,
 It is shocking for to hear,
None but a demon could abuse,
 Such unoffending dears.

Since the days Mother Brownrigg,
 Who those poor girls starved to death
In England we have never heard,
 Of such a cruel wretch ;
Just for the sake of a few pounds,
 It is dreadful for to tell,
That such a woman could be found,
 Her precious soul to sell.

This wicked Baby Farmer,
 A statement she did make,
To try to baffle Justice,
 And stay her wretched fate ;

She said that those poor children,
 She treated kind, but I ne'er can,
Believe her kindness any more,
 Than the wolf unto the lamb.

For the sake of those poor children,
 The tears bedim each eye,
While no one pities that base wretch,
 Unfit to live or die.
The advice that I give one and all,
 Of baby farmers pray beware,
So you mothers who have children small
 Give them a mother's care.

When in her cell what must have been
 Her thoughts by day and night,
Those little ones, as in a dream,
 For ever in her sight.
How could she dare for mercy ask,
 Upon the Judgement day,
When she that mercy did deny,
 To those darlings she did slay.

The solemn bell for her has tolled,
 Her glass on earth has run
May God forgive her guilty soul,
 For the crimes that she has done ;
The Baby Farmer is no more,
 The hangman's work is done,
And guilty Margaret Waters,
 To a murderer's grave has gone.

Printed for the Vendors.

*Because this woman killed a Child or Children, she was hanged—
Scoundrel Kings: Murder thousands; and are praised !
Where is the Morality ?*

122 *Confession and Execution of M. Waters*, criminal broadsheet, 1870.

flesh' (see fig. 58). The choice of these words was undoubtedly meant to suggest that mothers should face up to their responsibilities rather than contemplate infanticide or abandoning their child.

Baby farming was a particular problem. The practice of farming out babies to dry nurses or 'baby farmers' as opposed to wet nurses grew up with the increasing industrialisation of Britain. Baby farmers fed their charges by hand rather than by breast, and they had become more widespread by the nineteenth century, when wet nursing was on the decline and artificial feeding was becoming more common. Indeed, women were often compelled to return to work in the factory after a mere fortnight. This meant that baby farmers served parents who were working. Their charges were usually aged between six months and one year, but older infants who had previously resided in the workhouse were also farmed out.

Baby farmers earned a reputation for public scandal through committing infanticide, which they barely managed to conceal. These women often fed their charges with poisonous concoctions consisting of laudanum and treacle or, in the case of two women who were successfully prosecuted for killing their charges, laudanum, lime, corn flour, water, milk and washing powder.[71] One of these women was the notorious baby farmer Margaret Waters, who exploited the anguish of childless couples by selling infants for adoption for £5 each. She was charged with murder, tried at the Old Bailey and executed at Horsemonger Lane Gaol in 1870 for killing a child in her care (**fig. 122**). During the police investigation of her premises, nine infants were found dying of malnutrition and opium poisoning. After the infants had died of slow poisoning, Margaret and her sister allegedly would pack them up in brown paper and leave them in rubbish tips in different parts of town. This high-profile case caused such a scandal that it was influential in the Government introducing the 1872 Life Protection Act, which required baby farmers to register with the local authorities.

Conclusion

Throughout the period 1300 to 1900 childbirth and infant care took place either at home or within an institution or, more rarely, outside. Moreover, the conditions and procedures under which mothers gave birth and the rituals associated with birth and infancy changed over this period. There were also shifts in practices in how infants were nurtured and brought up. In spite of this changing environment, many of the objects associated with the material culture of birth and infancy such as birthing chairs, forceps, bottles and baby walkers have an enduring, timeless quality.

Today, women in Europe can exercise some choice and influence over where they give birth and who accompanies them. There were, however, extensive periods when women were effectively quarantined from the outside world, and many fathers apart from royalty and men of noble birth were excluded from the birth and during the lying-in period. The policy of excluding men and other family members was particularly prevalent in lying-in hospitals. Today, 97 per cent of deliveries in Britain involving couples have fathers present, but this was not always the case and the experience for women in the past was both more frightening and more solitary.

While medicalisation of the birth process and improvements in antenatal care have generated real health benefits to mothers by increasing survival rates and quality of life, it has heightened the tension between the respective benefits of giving birth at home and in hospital. Hospitals have been criticised for providing an uncaring environment with little intimacy or privacy, and the home has been subject to criticism of the risks to mother and baby if emergency medical intervention is required. But overall the prospects have greatly increased that the mother and child will experience a safe birth and a healthy future.

Some rituals and traditions associated with birth and early infancy covered in this book have lapsed, such as the churching ceremony, and others, such as baptism, still remain, although fewer baptisms are now performed. Gift giving and celebration at the birth of a child, however, have endured, and they have expanded enormously, being transformed by increasing consumerism and mass production. The 'baby shower', the modern party thrown before the baby is born at which the mother receives gifts, reflects not just the increasing confidence that mother and baby will survive but also the increase in commercialisation of the birth and the infant's early years.

Infant care and feeding have undergone profound changes. Mothers in the past were frequently coerced by family members to transfer the care and feeding of their

babies to wet nurses, and there was also great pressure for women who could not afford to bring up their own children to become wet nurses themselves. Today the source of contention has moved away from the pros and cons of wet nurses to whether a baby should be breast- or bottle-fed.

The new technological devices deployed by parents today to track and monitor their infants' health and growth have both raised expectations and awareness of reaching physical milestones and aroused anxieties about potential medical problems. Better safety standards have also made the home in general a potentially less hazardous place in which infants sleep and play and a safer physical haven. Above all, the increased survival rates and the improved standards of infant care have enabled parents to cherish their experience and provided an environment in which the infant can flourish.

Notes

Chapter 1

1 MacDonald 1981, p.101.
2 D. G. Charlton 1986, p.159.
3 Leyser 1995, p.122.
4 Hufton 1995, p.179.
5 MacDonald 1981, p.83.
6 Laurence 1988, p.74; Evans 2012, p.5.
7 Holmes 2003, p.120; Dewhurst 1980, p.11.
8 Evans 2012, p.5.
9 Foreman 1999, p.71.
10 Roy Porter in G. S. Rousseau and Porter 1992, p.156.
11 Jalland and Hooper 1986, p.131.
12 *The Almond Tree* in Grimm 1892, p.148.
13 Rublack 1996, p.88.
13 Rueff 1580, p.17.
15 Pelling 2003, pp.210–11.
16 Opie and Opie 1959, p.217; Gélis 1991, p.47.
17 Fontanel and d'Harcourt 1997, p.15.
18 Speert 1996, p.62.
19 Thomas 1971, p.223.
20 Crawford 1986, p.27.
21 Roodenburg 1988, p.708.
22 Harley 1990, p.11.
23 Rublack 1996, p.164.
24 Ballin 1902, p.7.
25 See *Recueil complet de pieces curieuses*, 1759, p.4. Wellcome 43297/A.
26 McTavish 2005, pp.160–61.
27 Warner 1978, p.50.
28 Gélis 1991, p.31.
29 Speert 1973, p.439.
30 Schneid Lewis 1986, p.194.
31 Farjeon 1960, p.285.
32 Meltzer 1981, p.46.
33 Llewelyn Davies 1977, p.25.
34 Gélis 1991, p.198.
35 Bayne-Powell 1939, p.24.
36 Thomas 1971, p.376.
37 Millen and Wolf 1989, p.93.
38 Hollander 1978, p.109.
39 Paris, Musée National du Moyen Age (formerly Musée du Cluny).
40 *Madonna del Parto* by Piero della Francesca. Cemetery chapel, Monterchi, Italy.
41 *Gabrielle d'Estrées with her Sister*, Fontainebleau School, *c.*1594. Paris, Musée du Louvre, RF 1937–1.
42 Gowing 1997.
43 Harrington 2009, p.36.
44 Gowing 2008, p.140; Jackson 1996, p.73.
45 L. Baumgarten 2002, p.151.
46 British maternity ensemble: cotton jacket, quilted petticoat and vest, 1780–95. Colonial Williamsburg 1936–666, 1°3.
47 French maternity boned corset, 1875–99. London, Victoria and Albert Museum, V&A: T98 and A–1984.
48 Ballin 1902, p.8.
49 Rudyard Kipling, 'The Three Decker', from *The Seven Seas* (Kipling 1896).
50 Woolgar 1999, p.99.
51 Hufton 1995, p.184.
52 Musacchio 1999, p.46; Thornton 1985, p.156.
53 L. Baumgarten 2002, p.149.
54 Dewhurst 1980, p.93.
55 Buchan 1784, p.530.
56 Hawkins Miller 1978, p.31.
57 C. Clinton 1982, p.152.
58 Chamberlain 2007, p.41.
59 Evans 2012, p.4.
60 Boorde 1557.
61 K. Charlton 1988, p.12.
62 Knight 1977, p.58.
63 Harrington 2009, p.46.
64 Rublack 1996, p.102.
65 Ashton 1883, pp.1–2
66 Bessborough 1955, p.27.
67 Buchan 1869, p.X1X.
68 Jalland and Hooper 1986, p.86; Ashton 1883, pp.1–2.
69 Gélis 1991, p.77.

Chapter 2

1 Macdonald 1981, p.38.
2 Rublack 1996, p.87.
3 Luther 1522, p.40.
4 Gray 1946, p.78.
5 Millen and Wolf 1989, p.92.
6 Watkins 1819, p.153.

7 Fitzgerald 1899, p.53.
8 Penny 1975, p.327.
9 New Hall pottery, Porcelain, transfer-printed in black enamel, 1817. London, Victoria and Albert Museum, V&A: 3226–1901.
10 Quoted in Gray 1946, p.108.
11 Hopkins 1910, p.255.
12 Kemble 1959, p.183.
13 Woodham Smith 1972, p.259.
14 Hawkins Miller 1978, p.38.
15 *The Lancet*, 18 December 1841.
16 Gélis 1991, p.114.
17 Millen and Wolf 1989, p.98.
18 Gélis 1991, p.145.
19 Cressy 1997, p.22.
20 Salmon 1994, pp.247–69
21 Thomas 1971, p.224.
22 Woolgar 1999, p.98.
23 Millen and Wolf 1989, p.92.
24 Leyser 1995, p.126.
25 Gélis 1991, p.113.
26 Burnett 1994, p.287.
27 Glanville and Lee 2007, p.54.
28 Halford 1828, p.383.
28 E. Porter 1969, p.13.
30 Chinnery 1979, p.273.
31 Wertz and Wertz 1977, p.13.
32 For example, the *Virgin and Child* by Jacob Jordaens, 1620. London, National Gallery.
33 Chinnery 1979, p.68.
34 Carson Banks 1999, p.20.
35 Tilly and Scott 1989, p.57.
36 Dewhurst 1980, p.4.
37 Ramsey 1988, p.23.
38 Gélis 1991, p.67.
39 Hufton 1996, p.212.
40 McKeon 2005, p.238.
41 Seymour 2001, p.29.
42 MacDonald 1981, p.108.
43 Harrington 2009, p.42.
44 E. Baumgarten 2004, p.175.
45 Cressy 1997, p.60.
46 Leyser 1995, p.27.
47 Fraser 1984, p.500.
48 R. Porter 1997, p.174.
49 Rublack 1996, p.88.
50 Carson Banks 1999, p.7.
51 Gray 1946, p.91.
52 Gray 1946, p.45.
53 Porter 1987, p.223.
54 Gray 1946, p.97.
55 Nightingale 1871, p.106.
56 McIntosh 2012, p.7.
57 Speert 1973, p.266.

58 Gray 1946, p.14.
59 Pollock 1987, p.60.
60 Speert 1973, figs 9–12, p.269.
61 Carson Banks 1999, p.73.
62 Gray 1946, p.45.
63 Radcliffe 1967, p.49. Gray 1946, p.45.
64 Gray 1946, p.78.
65 Quoted in Hawkins Miller 1978, p.29.
66 See Chapter I, note 41.
67 Scully 1980, p.26.
68 Steinburger 2000, p.202.
69 Kevill-Davies 1991, p.21.
70 Porter 1987, p.64
71 Rohl 1998, p.9
72 Dewhurst 1980, p.8.
73 Paschall and Lyon 2016, p.11
74 Hawkins Miller 1978, p.24.
75 Quoted in Hawkins Miller 1978, p.25
76 McMillen 1990, p.71.
77 Llewelyn Davies 1977, p.35

Chapter 3

1 Thomas 1971, p.68.
2 Burnett 1994, p.287.
3 Gillis 1996, p.163.
4 Graham et al. 1989, p.153.
5 Willes 1998, p.42.
6 Millen and Wolf 1989, p.92.
7 Black 2007, p.34.
8 Finer and Savage 1965, p.168.
9 McMillen 1990, p.72.
10 Llewelyn Davies 1977, pp.36–37
11 Holmes 2003, p.114.
12 Somerset 2012, p.92.
13 Carson Banks 1999, p.20.
14 Millen and Wolf 1989, p.92.
15 Fraser 2001, p.198.
16 Lipsedge 2006, p.115.
17 Fitzgerald 1899, p.54; Watkins 1819, p.153.
18 Woodham Smith 1972, p.271.
19 Staniland 1985, pp.2–3; Musacchio 1999, p.39.
20 L'Estrange 2008, p.76.
21 Watkins 1819, p.158.
22 Watkins 1819, p.155.
23 Hopkins 1910, p.260.
24 Conran 1978, p.63.
25 Staniland 1985, p.45.
26 Musacchio 1999, p.8.
27 Carson Banks 1999, p.20.
28 Sarti 2002, p.120.
29 Roodenburg 1988, p.708.
30 Millen and Wolf, 1989, p.93.
31 Foreman 1999, p.169.

32 Fraser 2001, p.263.
33 Gray 1946, p.33.
34 Chavasse 1839, p.51.
35 Eccles 1982, p.20.
36 Fraser 2001, p.199.
37 Bull 1865, p.75.
38 Halford 1828, p.203.
39 Riché and Alexandre-Bidon 1994, p.51.
40 See *The Artist's Family* by Benjamin West, 1772; Colonial Williamsburg G1979–193. Schama 1991, p.541.
41 Toomer 2004, p.39.
42 Gélis 1991, p.106.
43 Dickens 1868, p.13.
44 Ginnis Fuchs 1984, p.243.
45 Shefrin 2003, p.64.
46 Plumb 1982, p.317.
47 L. Baumgarten 2002, p.155.
48 Gowing 2003, p.21.
49 Postles 2006, p.165.
50 Panton 1896, p.33.
51 Hufton 1996, p.278.
52 Grimshaw 1989, p.201.
53 I.S.L. Loudon 1993, p.1050.
54 Rose 1986, p.32.
55 Yalom 1997, p.114.
56 McIntosh 2012, p.27.
57 Nightingale 1871, p.65. Letter from Florence Nightingale to Heywood Smith, 10 May 1876, London, Royal College of Obstetricians and Gynaecologists.
58 Cody 2005, p.178.
59 'Laws Rules and Orders for the Govt of the Westminster Lying-in Hospital', 1802, p.33. Wellcome EPB 35035/P.

Chapter 4

1 Flather 2007, p.140; M. Houlbrooke 2011, p.13.
2 Musacchio 1999, p.49.
3 Musacchio 1999, p.106.
4 Thomas 1971, p.42.
5 Cunnington and Lucas 1972, p.18.
6 Thomas 1971.
7 Fraser 1984, p.80.
8 Hair 1972, p.65.
9 Gowing 2008, p.143.
10 Gillis 1996, p.204.
11 Tillyard 1994, p.234.
12 Gillis 1996, p.65.
13 Staniland 1985, p.5.
14 Leyser 1995, p.129.
15 Watkins 1819, p.158.
16 Toomer 2004, p.117.

17 Dewhurst 1980, p.6.
18 Thomas 1971, p.41.
19 Toomer 2004, p.24.
20 Cressy 1997, p.150.
21 Gillis 1996, p.170.
22 Leyser 1995, p.126; Hanawalt 1993, p.46.
23 Fontanel and d'Harcourt 1997, p.41.
24 Toomer 2004, p.125.
25 Hopkins 1910, p.260.
26 E. Baumgarten 2004, p.60.
27 Judd 2015, p.31.
28 Klein 1998, p.228.
29 Toomer 2004, p.290.
30 Toomer 2004, p.106.
31 Barrie 1896, p.14.
32 Klein 1998, p.246.
33 R. Houlbrooke 1984, p.131.
34 Cressy 1997, p.165.
35 Quoted in Speert 1973, p.152.
36 Rublack 1996, p.102.
37 Wertz and Wertz 1977, p.5.
38 L. Baumgarten 2002, p.154.
39 Gillis 1996, p.185.
40 Dewhurst 1980, p.91.
41 Watkins 1819, p.200.
42 Dowager Countess of Jersey 1922, p.1.
43 Hufton 1996, p.178.
44 Cunnington and Lucas 1972, p.42.
45 Glanville and Lee 2007, p.55.
46 Staniland 1985, p.8.
47 Fraser 2001, p.201.
48 Musacchio 1999, p.46.
49 See the child clutching a coral stick in the painting of *Mrs Elijah Boardman and her Son, William Whiting Boardman* by Ralph Earl, c.1796. San Marino, Huntingdon Library.
50 Fraser 2001, p.228.
51 Silver filigree rattle, c.1763. Royal Collections Trust, RCIN 11944.
52 Gowing 2003, p.143.
53 Harrington 2009, p.40.
54 Hair 1972, p.196.
55 Bayne-Powell 1939, p.248.
56 Bett 1952, p.31.
57 Thomas 1971, p.732.
58 Dick 1987, p.104.
59 Ariès 1962, p.39.
60 E. Baumgarten 2004, p.97.
61 Laurence 1988, p.78.
62 *The Guardian*, 28 July 2011, p.21.
63 Davis 1987, p.130.
64 Gélis 1991, p.195.
65 Buck 1996, p.52.
66 Bett 1952, p.31.

67 *Book of Common Prayer* 1801, p.185.
68 Klein 1998, p.205.
69 Gélis 1991, p.194.
70 Shahar 1990, p.48.
71 Bett 1952, p.31.
72 Cressy 1997, p.82.
73 Harrington 2009, p.62.

Chapter 5

1 *The Oddie Children*, by William Beechey, 1789. Durham, North Carolina Museum.
2 Calvert 1992, p.33.
3 Halford 1828, p.310.
4 Gaskell 1923, p.7.
5 Braidwood 1874, p.22.
6 Creaton 2001, p.45.
7 See Hieronymus Bosch, *Christ Child with a Baby Walker*, 1480. Vienna, Kunsthistorisches Museum.
8 Halford 1828, p.310.
9 Toomer 2004, p.163; Calvert 1992, p.42.
10 Beekman 1977, p.82.
11 J. C. Loudon 1839, p.851.
12 Bagshawe 1937, p.325.
13 Symonds 1949, p.103.
14 Spaulding and Welch 1991, p.110.
15 Halford 1828, p.310
16 Colonial Williamsburg collection G 1971–1739.
17 Pollock 1987, p.74.
18 Pollock 1987, p.195.
19 Pollock 1987, p.73.
20 Toomer 2004, p.166.
21 Beeton 1869, p.2398.
22 Spaulding and Welch 1991, p.270.
23 See *Saying Grace* by Jean-Simeon Chardin, 1744. St Petersburg, State Hermitage Museum.
24 L. Baumgarten 2002, p.66.
25 Le Roy Ladurie 1978, p.208
26 Klapische-Zuber 1985, p.149.
27 See *Les sevreuses* by Jean-Baptiste Tilliard after Jean-Baptiste Greuze, 1765. Paris, Musée du Louvre.
28 C. Clinton 1982, p.156.
29 Crump 1929, p.48.
30 Royal Collections Trust 2014.
31 Dally 1996, p.1710.
32 Calvert 1992, p.49.
33 Kevill-Davies 1991, p.58.
34 Chavasse 1839, p.54.
35 McMillen 1990, p.83
36 Pinto 1969, p.361
37 Fontanel and d'Harcourt 1997, p.151.

38 Brecht 1990, p.204.
39 Hunt 1972, p.142.
40 Detail from *The Haywagon* by Hieronymous Bosch, 1500–02. Museo del Prado, Madrid.
41 Locke 1728, p.30.
42 See Cornelius Troost, *Family Group near a Harpsichord*, 1739. Amsterdam, Rijksmuseum.

Chapter 6

1 Shahar 1983, p.140.
2 Warner 1978, p.194.
3 Os 1995, p.52.
4 For example, *Charity*, Bow porcelain figure, 1750, V&A: 414:181–1885; and *Charity* made from Furstenburg porcelain, 1759, V&A: C141–1931.
5 Martin 2011, p.278.
6 Hollander 1978, p.187.
7 Warner 1985, p.283.
8 Penny 1975, p.314. MacDonald 1981, p.81.
9 Fildes 1988, p.116.
10 Private collection, mentioned in Postle 2011, p.226.
11 D. G. Charlton 1984, p.139.
12 Brookner 1972, p.111.
13 Barker 2005, p.93.
14 Seznec and Adhémar 1979, p.155.
15 Barker 2005, p.155.
16 Lithograph by d'Aubert and de Junier after Tellier, 19th century. Private collection, mentioned in Spaulding and Welch 1991, p.14.
17 *Motherhood* by Françoise Duparc, 1810. Baltimore, Baltimore Museum of Art.
18 Hardyment 1992, p.5.
19 Pollock 1987, p.193; Pollock 1983, p.216.
20 E. Clinton 1622, p.16.
21 Schama 1989, p.125.
22 Susmann 1982, p.28.
23 Cobbett 1876, p.216.
24 Vickery 1988, p.316.
25 Wollstonecraft 1787, p.3.
26 Wollstonecraft 1792, section 1, chapter 5.
27 Tomalin 1992, p.218.
28 Schama 1989, pp.123–24.
29 Warner 1985, pp.250 and 285.
30 Warner 1985, p.286.
31 Schama 1989, p.124.
32 Rose 1986, pp.52–54.
33 Halford 1828, p.265.
34 Clinton 1622, p.16.
35 Foreman 1999, p.122.
36 Golden 1996, p.23.

37 Shefrin 2003, p.3.
38 Shefrin 2003, p.3.
39 Barker 2005, p.143.
40 Fraser 2001, p.201.
41 Schama 1989, p.128.
42 Engraving by Chevillet (1769–80) after Jean Anton de Peters, France (Drake collection, Toronto, Ontario, acc. no. TDPA 351).
43 Trianon catalogue 2001, p.305; Witkowski 1898, p.4.
44 Halford 1828, p.371.
45 Halford 1828, p.265
46 Fontanel and d'Harcourt 1996, p.112.
47 Lett and Morel 2006, p.110.
48 Holmes 2003, p.41.
49 Graham et al. 1989, p.153.
50 Crawford 1986, p.48.
51 Dick 1987, p.72.
52 La Berge 1991, p.30.
53 La Berge 1991, p.27.
54 D. G. Charlton 1984, p.147.
55 Ginnis Fuchs 1984, p.13.
56 Hufton 1996, p.202.
57 Ginnis Fuchs 1982, p.246.
58 Panton 1896, p.222.
59 Beeton 1869, p.1069.
60 Opie and Opie 1958, p.94.
61 For example, the bubby pot, Wedgwood, Staffordshire, 1770–1835. London, Science Museum, A600084. Haskell and Lewis 1971, p.37.
62 Boat-shaped infant's feeding bottle, transfer-printed glazed stoneware, Crellin 33, English, 1801–91. London, Science Museum, A625741.
63 Ginnis Fuchs 1982, p.246.
64 Hodgson 1909, p.11.
65 Gray 1946, p.58; Radcliffe 1967, p.50.
66 Sperling 2013, p.2.
67 Martin 2011, p.254.
68 Hardyment 1992, p.21.
69 Lett and Morel 2006, p.131. Fontanel and d'Harcourt 1997, p.120. Sperling 2013, p.212.

Chapter 7

1 Pinchbeck 1969, p.232.
2 Hufton 1995, p.193.
3 Fletcher 2008, p.58.
4 Fletcher 2008, p.177.
5 Orme 2001, p.68.
3 Cobbett 1876, p.239.
7 Flaubert 1964, p.100.
8 Klapische-Zuber 1985 p.148.

9 See Loudon 1839, p.1086.
10 Panton 1896, p.204.
11 J.-J. Rousseau 1995, p.12.
12 Engels 1977, p.132.
13 Orme 2001, p.99.
14 Kinmonth 1993, p.175.
15 Braudel 1981, p.283; Sarti 2002, p.90.
16 Kinmonth 1993, p.175.
17 Seventeenth-century example in Strangers' Hall, Norwich.
18 Symonds 1949, p.103.
19 Buchan 1869, p.22.
20 Calvert 1992, p.36.
21 Halford 1828, p.305.
22 Laurence 1988, p.76.
23 Riché and Alexandre-Bidon 1994, p.52.
24 D. G. Charlton 1984, p.156.
25 See Steward 1996, p.112.
26 J.-J. Rousseau 1995, p.12.
27 D. G. Charlton 1984, p.147.
28 D. G. Charlton 1984, p.155.
29 Cadogan 1748, p.12.
30 Ballin 1902, p.36.
31 Calvert 1992, p.48.
32 Beeton 1869, p.1073.
33 Klapische-Zuber 1985, p.147.
34 *British Medical Journal*, 10 August 1865, pp.380, 382; O'Hara 1989, p.3.
35 Fildes 1988, p.96.
36 Flandrin 1979, p.98.
37 Cressy 1997, p.89.
38 Beeton 1869, p.1067.
39 Rose 1986, p.10.
40 Ballin 1902, p.8.
41 Riché and Alexandre-Bidon 1994, p.52.
42 Evelyn 1819, p.311.
43 Heijman Jacobis, *Shat der Armin*, seventeenth century. Cambridge, MA, Harvard University, Houghton Library.
44 Gélis 1991, p.194.
45 Halford 1828, p.287.
46 Gilbert 1991, p.112.
47 Panton 1896, p.211.
48 Chinnery 1979, p.396.
49 Scott 2012, p.43.
50 Fresco by Domenico di Bartolo, 1441–42. Siena, Hospital of Santa Maria della Scala.
51 Honour 1997, pp.87–88.
52 Gowing 2008, p.137.
53 Gowing 2008, p.147.
54 Hair 1972, p.106.
55 Dolan 1994, p.125.
56 Foundling Museum Guide 2004, p.12.
57 Fielding 1963, p.56.

58 D. G. Charlton 1984, p.149.
59 Klapische-Zuber 1985, p.149.
60 MacDonald 1981, p.32.
61 Steinburger 2000, p.333.
62 Dolan 1994, p.132.
63 https://www.oldbaileyonline.org (1 June 1677).
64 Hunter 1783, p.153.

65 Dolan 1994, p.127.
66 Riding 2017, p.117.
67 John Styles 2010, p.43
68 Uglow 1997, p.329.
69 Uglow 1997, p.329.
70 Gray 1946, pp.32–33.
71 Gibbon and Bell 1939, p.295.

Bibliography

Ariès, Philippe, *Centuries of Childhood: A Social History of Family Life*, New York: Vintage Books, and London: Jonathan Cape, 1962

Ashton, John, *Social Life in the Reign of Queen Anne, Taken from Original Sources*, London: Chatto and Windus, 1883

Bagshawe, Thomas W., 'Baby-Cages', in *Apollo*, vol. 26, no. 156 (December 1937)

Ballin, Ada, *From Cradle to School*, London: Constable, 1902

Barker, Emma, *Greuze and the Painting of Sentiment*, Cambridge: Cambridge University Press, 2005

Barrie, J. M., *Margaret Ogilvy: By her Son*, London: Hodder and Stoughton, 1896

Baumgarten, Elisheva, *Mothers and Children: Jewish Family Life in Medieval Europe*, Oxford: Princeton University Press, 2004

Baumgarten, Linda, *What Clothes Reveal: The Language of Clothing in Colonial and Federal America*, New Haven and London: Colonial Williamsburg Foundation / Yale University Press, 2002

Bayne-Powell, Rosamund, *The English Child in the Eighteenth Century*, London: John Murray, 1939

Beekman, Daniel, *The Mechanical Baby: A Popular History of the Theory and Practice of Child Raising*, Westport, CT: Lawrence Hill, 1977

Beeton, Isabella [Mrs], *The Book of Household Management*, London: J. Ogden, 1869

Bessborough, Earl of (ed.), *Extracts from the Correspondence of Georgiana, Duchess of Devonshire*, London: John Murray, 1955

Bett, Henry, *English Myths and Traditions*, London: Batsford, 1952

Black, Peter (ed.), *'My Highest Pleasures': William Hunter's Art Collection*, Glasgow and London: Hunterian Museum, University of Glasgow / Paul Holberton, 2007

Book of Common Prayer, London: J. Wright, 1801

Boorde, Andrew, *The Breviary of Healthe*, London: Wyllam Powell, 1557

Braidwood, Peter Murray, *The Domestic Management of Children*, London: Smith, Elder, 1874

Braudel, Fernand, *The Structures of Everyday Life*, London: Collins, 1981

Brecht, Martin, *Martin Luther: Shaping and Defining the Reformation*, Minneapolis: Fortress Press, 1990

Brookner, Anita, *Greuze: The Rise and Fall of an Eighteenth Century Phenomenon*, London: Elek, 1972

Buchan, William, Dr, *Advice to Mothers on the Subject of Their Own Health, and on the Means of Promoting the Health, Strength, and Beauty of Their Offspring*, London: T. Cadell and W. Davies, 1784

––, *Domestic Medicine*, Edinburgh: Balfour, Auld and Smellie, 1869

Buck, Anne, *Clothes and the Child: A Handbook of Children's Dress in England 1500–1900*, Bedford: Ruth Bean Publishers, 1996

Bull, Thomas, Dr, *Hints to Mothers and the Management of Health during the Pregnancy and in the Lying-in Room*, London, 1865

Burnett, John (ed.), *Destiny Obscure: Autobiographies of Childhood, Education and Family from the 1820s to the 1920s*, London: Routledge, 1994

Cadogan, William, *An Essay upon Nursing and the Management of Children from Birth to Three Years of Age*, London: John Knapton, 1748

Calvert, Karin, *Childhood in the House: The Material Culture of Early Childhood, 1600–1900*, Boston, MA: North Eastern University Press, 1992

Carson Banks, Amanda, *Birth Chairs, Midwives and Medicine*, Jackson: University Press of Mississippi, 1999

Chamberlain, Geoffrey, *From Witchcraft to Wisdom: A History of Obstetrics and Gynaecology in Britain*, London: Royal College of Obstetricians and Gynaecologists, 2007

Charlton, D. G., *New Images of the Natural in France: A Study in European Cultural History, 1750–1800*, Cambridge: Cambridge University Press, 1984

Charlton, Kenneth, 'Mothers and Familial Education in Pre-Industrial England', in *History of Education*, vol. 17, no. 1 (1988)

Chavasse, Henry Pye, *Advice to a Mother*, tenth edition, London: Cassell, 1939

Chinnery, Victor, *Oak Furniture: The British Tradition: A History of Early Furniture in the British Isles and New England*, Woodbridge: Antique Collectors Club, 1979

Clinton, Catherine, *The Plantation Mistress: Woman's World in the Old South*, New York: Pantheon Books, 1982

Clinton, Elizabeth, *The Countess of Lincolne's Nurserie*, Oxford: J. Lichfield and J. Short, 1622

Cobbett, William, *Advice to Young Men and Young Women*, London: Charles Griffin, 1876

Cody, Lisa Forman, *Birthing the Nation: Sex, Science and the Conception of Eighteenth-century Britons*, Oxford: Oxford University Press, 2005

Conran, Terence, *The Bed and Bath Book*, London: Mitchell Beazley, 1978

Country Doctor, 'Husband in Bedrooms during Parturition', in *The Lancet*, 11 December 1841

Crawford, Patricia, 'The Sucking Child: Adult Attitudes to Childcare in the First Year of Life in the Seventeenth Century', in *Continuity and Change*, vol. 1 (1986)

Creaton, Heather, *Victorian Diaries: The Daily Lives of Victorian Men and Women: Fascinating Diaries of Ordinary Lives*, London: Mitchell Beazley, 2001

Cressy, David, *Birth, Marriage and Death: Ritual, Religion and the Life-cycle in Tudor and Stuart England*, Oxford: Oxford University Press, 1997

Crump, Lucy, *Nursery Life 300 Years Ago*, London: Routledge, 1929

Cunnington, Phillis, and Catherine Lucas, *Costumes for Births, Marriages and Deaths*, London: A. & C. Black, 1972

Dally, Ann, 'The Lancet and the Gum Lancet: 400 Years of Teething Babies', in *The Lancet*, no. 21/28 (1996)

Davis, Natalie Zemon, *Society and Culture in Early Modern France: Eight Essays*, London: Duckworth, 1987

Dewhurst, Jack, *Royal Confinements*, London: Weidenfeld and Nicolson, 1980

Dick, Diana, *Yesterday's Babies*, London: Bodley Head, 1987

Dickens, Charles, *Oliver Twist*, London: Hazell, Watson and Viney, 1868

Disraeli, Benjamin, *Sybil: Two Nations*, London: David and Bruce, 1853

Dolan, Frances E., *Dangerous Families: Representations of Domestic Crime in England, 1550–1700*, Ithaca and London: Cornell University Press, 1994

Eccles, Audrey, *Obstetrics and Gynaecology in Tudor and Stuart England*, London: Croom Helm, 1982

Engels, Friedrich, *The Condition of the Working Class in England*, Moscow: Progress Publishing, 1977

Evans, Jennifer, 'Menstrual Provocation and Procreation in Early Modern England', in *Social History of Medicine*, vol. 25, no. 1 (February 2012)

Evelyn, John, *Memoirs illustrative of the life and writings of John Evelyn comprising his diary from the year 1641 to 1705*, ed. William Bray, London: Murray, 1819

Farjeon, Eleanor, *A Nursery in the Nineties*, London: Oxford University Press, 1960

Fielding, Henry, *The History of Tom Jones*, vol. 1 (1749); reprinted London: Dent, 1963

Fildes, Valerie, *Wet Nursing*, Oxford and New York: Basil Blackwell, 1988

Finer, Ann, and George Savage (eds.), *The Selected Letters of Josiah Wedgwood*, London: Adams and Mackay, 1965

Fitzgerald, Hetherington Percy, *The Good Queen Charlotte*, London: Downey, 1899

Flandrin, Jean-Louis, *Families in Former Times: Kinship, Household and Sexuality*, Cambridge: Cambridge University Press, 1979

Flather, Amanda, *Gender and Space in Early Modern England*, Woodbridge: Boydell Press, 2007

Flaubert, Gustave, *Sentimental Education*, Harmondsworth: Penguin, 1964

Fletcher, Anthony, *Growing Up in England: The Experience of Childhood, 1600–1914*, New Haven and London: Yale University Press, 2008

Fontanel, Béatrice, and Claire d'Harcourt, *Babies: History, Art and Folklore*, New York: Harry N. Abrams, 1997

Foreman, Amanda, *Georgiana, Duchess of Devonshire*, London: Harper Collins, 1999

Foundling Museum Guide, *The Foundling Museum*, 2004

Fraser, Antonia, *The Weaker Vessel: A Woman's Lot in Seventeenth Century England*, London: Methuen, 1984

−−, *Marie-Antoinette*, London: Weidenfeld and Nicolson, 2001

Gaskell, Elizabeth Cleghorn, '*My Diary': The Early Years of my Daughter Marianne*, London: privately printed by Clement Shorter, 1923

Gélis, Jacques, *History of Childbirth: Fertility, Pregnancy and Birth in Early Modern Europe*, Cambridge: Polity Press, 1991

Gibbon, Sir Gwilym, and Reginald W. Bell, *History of the London County Council*, London: Macmillan, 1939

Gilbert, Christopher, *English Vernacular Furniture*, New Haven and London: Yale University Press, 1991

Gillis, John R., *A World of Their Own Making: Myth, Ritual and the Quest for Family Values*, New York: Basic Books, 1996

Ginnis Fuchs, Rachel, 'Crimes Against Children in 19th Century France: Child Abuse', in *Law and Human Behaviour*, vol. 6, no. 3/4 (1982)

−−, *Abandoned Children: Foundlings and Child Welfare in Nineteenth-century France*, Albany, NY: State University of New York Press, 1984

Glanville, P., and S. Lee (eds), *The Art of Drinking*, London: V&A Publications, 2007

Golden, Janet, *A Social History of Wet Nursing in America: From Breast to Bottle*, Cambridge: Cambridge University Press, 1996

Gowing, Laura, 'Secret Births and Infanticide in 17th century England', in *Past and Present*, no. 156 (August 1997)

−−, *Common Bodies: Women, Touch and Power in 17th Century England*, New Haven and London: Yale University Press, 2003

−−, 'Giving Birth at the Magistrate's Gate: Single Mothers in the Early Modern City', in *Women, Identities and Communities in Early Modern Europe*, ed. Susan Broomhall and Stephanie Turbin, London: Routledge, 2008

Graham, Elspeth, et al. (eds.), *Her Own Life: Autobiographical Writings by Seventeenth-century Englishwomen*, London: Routledge, 1989

Gray, Ernest, *Man Midwife: The Further Experiences of John Knyveton, MD, Late Surgeon in the British Fleet during the Years 1763–1809*, London: Robert Hale, 1946

Grimm, the Brothers, *Household Stories*, London: George Routledge, 1892

Grimshaw, Lindsay, 'Fame and Fortune by Means of "Bricks and Mortars": The Medical Profession and Specialist Hospitals in Britain, 1800–1948', in *The Hospital in History*, ed. Lindsay Grimshaw and Roy Porter, London and New York: Routledge, 1989

Hair, Paul (ed.), *Before the Bawdy Court: Selections from Church Court and Other Records Relating to the Correction of Moral Offences in England, Scotland and New England, 1300–1800*, London: Elek, 1972

Halford, Elizabeth, *The Good Nurse; or, Hints on the Management of the Sick and Lying-in Chamber and the Nursery*, n.p., 1828

Hanawalt, Barbara, *Growing Up in Medieval London: The Experience of Childhood in History*, Oxford: Oxford University Press, 1993

Hardyment, Christina, *Perfect Parents: Babycare Advice Past and Present*, Oxford: Oxford University Press, 1995

Harley, David, 'Historians as Demonologists: The Myth of the Midwife Witch', in *Social History of Medicine*, vol. 3, no. 1 (1990)

Harrington, Joel F., *The Unwanted Child: The Fate of Foundlings, Orphans and Juvenile Criminals in Early Modern Germany*, Chicago: University of Chicago Press, 2009

Haskell, Arnold, and Min Lewis, *Infantilia: The Archaeology of the Nursery*, London: Dennis Dobson, 1971

Hawkins Miller, John, '"Temple and Sewer": Childbirth, Prudery and *Victoria Regina*', in *The Victorian Family*, ed. Anthony S. Wohl, London: Croom Helm, 1978

Hodgson, Helen S. Cooper, *Mrs Blossom on Babies*, London: Scientific Press, 1909

Hollander, Anne, *Seeing Through Clothes*, New York: Viking Press, 1978

Holmes, Frederick F., *The Sickly Stuarts: The Medical Downfall of a Dynasty*, Stroud: Sutton, 2003

Honour, Hugh, *The Companion Guide to Venice*, fourth edition, Woodbridge: Companion Guides, 1997

Hopkins, Tighe, *The Women Napoleon Loved*, London: Eveleigh Nash, 1910

Houlbrooke, Margaret, *Rite Out of Time: A Study of the Ancient Rite of Churching and its Survival in the 20th Century*, Donington: Shaun Tyas, 2011

Houlbrooke, Ralph, *The English Family, 1450–1700*, London: Longman, 1984

Hufton, Olwen, *The Prospect Before Her: A History of Women in Western Europe, 1500–1800*, London: Harper Collins, 1996

Hunt, David, *Parents and Children in History: The Psychology of Family Life in Early Modern France*, New York: Harper and Row, 1972

Hunter, William, *An Account of the Life and Writings of William Hunter, MD*, London: Samuel Foart Simmons, 1783

Jackson, Mark, *New-born Child Murder: Women, Illegitimacy and the Courts in Eighteenth-century England*, Manchester: Manchester University Press, 1996

Jalland, Pat, and John Hooper, *Women from Birth to Death: The Female Life Cycle in Britain, 1830–1914*, Brighton: Harvester, 1986

Jersey, Dowager Countess of, *Fifty-one Years of Victorian Life*, London: John Murray, 1922

Judd, Robin, 'Blood Imagery, Jewish Ritual and Social Activism', in *Blood: Reflections of What Unites and Divides Us*, ed. Anthony Bale and David Feldman, London: Pears Institute for the Study of Anti-Semitism, Birkbeck, University of London, and the Jewish Museum, 2015

Kemble, James, *Napoleon Immortal: The Medical History and Private Life of Napoleon Bonaparte*, London: John Murray, 1959

Kevill-Davies, Sally, *Yesterday's Children: The Antiques and History of Childcare*, Woodbridge: Antique Collectors Club, 1991

Kinmonth, Claudia, *Irish Country Furniture, 1700–1950*, New Haven and London: Yale University Press, 1993

Kipling, Rudyard, *The Seven Seas*, London: Methuen, 1896

Klapische-Zuber, Christiane, *Women, Family and Ritual in Renaissance Italy*, Chicago: Chicago University Press, 1985

Klein, Michelle, *A Time to be Born: Custom and Folklore of Jewish Birth*, London: Jewish Publication Society, 1998

Knight, Patricia, 'Women and Abortion in Victorian and Edwardian England', in *History Workshop Journal*, no. 4 (Autumn 1977)

La Berge, Anne, 'Mothers and Infants, Nurses and Nursing: Alfred Donné and the Medicalisation of Child-care in Nineteenth-century France', in *Journal of the History of Medicine and Allied Sciences*, vol. 46, no. 1 (January 1991)

Laurence, Anne, 'The Cradle to the Grave: English Observation of Irish Social Customs in the Seventeenth Century', in *Seventeenth Century*, vol. 3, no. 1 (Spring 1988)

––, *Women in England, 1500–1760: A Social History*, London: Weidenfeld and Nicolson, 1994

L'Estrange, Elizabeth, *Holy Motherhood: Gender, Dynasty and Visual Culture in the Later Middle Ages*, Manchester: Manchester University Press, 2008

Le Roy Ladurie, Emmanuel, *Montaillou: Cathars and Catholics in a French Village, 1294–1324*, London: Solar Press, 1978

Lett, Didier, and Marie-France Morel, *Une histoire de l'allaitement*, Paris: Martinière, 2006

Leyser, Henrietta, *Medieval Women: A Social History of Women in England*, London: Weidenfeld and Nicolson, 1995

Lipsedge, Karen, '"Enter into thy closet": Women Closet Culture in the 18th Century Novel', in *Gender, Taste and Material Culture in Britain and North America, 1700–1830*, ed. John Styles and Amanda Vickery, New Haven and London: Yale Center for British Art and Paul Mellon Centre for Studies in British Art, 2006

Llewelyn Davies, Margaret (ed.), *Life as We Have Known It by Co-operative Working Women*, London: Virago, 1977

Locke, John, *Some Thoughts Concerning Education*, Dublin: S. Powell, 1728

Loudon, Irvine S. L., 'Childbirth', in *Companion Encyclopaedia of the History of Medicine*, ed. W. F. Bynum and Roy Porter, vol. 2, London: Routledge, 1993

Loudon, John Claudius, *An Encyclopaedia of Cottage, Farm and Villa Architecture*, London: Longman, 1839

Luther, Martin, 'Estate of Marriage', in *Luther's Works*, Saint Louis, Concordia Publications House, 1958

MacDonald, Michael, *Mystical Bedlam: Madness, Anxiety and Healing in Seventeenth Century England*, Cambridge: Cambridge University Press, 1981

McIntosh, Tania, *Key Themes in Maternity Care: A Social History of Maternity and Childbirth*, London: Routledge, 2012

McKeon, Michael, *The Secret History of Domesticity: Public, Private and the Division of Knowledge*, Baltimore and London: Johns Hopkins University of Press, 2005

McMillen, Sally G., *Motherhood in the Old South: Pregnancy, Childbirth and Infant Rearing*, Baton Rouge: Louisiana State University Press, 1990

McTavish, Lianne, *Childbirth and the Display of Authority in Early Modern France*, Aldershot: Ashgate, 2005

Martin, Meredith, *Dairy Queens: The Politics of Pastoral Architecture from Catherine de' Medici to Marie Antoinette*, Cambridge, MA, and London: Harvard University Press, 2011

Meltzer, David (ed.), *Birth: An Anthology of Ancient Texts, Songs, Prayers and Stories*, San Francisco: North Point Press, 1981

Millen, Ronald Forsyth, and Erich Robert Wolf, *Heroic Deeds and Mystic Figures: A New Reading of Rubens' Life of Maria de' Medici*, Oxford: Princeton University Press, 1989

Musacchio, Jacqueline Marie, *The Art and Ritual of Childbirth in Renaissance Italy*, New Haven and London: Yale University Press, 1999

Nightingale, Florence, *Introductory Notes on Lying-in Institutions with a Proposal for Organising the Institution for Training Midwives*, London, 1871

O'Hara, Georgina, *The World of the Baby: A Celebration of Infancy through the Ages*, London: Michael Joseph, 1989

Opie, Iona, and Peter Opie, *The Oxford Dictionary of Nursery Rhymes*, Oxford: Clarendon Press, 1958

––, and ––, *The Lore and Language of School Children*, Oxford: Clarendon Press, 1959

Orme, Nicholas, *Medieval Children*, New Haven and London: Yale University Press, 2001

Os, Henk van, *The Art of Devotion: In the Late Middle Ages in Europe, 1300–1500*, London: Merrell Holberton / Rijksmuseum, Amsterdam, 1995

Panton, Jane Ellen, *The Way They Should Go: Hints to Young Parents*, London: Downey, 1896

Paschall, Jenny, and Ron Lyon, *Hatches, Matches and Dispatches: Birth, Marriage and Burial around the World*, London: Harper Collins, 2016

Pelling, Margaret, *Medical Conflicts in Early Modern London: Patronage, Physicians and Irregular Practitioners, 1550–1640*, Oxford: Clarendon Press, and New York: Oxford University Press, 2003

Penny, Nicholas, 'Themes and Conventions in English Commemorative Sculpture, 1780–1840', PhD thesis, University of London, 1975

Pinchbeck, Ivy, *Women Workers and the Industrial Revolution*, London: Virago, 1969

Pinto, Edward, *Treen and Other Wooden Bygones: An Encyclopaedia and Social History*, London: Bell and Hyman, 1969

Plumb, J. H., 'The New World of Children in Eighteenth Century England', in *The Birth of a Consumer Society: The Commercialisation of Eighteenth-century England*, ed. Neil McKendrick, John Brewer, and J. H. Plumb, Bloomington: Indiana University Press, 1982

Pollock, Linda, *Forgotten Children: Parent, Child Relations from 1500–1900*, Cambridge: Cambridge University Press, 1983

––, *A Lasting Relationship: Parents and Childcare over Three Centuries*, London: Fourth Estate, 1987

Porter, Enid (ed.), *Cambridgeshire Customs and Folklore*, London: Routledge & Kegan Paul, 1969

Porter, Roy, 'A touch of danger: the man-midwife as sexual predator', in *Sexual Underworlds of the Enlightenment*, ed. G. S. Rousseau and R. Porter, London: Harper Collins, 1987

––, *The Greatest Benefit to Mankind: A Medical History of Humanity from Antiquity to the Present*, London: Harper Collins, 1997

Postle, Martin (ed.), *Johan Zoffany RA: Society Observed*, New Haven and London: Royal Academy of Arts / Yale University Press, 2011

Postles, David, 'Surviving Lone Motherhood in Early Modern England', in *Seventeenth Century Journal*, vol. 21, no. 1 (2006)

Radcliffe, Walter, *Milestones in Midwifery*, Bristol: John Wright and Sons, 1967

Ramsey, Matthew, *Professional and Popular Medicine in France, 1770–1830: The Social World of Medical Practice*, Cambridge: Cambridge University Press, 1988

Riché, Pierre, and Danièle Alexandre-Bidon, *L'enfance au Moyen Age*, Paris: Seuil and Bibliothèque Nationale de France, 1994

Riding, Jacqueline, *Basic Instincts: Love, Passion and Violence in the Art of Joseph Highmore*, London: Paul Holberton, 2017

Rohl, John C., *Young Wilhelm: The Kaiser's Early Life, 1859–1888*, Cambridge: Cambridge University Press, 1998

Roodenburg, Herman W., 'The Maternal Imagination: The Fears of Pregnant Women in Seventeenth-century Holland', in *Journal of Social History*, vol. 21, no. 4 (July 1988)

Rose, Lionel, *The Massacre of the Innocents: Infanticide in Britain, 1800–1939*, London: Routledge & Kegan Paul, 1986

Rousseau, G. S., and Roy Porter, *Sexual Underworlds of the Enlightenment*, Manchester: Manchester University Press, 1992

Rousseau, Jean-Jacques, *Emile*, London: Everyman, J. M. Dent, 1995

Royal Collections Trust, *Childhood Exhibition Catalogue*, 2014

Rublack, Ulinka, 'Pregnancy and Childbirth in Early Modern Germany', in *Past and Present*, no. 150 (February 1996)

Rueff, Jacob, *De conceptu et generatione hominis*, Frankfurt, 1580; Wellcome L0015697

Salmon, Marilyn, 'The Cultural Significance of Breast-Feeding and Infant Care in Early Modern England and America', in *Journal of Social History*, vol. 28, no. 2 (1994)

Sarti, Rafaella, *Europe at Home: Family and Material Culture, 1500–1800*, New Haven and London: Yale University Press, 2002

Schama, Simon, *Citizens: A Chronicle of the French Revolution*, London: Viking, 1989

––, *The Embarrassment of Riches: An Interpretation of Dutch Culture in the Golden Age*, London: Fontana Press, 1991

Schneid Lewis, Judith, *In the Family Way: Childbearing in the British Aristocracy, 1760–1860*, New Brunswick, NJ: Rutgers University Press, 1986

Scott, Anne M. (ed.), *Experiences of Poverty in Late Medieval and Early Modern England and France*, Farnham and Burlington, VT: Ashgate, 2012

Scully, Diana, *Men Who Control Women's Health: The Miseducation of Obstetrician-Gynaecologists*, Boston, MA: Houghton Mifflin, 1980

Seymour, Miranda, *Mary Shelley*, London: Picador, 2001

Seznec, Jean, and Jean Adhémar, *Denis Diderot: Salons*, vol. 2, Oxford: Clarendon Press, 1979

Shahar, Shulamith, *The Fourth Estate: A History of Women in the Middle Ages*, London: Methuen, 1983

––, *Childhood in the Middle Ages*, London: Routledge, 1990

Shefrin, Jill, *Such Constant Affectionate Care: Lady Charlotte Finch, Royal Governess, and the Children of George III*, Los Angeles: Cotsen Occasional Press, 2003

Somerset, Anne, *Queen Anne: The Politics of Passion: A Biography*, London: Harper Press, 2012

Spaulding, Mary, and Penny Welch, *Nurturing Yesterday's Child: A Portrayal of the Drake Collection of Paediatric History*, Philadelphia: Decker, 1991

Speert, Harold, *Iconographia gyniatrica: A Pictorial History of Gynaecology*, Philadelphia: F. A. Davis, 1973

––, *Obstetric and Gynaecological Milestones*, London: Parthenon, 1996

Sperling, Jutta Gisela (ed.), *Medieval and Religious Lactations: Images, Rhetorics, Practices*, Farnham: Ashgate, 2013

Staniland, Kay, 'Welcome Royal Babe! The Birth of Thomas Brotherton in 1300', in *Costume*, no. 19 (1985)

Steinburger, Deborah, 'The Difficult Birth and the Good Mother', in *Maternal Measures: Figuring Caregiving in the Early Modern Period*, ed. Naomi J. Miller and Naomi Yavneh, Brookfield, VT, and Aldershot: Ashgate, 2000

Steward, James Christen, *The New Child: British Art and the Origins of Modern Childhood, 1730–1830*, Berkeley, University Art Museum and Pacific Film Archive / University of Washington Press, 1996

Styles, John, *Threads of Feeling: the London Foundling Hospital's Textile Tokens, 1740–1770.* London: The Foundling Museum 2010

Styles, John and Amanda Vickery (eds.) *Taste and Material Culture in Britain and North America 1730–1830*, New Haven, Connecticut, London: Yale Center for British Art and Paul Mellon Center for Studies in British Art, 2010

Susmann, George D., *Selling Mothers' Milk: The Wet-nursing Business in France, 1715–1914*, Urbana and London: University of Illinois Press, 1982

Symonds, R. W., 'Furniture of the Nursery', in *Antique Collector*, May–June 1949

Thomas, Keith, *Religion and the Decline in Magic: Studies in Popular Belief in Sixteenth- and Seventeenth-century England*, London: Penguin, 1971

Thornton, Peter, *Authentic Décor: The Domestic Interior, 1620–1920*, London: Weidenfeld and Nicolson, 1985

Tilly, Louise A., and Joan W. Scott, *Women, Work and Family*, New York and London: Routledge, 1989

Tillyard, Stella, *Aristocrats: Caroline, Emily, Louise and Sarah Lennox, 1750–1832*, London: Chatto and Windus, 1994

Tomalin, Claire, *The Life and Death of Mary Wollstonecraft*, London: Penguin Books, 1992

Toomer, Heather, *Baby Wore White: Robes for Special Occasions, 1800–1919*, Radstock: Heather Toomer Antique Lace, 2004

Uglow, Jenny, *Hogarth: A Life and a World*, London: Faber and Faber, 1997

Vickery, Amanda, *The Gentleman's Daughter: Women's Lives in Georgian England*, New Haven and London: Yale University Press, 1988

Warner, Marina, *Alone of All Her Sex: The Myth and Cult of the Virgin Mary*, London: Quartet Books, 1978

— —, *Monuments and Maidens: The Allegory of the Female Form*, London: Weidenfeld and Nicolson, 1985

Watkins, John, *Memoirs of Her Majesty, Sophia Charlotte, Queen of Great Britain*, London, 1819

Wellcome Library, *Recueil complete de pièces curieuses*, Special Collection 43297/A

Wertz, Richard W., and Dorothy C. Wertz, *Lying-in: A History of Childbirth in America*, New York: Free Press, and London: Collier Macmillan, 1977

Willes, Margaret, *And So To Bed*, London: National Trust, 1998

Witkowski, G. J., *Les seins et l'allaitement comprenant l'histoire de décolletage et du Corset*, Paris: A. Maloine, 1898

Wollstonecraft, Mary, *Thoughts on the Education of Daughters: With Reflections on Female Conduct in the More Important Duties of Life*, London, 1787

— —, *A Vindication of the Rights of Women* (1792), London: Everyman, 1932

Woodham Smith, Cecil, *Queen Victoria: Her Life and Times, vol. 1: 1819–1861*, London: Hamish Hamilton, 1972

Woolgar, C. M., *The Great Household in Late Medieval England*, New Haven and London: Yale University Press, 1999

Yalom, Marilyn, *A History of the Breast*, London: Harper Collins, 1997

Picture Credits

The author and publisher have made every effort to identify and contact copyright holders. We will happily correct, in subsequent editions, any errors or omissions that are brought to our attention.

Index